PICKING UP THE PIECES

RESIDENTIAL SCHOOL MEMORIES AND THE MAKING OF THE WITNESS BLANKET

◆ ◆ ◆ ◆ ◆

Carey Newman *and* Kirstie Hudson

ORCA BOOK PUBLISHERS

Library and Archives Canada Cataloguing in Publication

Title: Picking up the pieces: residential school memories and the making of the Witness Blanket / Carey Newman and Kirstie Hudson.
Names: Newman, Carey, 1975– author. | Hudson, Kirstie, 1976– author.

Description: Includes bibliographical references and index.

Identifiers: Canadiana (print) 2019007731x | Canadiana (ebook) 20190077352 | ISBN 9781459819955 (hardcover) | ISBN 9781459819979 (PDF) | ISBN 9781459819962 (EPUB)

Subjects: LCSH: Indian blankets—Canada. | LCSH: Adult child abuse victims—Canada. | LCSH: Adult child abuse victims—Mental health—Canada. | LCSH: Art therapy—Canada. | LCSH: Native art—Canada. | Native peoples—Canada—Residential schools. | Native peoples—Mental health—Canada

Classification: LCC E96.2.N49 2019 | DDC 371.829/97071—dc23

Library of Congress Control Number: 2019934047
Simultaneously published in Canada and the United States in 2019

Summary: This nonfiction book, illustrated with photographs, tells the story of the making of the Witness Blanket, a work by Indigenous artist Carey Newman that includes items from every residential school in Canada and stories from the Survivors who donated them.

Orca Book Publishers is committed to reducing the consumption of nonrenewable resources in the making of our books. We make every effort to use materials that support a sustainable future.

Orca Book Publishers gratefully acknowledges the support for its publishing programs provided by the following agencies: the Government of Canada, the Canada Council for the Arts and the Province of British Columbia through the BC Arts Council and the Book Publishing Tax Credit.

Edited by Sarah N. Harvey
Design by Teresa Bubela
Cover photos by Jessica Sigurdson, Canadian Museum for Human Rights
Carey Newman photo by Roth and Ramberg
Kirstie Hudson photo by Ken Wilkinson

ORCA BOOK PUBLISHERS
orcabook.com

Printed and bound in China.

22 21 20 19 • 4 3 2 1

To my father, Victor, for his strength; my wife, Elaine, for her support;
and my daughter, Adelyn, for her hope
— CN

To Elliot and Hazel
— KH

CONTENTS

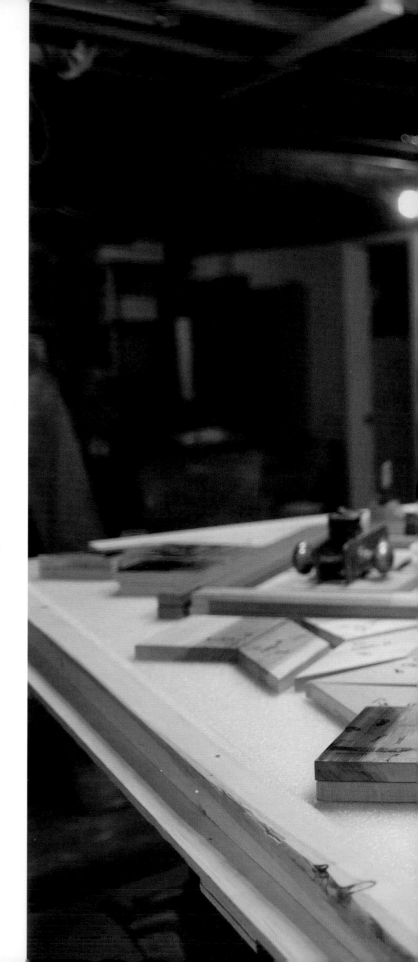

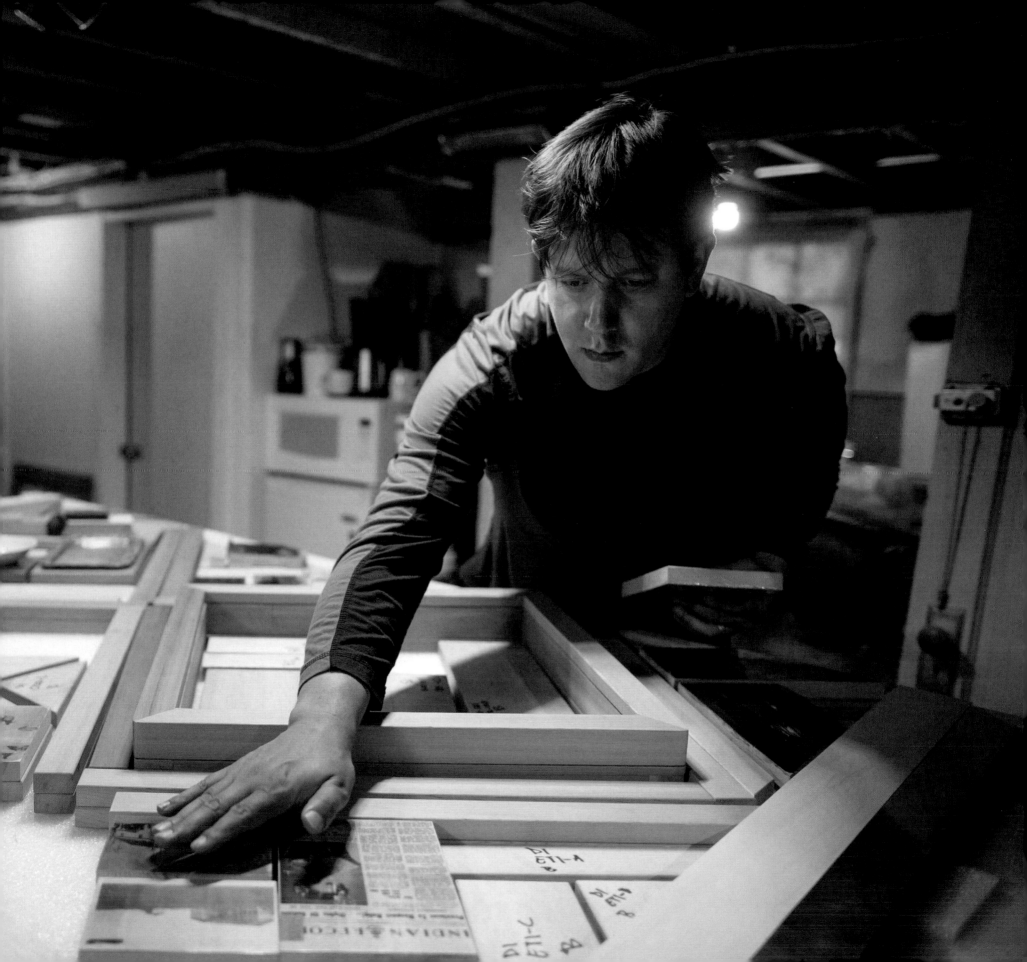

FOREWORD

I'LL NEVER FORGET THE DAY I began what was to become a six-and-a-half-year journey as one of the three commissioners of the Truth and Reconciliation Commission of Canada—July 1, 2009. Canada Day. The irony was never lost on me. For rather than celebrating Canada in all its greatness, our commission was setting out to expose the longest-running human-rights abuse in our country's history: forced residential schooling for Indigenous children, sanctioned by government, enforced by churches.

Among our many duties, the TRC had to recommend how to divide up a $20 million commemoration fund among hundreds of competing proposals. Projects with the potential for lasting impact got priority, contributing to new understanding and respect within families and between peoples. Proposals were widely diverse: monuments, books, documentary films, community arbours, graveyard restorations—even a commissioned piece for the Royal Winnipeg Ballet. And then there was the Witness Blanket!

I remember reading Carey Newman's Witness Blanket proposal, struggling at first to grasp what it really was and why it would be called a blanket at all. This was like no other blanket I had ever seen or heard of. Its size alone, with its intention to travel, to tell its own story, to outlast all of us, put it in the category of a national project with huge, ongoing reconciliation potential. So much more than a sculptural installation, it could become a multi-dimensional production—an unforgettable sensory experience.

There's a lot to be said for blankets. They can offer comfort, warmth, protection...decorate and dress up the look of a place...hide messy sheets beneath.

For 130 years that's what Canada did, blanketing over residential schools, tucking the truth of those schools under covers of denial and self-righteousness, keeping the country comfortable, safe and asleep to its own history. As a commissioner, I championed the potential of this proposed Witness Blanket for the important role it could play in a great national awakening. But back then I could never have adequately foreseen its sheer, imposing beauty or even begun to imagine the profound impact it would eventually have, including its prominent place in the 2015 closing activities of the Truth and Reconciliation Commission.

Now, several years later, *Picking Up the Pieces: Residential School Memories and the Making of the Witness Blanket* unfolds a new kind of blanket. Carey Newman, master carver and sculptor turned storyteller, and co-writer Kirstie Hudson have woven together in book form the creation story behind his monumental art installation.

Breathtaking in scale and complexity, the Blanket itself is a multi-panelled, three-dimensional travelling art installation that has criss-crossed the country. Soul-stirring in impact, it is an intricate quilting together of material objects, each one telling a piece of Canada's residential school story, from coast to coast to coast. It is a blanket that lays bare our history. It scratches, touches, comforts, redeems. It chills—but with the beauty and light of a fresh blanket of snow. Now, through his personal reflections, Carey brings new light both to the making of his timeless masterpiece and to the intergenerational Survivors now at the heart of a story far from over in Canada.

As art installation, the Witness Blanket will find its long-term home in the Canadian Museum of Human Rights, standing for decades to come as a material witness to, and reflection of, the residential school experience in Canada. But as a book, *Picking Up the Pieces* allows the Blanket to keep travelling, uncovering the Survivors' stories beneath the artist's hand. Here is a work bearing the stamp of authenticity from artist–author Carey's own heart, as he offers this major contribution to the ongoing work of reconciliation in Canada.

Dr. Marie Wilson, Commissioner
Truth and Reconciliation Commission of Canada, 2009–2015

INTRODUCTION

MY NAME IS CAREY NEWMAN. My traditional name is Hayalthkin'geme.

Through my father I am Kwagiulth of the Kwakwa̱ka̱'wakw Nation from northern Vancouver Island, in British Columbia. Through his mother, I am Coast Salish from Cheam of the Stó:lō Nation along the Upper Fraser Valley.

On my mother's side of the family, I am descended from English, Irish and Scottish **settlers**, who planted their roots in Saskatchewan.

Being of mixed heritage, I have always felt conflicted about my experience growing up in Canada. This country provided one side of my family with the opportunity for a better life. At the same time, the **colonization** that Canada was founded on has damaged generations of my **Indigenous** relatives.

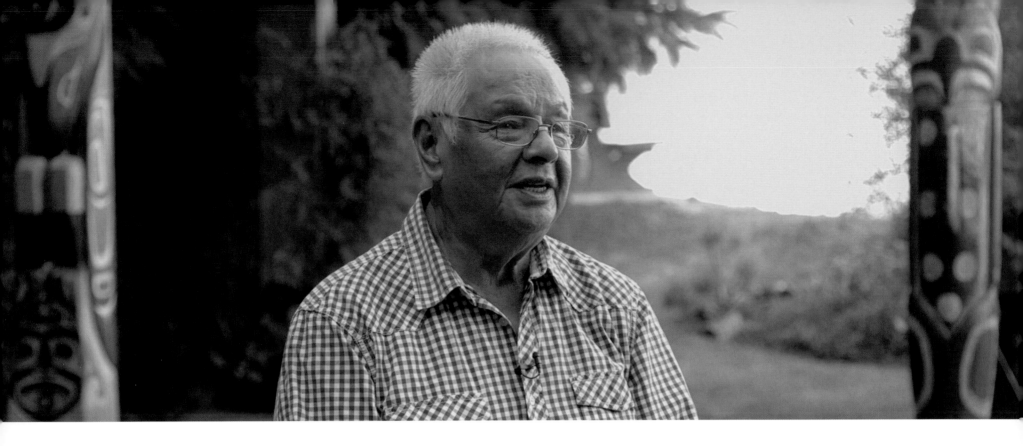

Carey's father, Victor Newman, at the site of St. Mary's in Mission, BC, the last residential school he was sent to.

MY FAMILY

One part of Canadian history that has directly affected my family is the ***Indian residential school system*** that operated from 1870 to 1998. During that time, more than 150,000 Indigenous children were forcibly taken from their families and sent to live at schools set up by the federal government and run by several different religious groups.

My father was born in 1937 in the small remote town of Alert Bay, British Columbia. At age seven he was taken from his parents and sent to a residential school far away from home.

Part of the purpose of residential schools was to ***assimilate*** Indigenous people like my father and other members of his family—to make them think, act and speak less like their own people and more like non-Indigenous Canadians. In 1879 Sir John A. Macdonald, one of the key politicians behind the establishment of residential schools in Canada, said, "It has been strongly impressed upon myself, as head of the Department, that Indian children should be withdrawn as

much as possible from the parental influence, and the only way to do that would be to put them in central training **industrial schools** where they will acquire the habits and modes of thought of white men."

At residential school, my father wasn't allowed to speak Kwak'wala, the language of his people. He couldn't learn his people's traditional ways or practise their cultural ceremonies. He wasn't even allowed to talk to his siblings. Losing these key parts of his identity changed who he became, altered how he thought of himself and disrupted his connection with his family.

Many people who have suffered trauma don't like to talk about their experiences. This is how it is for my father. And although he has shared a few details about his years at residential school, in order to protect us he chose not to tell me and my sisters about the abuse he endured. Of the few stories he did tell us, the ones that stuck with me are about how he protected the younger boys and his friends whenever he could.

Carey's grandmother, Mary Agnes Newman (nee Victor), with his aunt Georgina (left), aunt Doris (right), father Victor, in the striped shirt, and Victor's baby brother Ted.

Attending residential schools had a lasting effect on my father and shaped the kind of parent he became. For the most part, I had a happy childhood, but I can still remember the change that happened when I turned seven, the same age he was when he was taken away from his parents. From 1944, when he was seven, until he left school in 1956, just before his nineteenth birthday, the adults in his life were mostly residential school supervisors. They were the only "parents" he knew, and his relationship with them influenced his relationship with me and my sisters.

Intergenerational trauma happens when parents pass some of their fears or bad experiences down to their children. Although my relationship with my dad was sometimes difficult, I consider myself fortunate because I also knew that he loved me. This was never clearer than in my early teens, when my mother sent us to see a counsellor together. She wanted us to mend our relationship. That was when I learned about how difficult his childhood had

Victor, Marion and Carey Newman outside their family home in Sooke, BC.

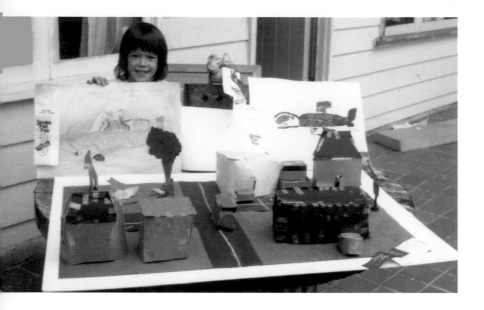

Carey with his Sooke Fall Fair submissions, outside his family home in Sooke, BC, in 1980.

been at residential school and how he had lost his connection with his own father. Knowing this helped me to understand him better. I also began to understand our relationship, and even myself, a little bit better.

Knowing that my father went to residential school and that my sisters and I were **Intergenerational Survivors** led me to want to know more about that part of Canadian history. That is why, when the **Truth and Reconciliation Commission (TRC)** began in June 2008, I followed its progress closely. The TRC's mandate was to tell Canadians what happened at residential schools and to document the experiences **Survivors** had at those schools. By that time I had been earning a living as an artist for more than twenty years and was keenly interested in making art that involved community or had social purpose.

I started my artistic education at my father's knee at about age five. I remember watching him carve in his workshop. With his help I would make drawings and paintings that I then sold at the various craft shows and markets that he attended.

Carey's 1980 painting Killer Whale, *done when he was five years old.*

It was around that time that I got my first carving injury—I cut my thumb while I was making a car out of some of my dad's leftover cedar scraps. At age twelve, I made my first two editions of silkscreen prints, and from then until now, the only career I've ever known is that of artist.

Carey with a collection of his artwork at age 13.

TELLING OUR STORY

When the TRC announced it was looking for proposals for commemoration projects, I began to wonder what I could do. The options were to do an individual project, a regional project, a provincial project or a national project. I wanted to do a national project, because I wanted to tell the *whole* story of residential schools in Canada.

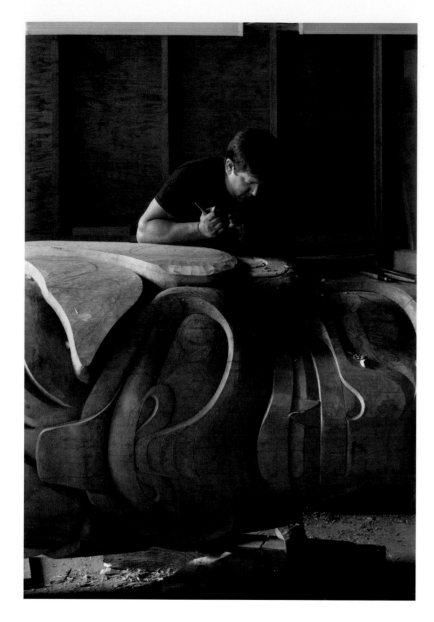

Carey in his studio in 2018, carving details on a 36-foot red cedar totem.

But how could I use my art to tell a story that big? Most of what I do is carving—in wood, in stone, in metal. I take something and remove the parts I don't want, slowly revealing a mask or a **totem pole** or a sculpture. This new project was unique. Rather than making a different version of something that I had seen before, I needed to come up with a completely original idea.

It didn't come to me right away; for a long time all my ideas seemed too small. I wanted to represent the story of residential school Survivors all across Canada. To do that, I needed to think of something I could make that wasn't just big in scale but was also a big-enough idea to contain such an enormous story.

That was when I came up with the idea of gathering objects from the schools. I was sitting in my living room, and I had my feet on a little folding stool. The part my feet were resting on is made from bits of wood strung together to create a sort of flexible sling. That was my eureka moment. I thought, "I'll do something like this! But much bigger! I'll create a blanket made of solid objects, strung together like my stool. That way I can gather pieces from all the residential schools and collectively, like a huge patchwork quilt, they will tell the whole story." That is when I first felt like I was finally on the right track.

The original idea was to include only objects from residential schools. As I thought more about it, I realized I should also include items from **day schools** and government buildings and churches, because they're part of the same story. Government buildings were where the decisions and policies were made that led to the establishment and running of the schools, and churches operated the schools.

Eventually I realized that the story didn't end when the last residential school was closed. The effects continue in our communities. The people and cultures that were targeted have survived. To give voice to that resilience and reflect the continuing work of healing, I decided to include pieces from traditional structures like **Big Houses**, **sweat lodges** and tipis, as well as urban or contemporary Indigenous places like healing centres, Indigenous schools and universities, and Native Friendship Centres. That is how I came up with the idea for the Witness Blanket. It evolved from my desire to both honour my father and tell the whole story.

I needed to think of something I could make that wasn't just big in scale but was also a big-enough idea to contain such an enormous story.

I wanted it to be a blanket for multiple reasons, but especially because blankets have particular significance in both of my Indigenous cultures—Kwakwa̱ka'wakw and Salish. Blankets are used in different ways across cultures and traditions. In my Kwakwa̱ka'wakw culture, blankets represent who we are. We stitch our symbols on them—our totems and family crests. We wear them in ceremony; they are part of our identity and they identify our lineage. In my Salish tradition, we use blankets to honour, uplift and protect people. If somebody has achieved something wonderful for themselves or the community, we acknowledge that by putting a blanket around them as a sign of honour or gratitude. If someone has gone through trauma or falls on hard times, we do the same thing as a gesture of protection.

Expanding that to include the rest of the world, I think about how we wrap our babies in blankets when they're born, and how we often wrap our loved ones in blankets when they die. The blanket carries symbolic importance in almost every culture. Ultimately I chose to make this work in the image of a blanket because it is a strong universal symbol.

The Witness Blanket collection team visiting Alert Bay, BC, in January 2014.

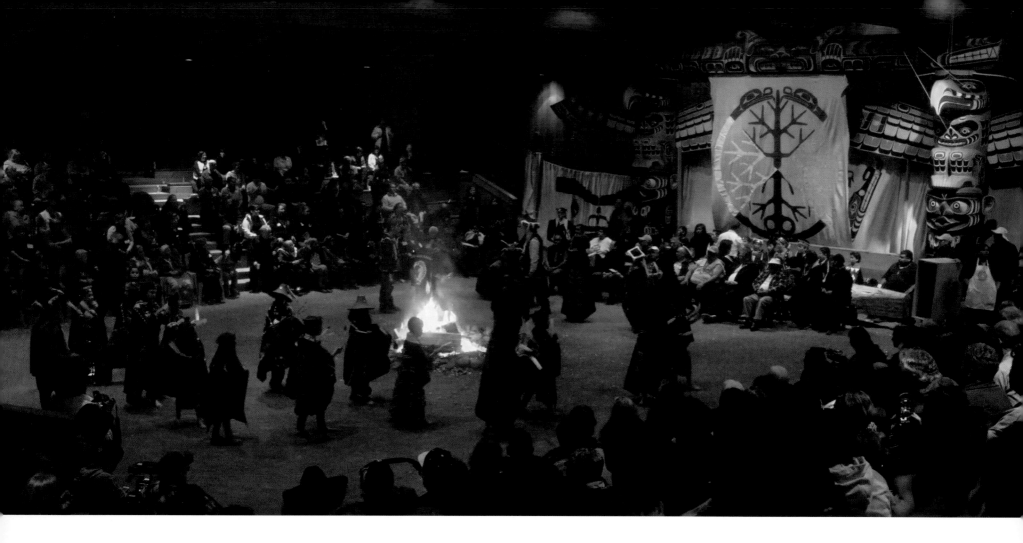

A ceremony following the demolition of St. Michael's residential school in Alert Bay, BC, in February 2015.

BEARING WITNESS

As for the name of the project, it came from something my wife, Elaine, heard on **CBC** Radio. A reporter was interviewing people about a TRC event, and when he asked a priest why he was there, the priest said, simply, "I'm here to bear witness." After hearing that, Elaine phoned me and said, "Bear witness, bear witness—it's about bearing witness." I looked up the definition of the term and found something like "to show by your existence that something is true"—and I realized that it was perfect, because the project *was* about bearing witness. My role as an artist is to bear witness. The pieces themselves are witnesses. The people giving us the pieces are witnesses and, at some level, we are all—or we should all be—witnesses.

In both Kwakwa̱ka'wakw and Salish oral traditions, we have witnesses. That is how we preserve history or important moments. In Kwakwa̱ka'wakw ways, we hold **Potlatches** to tell our stories, and then we give gifts to our guests and ask them to remember what they saw. In the Salish tradition, we ask people to stand and speak about what they have witnessed. Then we acknowledge them by giving tokens or paying them to carry our history.

Following that tradition, I created Witness Blanket coins to acknowledge people who made contributions or helped us along the way. Everywhere we went we gave out the coins, which said "thank you" in many different languages.

That is how the Witness and Blanket traditions came together.

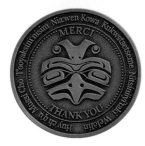

Witness Blanket coins were given to those who made contributions to the Blanket.

RESIDENTIAL SCHOOL NAMES

We have used the Truth and Reconciliation Commission's list of residential schools as a guide to the names of the schools we mention in the book. (The list is on page 164.) Many of the schools changed their names over the years, sometimes several times, and we tried to honour the name that the Survivors used when they spoke or wrote to us.

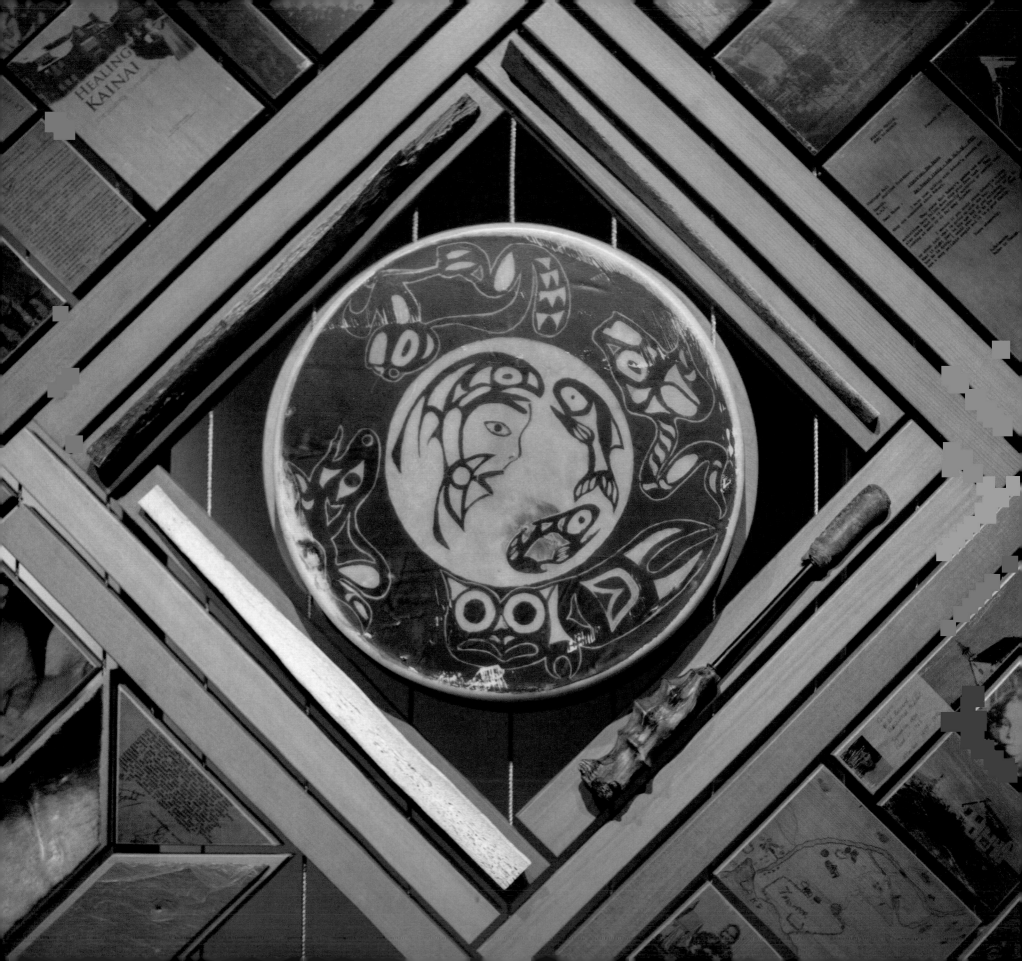

PICKING UP THE PIECES

THE WITNESS BLANKET STARTED with a very simple idea: one brick from every residential school across Canada. But how would I do it? How would I collect pieces for the Blanket from all these schools, in all these communities, right across the country? How would I do that while at the same time building the Witness Blanket?

Early on, I realized that I needed a team of people to help me do it. Over the course of a year, I hired three people to travel the country collecting items. They were Rosy Hartman, Jamie Elizabeth Lewis and Marek Tyler.

Rosy is from the Saddle Lake Cree Nation in Alberta, and she was the collections coordinator. It was her job to decide where the team would go and keep track of all of the items that we collected.

Rosy Hartman in Iqaluit, NU, collecting objects for the Blanket.

She and I built a database so we could log the details for each piece. We needed to record what it was, where it was from, what residential school it was connected with, who gave it to us and so on. Rosy would also do the travelling and collecting in western Canada.

Jamie is an Anishinaabe woman who grew up in the Chippewas of Georgina Island First Nation in Lake Simcoe, in Ontario, but her official band membership is with the Batchewana First Nation. She was originally hired to manage collecting pieces in eastern Canada. Although she believed deeply in the importance of the project, eventually the wear and tear of travel and the weight of the work began to affect her personally and she left the project. She was replaced by Marek, a Cree man from the Onion Lake First Nation in Alberta. He took over from Jamie about halfway through the project. He and I had worked together before, and he happened to be living in Ottawa at the time, so he was perfectly positioned to continue gathering pieces from eastern Canada.

While the collection team was on the road, a design team based in Victoria, British Columbia, where I live, would build the Blanket. I asked Colin Graham

to help me with that part of the project. Colin is non-Indigenous; he is also one of my lifelong friends and an excellent carpenter. He is the kind of person who can figure out simple solutions to complex problems, so I knew he would be essential in bringing my vision for the Blanket to life. Together we would solve the technical aspects of connecting all the pieces.

Another member of the team was my apprentice, Tejas Collison, who is from Haida Gwaii and part Haida. He had recently started working for me on another project, and I knew that his attention to detail made him perfect for the job of sanding and shaping cedar blocks to the exact specifications of my design. Tejas spent countless hours measuring and sanding those blocks to fit the pattern I laid out for the Blanket, preparing them for when we would eventually begin mounting objects on them.

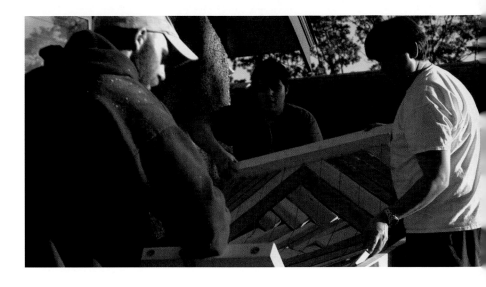
Carey, Colin and Tejas make the first prototype of the Blanket.

With a project this big, we also needed someone to keep track of all of the small details. That's where Jennifer Ambers came in. She did a lot of the advance work for the collection team. She phoned ahead to the communities we wanted to visit, sent letters, organized travel and contacted Survivors and **Elders**.

That was the core team for the project, but as different challenges came up while we were building the Witness Blanket, other people shared specific skills that I didn't have.

Lindsay Delaronde, a Haudenosaunee artist from Quebec, taught me the basics of transferring images onto wood. Then, when I was struggling to figure out how to mount the more delicate objects on the Blanket, my mom introduced me to Robert Byers, who had retired from a career building museum exhibits. He can figure out how to mount just about anything, and he made things like special-ized clips from brass wires to hold plates and crystals in place on the Blanket. His partner, Jane Hutchins, is a textile

Robert Byers mounts objects on the Blanket.

conservator who gave advice and guidance on how to properly mount fabrics and leather and other objects we had that were made with yarn or thread.

Ron Rice was our cultural advisor. When the Blanket was done, it would tour the country. I wanted it to have a traditional ceremony every time it was installed in a community. With Ron's guidance, I decided we would do a ceremony that reflected the territory we were on. The Witness Blanket has been through several different cultural blessings, including **pipe ceremonies**, smudging (see page 86) and traditional dances.

A BLANKET OUT OF SOLID OBJECTS

I had a plan and a team to make the project happen. It was time to start collecting objects to build the Blanket. The scope of the project was big. My goal was to collect a piece from every residential school in Canada, a piece from every province and territory, a piece from each provincial legislative building, a piece from the federal parliament buildings, a piece from each of the major churches that were involved in the residential school system and a piece from as many current traditional structures in Indigenous communities as I could find.

The collection team started reaching out to dozens of communities across Canada to spread the word about what we were trying to do. They wrote letters, advertised in different publications and held information sessions at the Truth and Reconciliation Commission hearings across the country.

One day early in the project, an envelope arrived in the mail. In it were pieces of blue stained glass. I remember the moment clearly. They were the first objects we collected for the Witness Blanket. They came from the church at St. Eugene Mission, near Cranbrook, British Columbia. Those pieces of blue glass were photographed, recorded and filed away. We had started our collection.

It was slow going at the start, but I believed in the project, and I was sure it was going to work. At the beginning, when the Witness Blanket was just a concept, we didn't have the ability to show what it would look like, so it was hard

Blue glass from the church at St. Eugene Mission.

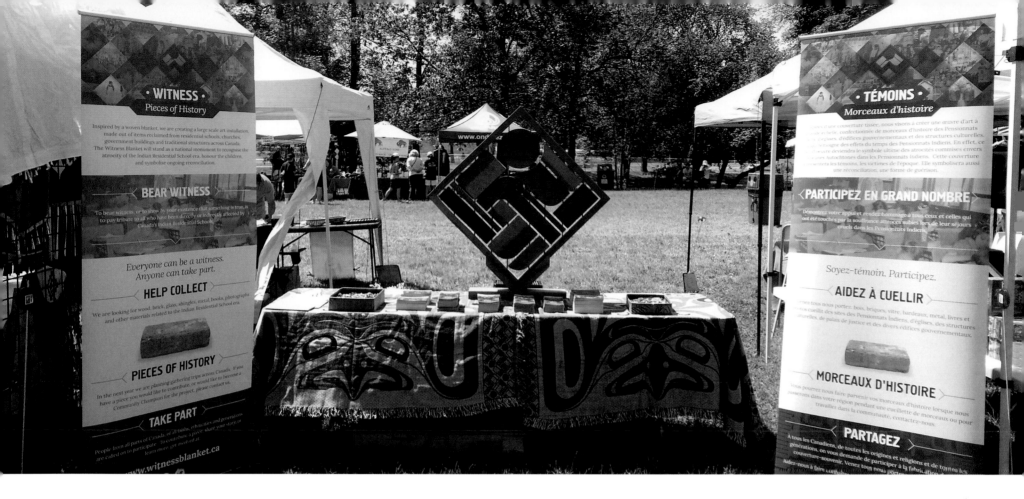

An information booth about the Witness Blanket on National Aboriginal Day in Ottawa, 2013.

to explain exactly what it was. Also, it wasn't always easy to know the right way to ask for an object. Sometimes Jamie, Rosy or Marek would visit a community and walk away with nothing. People would ask, "How do you make a blanket out of solid objects? A blanket is supposed to be soft."

I knew we needed to answer these questions, so Colin and I built a small replica of the project logo, which is in the form of a Blanket panel, and put it in a cedar frame. The team could take it with them into the communities they visited, carrying it back and forth across the country. It helped people understand what it was that we were trying to create.

Momentum started to build, and word about the project spread. Often people needed time to think about what they wanted to contribute and would send an object in the mail weeks later. Other times the collection team would get an object right away. One of the first trips was to Nunavut, and the

Reverend Cyrus Blanchet, Jamie Lewis and Rosy Hartman collected a prayer book at St. Jude's Anglican Church, Iqaluit, NU.

team came home with a prayer book, written in Inuktitut, from St. Jude's Cathedral in Iqaluit.

Once a week I picked up the packages that had arrived at the Victoria Native Friendship Centre. Every week, there were a few more than the week before. It was exciting to see objects coming in from all over the country and to read the personal stories attached to them. Seeing the diversity of pieces and stories, I knew the Blanket was going to become something very special.

As the number of items we had continued to grow, the generosity of the people who had contributed so far began to help in another way. Now we could go into communities and talk about some of the objects that other Survivors had donated and show pictures of what we had already collected. The trust that those earliest contributors placed in us gave the new people we met confidence in us and in our project. People could see that the Blanket was going to be built—and even begin to imagine how the items they donated would become part of something real.

When we talked with Survivors and asked them to donate something to the project, they would put all sorts of things into our hands, objects that connected them with their own residential school experience, their own memories, their own stories. They would ask us if we would take these hockey skates, or these photographs, this pair of moccasins, a graduation certificate, or their doll. We said yes. We took it all.

> **What began as a simple idea turned into something so much more than I could have ever imagined.**

It was through meeting with people and keeping an open mind that I realized that the buildings themselves and what they were made from were just one part of the residential school experience. What is a brick without the story behind it? And it was through the grace of Survivors and people from all different backgrounds and parts of the country that what began as a simple idea turned into something so much more than I could have ever imagined.

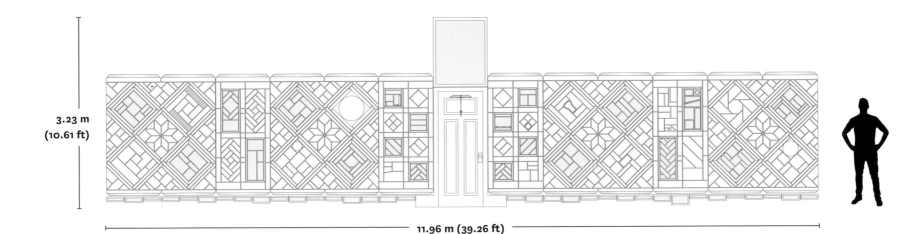

3.23 m
(10.61 ft)

11.96 m (39.26 ft)

This drawing shows the finished size of the Witness Blanket.

The team eventually went to every province and territory, travelled over 200,000 kilometres (124,000 miles), visited 77 communities and met over 10,000 people. Along the way we gathered more than 889 pieces of history, including documents, braids of hair, merit badges and piano keys.

The finished Witness Blanket is about 12 metres (39 feet) long. The tallest point is over 3 metres (10 feet) high. And when assembled, the 13 panels weigh more than 1.8 tonnes (2 tons).

Each of the pieces has a story of its own. One by one they tell individual stories of Survivors and Intergenerational Survivors and the ways in which residential schools affected people and families in the past and continue to affect them in the present. Together they show the whole history of residential schools in Canada: the government policy that made them and the churches that ran them. They illustrate the damaging idea that Indigenous people should be taught to look and act and speak like the settlers who named this country Canada.

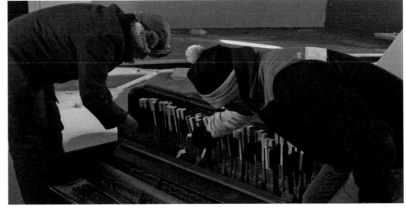

Marek found these piano keys in a room that used to be the chapel of the residential school in Lestock, SK.

In the coming chapters, you will see and read about the pieces and stories that make up the Witness Blanket. You will meet some of the people we met along the way. Through their words and stories, you will have a chance to understand a little bit about what it means to be Indigenous in Canada today. Some of the stories might be sad, some will lift your spirits, and I hope all will teach you about an important part of our shared history.

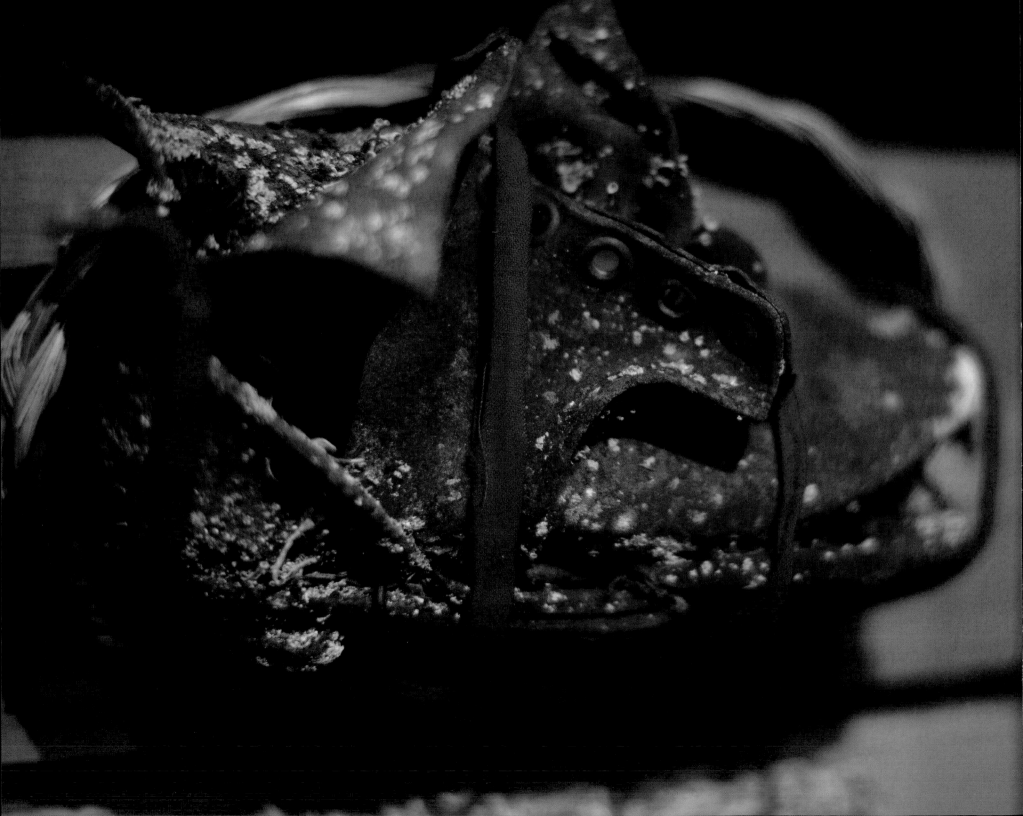

SILENT WITNESS

WHEN I STARTED THE PROCESS of collecting pieces to make the Witness Blanket, I knew enough about residential school history to be prepared for how emotional the stories that came with them would be. I also knew that I would need to be gentle with myself and the team, and that together we would need to be kind and caring with Survivors and other people who participated. Sometimes just asking people to talk about what they have experienced can trigger their emotions and retraumatize them.

What I didn't anticipate or prepare myself for was the power that was held within individual items. I got an important lesson early on when Rosy brought me a piece she had collected, a child's shoe from the site of a residential school in Yukon that had burned down.

Rosy with Harold Gatensby on the site of the Carcross (Chooutla) residential school.

It was called the Carcross (Chooutla) residential school, and it sat in a valley on the shore of Nares Lake, just a short distance from the village of Carcross, Yukon. There have been mission schools in Carcross since the early 1900s. The government run residential school opened in 1911 and closed in 1969. Over the years it was rebuilt several times. Harold Gatensby went to school there as a boy. Now he lives on the site where the school once stood.

"I've lived here thirty years and I've lived here intentionally," Harold said. "I say something's got to be done about this horrible legacy we've inherited here. And as long as I'm living here I'm going to be constantly reminded of that."

He said that even though the building isn't there, he can still feel it. Harold doesn't have good memories of his experience at the school.

"I knew three things at twelve years old: I was stupid, I was ugly and I was going to hell," Harold said. "Those three things I knew for sure. Everything else was mixed up and confusing. That's what residential school did to me. That's the gift they left me with. I don't ever want any twelve-year-old kid to be feeling like that."

Harold wonders what people would say now if kids were taken from their homes and families and put in a place where they didn't know anyone, where

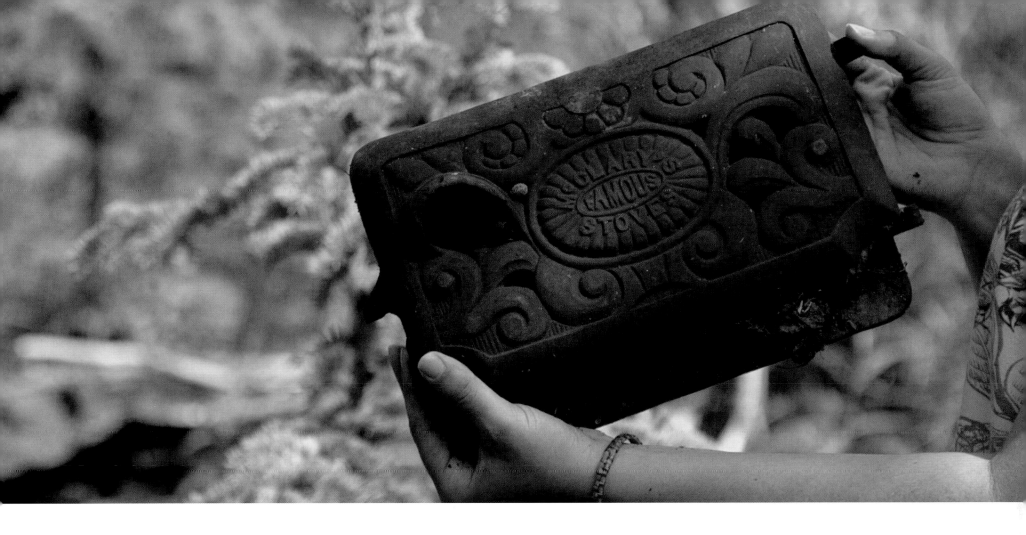

they didn't speak the language and where they got in trouble—not for something they did or didn't do but because of who they were.

"Maybe then they'll understand what it is that we carry in our hearts," Harold said. He called that the "unfinished business" of residential school.

Harold took Rosy on a walk where the school used to be and shared his story with her. They collected objects for the Witness Blanket as they went. He pointed out an abandoned building that was once the staff house for the school. He showed Rosy where the farm and the garden used to be. In a clearing, a concrete set of stairs from the boys' dormitory is all that's left of the original building.

Harold led Rosy to a trail at the edge of the clearing. They had to push through branches and step over bushes to make a path through the forest.

Rosy holds the grate of a wood stove from the site at Carcross, YT.

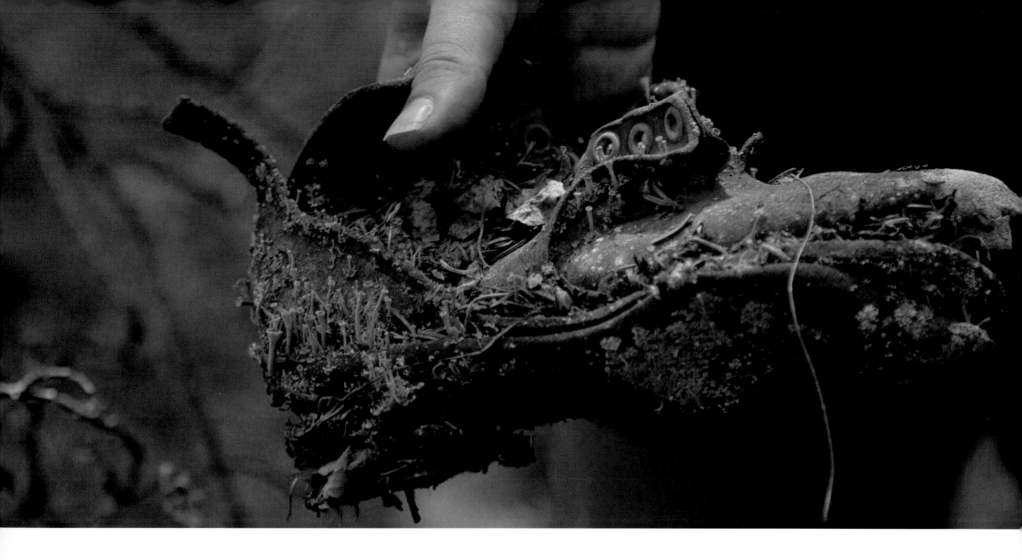

The shoe being collected from the forest floor in Carcross, YT.

Every few steps they would come across objects from the old residential school. There were washtubs, 19-litre (five-gallon) gas cans, cooking pots, glass bricks from the windows and even a bed frame. The forest was slowly growing around them and obscuring them from view.

Harold stopped, noticing something small. He turned and faced Rosy.

"Maybe you'd like this," he said. He pointed to a child's leather shoe, almost covered over by the forest. It was warped and disfigured from being out in the elements. It was covered with moss and tree needles. Rosy gently took it in her hands.

The day after she returned to Victoria, there was a knock at my door at eight thirty in the morning, which was unusual. It was Rosy. She was holding

a little box, and inside it was the small, weathered and moss-covered leather shoe. After I invited her inside, she handed the box to me. She told me that the evening after she collected the shoe, she had woken up in the middle of the night feeling terribly afraid. She'd been running from something in her sleep. The nightmare really scared her. The next morning, she travelled home and forgot about her experience, dropping her bags and spending some downtime with her husband. Later that night *he* woke up after having the exact same nightmare, running from something in his sleep. Remembering her own experience from the night before, Rosy thought, "It has to be the shoe." When morning came, she brought it over to my house, bright and early.

When I received the shoe and heard the story, I wasn't sure what to do. All I knew was that I needed to do something. What if my family or I had the nightmare? Were the nightmares really caused by this little shoe? If they were, was I doing the right thing by bringing all these pieces together?

That evening I went down to my workshop, took out the box, removed the shoe and just held it. I remember the powerful wave of sadness that filled me as I held it. I still get tears in my eyes when I think about that shoe, maybe because objects don't often make me feel that kind of emotion, or maybe because it makes me imagine my own father when he was small enough to wear it. Holding the shoe, I tried to imagine what it would be feeling if it were a person, scooped up from the forest, put in a box and carried a long, long way from home. Almost like a child taken to residential school. What I sensed wasn't exactly anger—it was mostly fear.

> *Holding the shoe, I tried to imagine what it would be feeling if it were a person, scooped up from the forest, put in a box and carried a long, long way from home.*

Not knowing what else to do, I started to talk about the project. There I was, trying to deal with my own fears and doubts, while also trying to calm the unsettled feeling that came with this little shoe. I talked about what I was doing, about my ideas, about my vision for the Witness Blanket. In a way I was asking the shoe for consent or approval, but saying those things out loud also helped me clarify the project in my own mind.

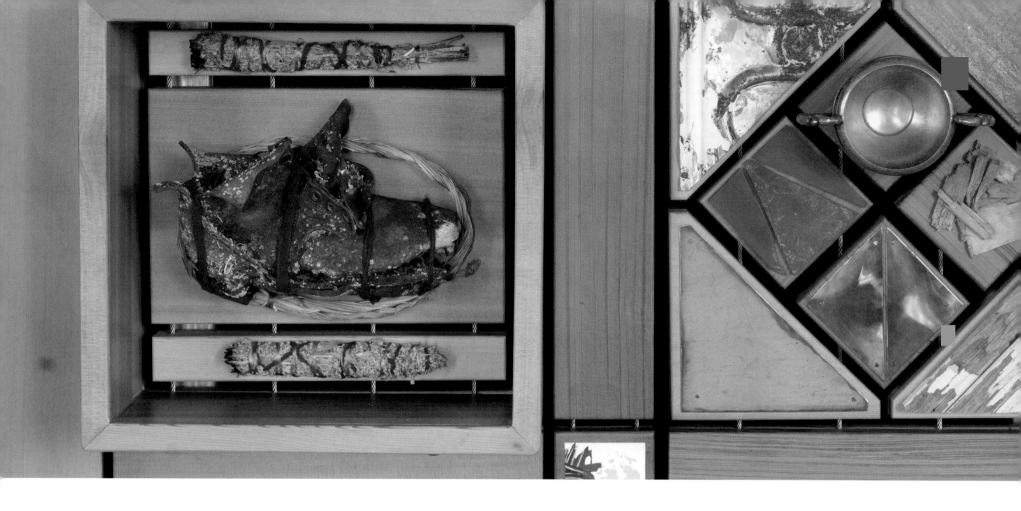

The shoe as it appears on the Blanket.

I repeated that process each night for the next week or so. Each time, the shoe felt a little different. It slowly changed from giving off fear and frantic energy, and moved toward sadness. Even when I sensed acceptance or understanding from the shoe, it was still full of sadness.

I too felt different each night. I started out a little afraid, both because of the story Rosy had told me and from taking on this great big project. I had never done anything this big or important to so many people before, so I wasn't confident that I would know what to do. Slowly my fears went away and were replaced with a sense of responsibility. As I talked about the project and what I had to do, the Witness Blanket became clearer in my mind.

I never had the experience of waking up afraid in the night, but having the shoe arrive early in the process taught me an important lesson: I had to respect the power of objects, stories and people equally.

That experience changed my way of thinking. It changed the way we handled the items we collected. It changed my creative process and likely changed the final work itself. From that point on, rather than seeing those items as just a bunch of random "things" that I was sticking on this Blanket, I recognized each object as sacred.

It became part of my routine to take a moment to connect with each piece as it came in. I went through all of them, one by one. I held each object, feeling its weight and shape in my hands. I learned their stories and thought about how they were similar or different. I thought about how to transform them to fit them together on the Blanket. I thought about how I might fasten them to the Blanket. I measured them and recorded the information I would need to include for each one.

I knew I had to treat them with care. I knew it was important to place them on the Witness Blanket with some sense of equality. I couldn't simply take the ones I liked because of their colour or their shape, or because of how much I liked their stories or the people who contributed them. To properly reflect their unique and **collective truth**, I needed to treat them all fairly.

I don't consider myself an overly spiritual person, but sometimes you can't deny the effect of an unexpected experience. Having that shoe arrive when it did, with the realizations it brought, played a big part in my coming to understand the magnitude of the project as a whole.

Like all of us, each of these objects were witnesses. In addition to the stories that their contributors shared, the pieces had untold stories of their own. They were there, part of residential schools, silent observers of the events that took place. A brick in a wall, a shoe, a doorknob, a bowl, piano keys or a hockey skate, a moccasin or merit badges. What had each of these objects seen? If they could speak, what stories would they tell?

For me, that is the magic of art: it leaves so much to the imagination or to interpretation. Thinking about this taught me what it was going to mean to bring all those objects and stories together on the Witness Blanket.

Carey figuring out where and how to place items on the Blanket.

Sweetgrass surrounds the shoe on the Blanket.

THE FIRST DAY OF SCHOOL

BUILDINGS ARE MADE FOR DIFFERENT REASONS, and the architecture or layout often reflects their purpose. For example, my house is built to make my family feel safe and comfortable, with spaces specially designed to meet our needs. I didn't really think about how much thought went into various structures until I learned more about the history of our traditional Big Houses. They too were designed to meet particular needs.

Here is what a Kwakwa̱ka'wakw Big House looks like: It is a large square structure made from cedar planks, posts and beams. There are no windows and the only openings are the front and back doors and the smoke hole in the centre of the roof. When you enter through the front doors, you see a firepit in the middle of the main area. Beyond that, at the far end, is a *dance screen* with a drum log. On either side there is tiered seating, and behind the dance screen are areas for the dancers to get ready and for food preparation.

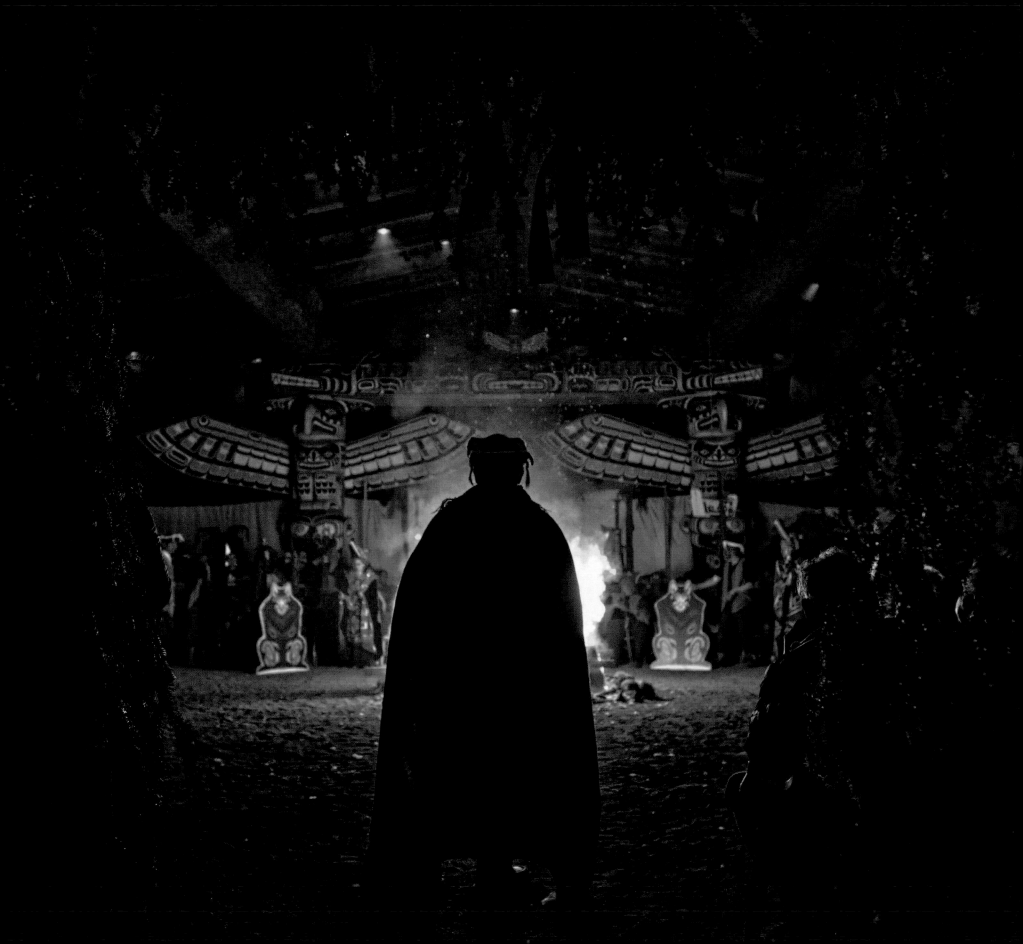

All of these design elements meet the needs of a Potlatch or other ceremony, but there is one aspect of them that I rarely considered before: Big Houses are thought of as an embodiment of our **ancestors**. The area behind the dance screen was the mind, the fire in the middle of the building was the heart, the rafters were the ribs, the support beam was the spine, the doorway was the mouth, and all of these together made the body. Learning this taught me that for my ancestors, Big Houses were more than just buildings—they were living beings.

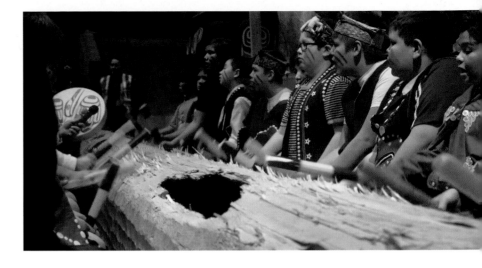

Kids with a drum log at the ceremony after St. Michael's residential school was torn down on February 18, 2015.

That thought was in the back of my mind as we began collecting pieces for the Witness Blanket. It is also the reason why I initially focused on collecting the physical materials that made up the structures of residential school buildings. Members of the team dug up a piece of rotten board from the Fort George (St. Philip's) residential school in Quebec; chipped a piece of the cement foundation from Coudert Hall residential school in Whitehorse, Yukon; and hiked through the snow in Sault Ste. Marie, Ontario, to get a piece of stone from the Shingwauk residential school. We also collected bricks from residential schools across the country, in places like Port Alberni, British Columbia; Delmas, Saskatchewan; and Gleichen, Alberta.

> *For my ancestors, Big Houses were more than just buildings— they were living beings.*

Most of the residential schools were built with the same red brick. Even the buildings themselves were made to look the same, with standardized floor plans. It didn't matter if the school was in British Columbia, Ontario, Quebec or Nova Scotia—the building and the layout of the rooms inside were almost identical. If you walked into a residential school on Vancouver Island, the classrooms, kitchen, bathrooms and sewing room would be in the same place as they were in a school in Shubenacadie, Nova Scotia.

They were big, imposing buildings. The main door, right in the middle of the building, was the first part of the residential school a child would see. On top of

Opposite: The Willie family Potlatch on Cormorant Island, BC.

Floor plans for the industrial school at St. Eugene Mission in BC.

the entrance there was a spire, like you would see on a church. Because religious education was a key part of residential school, every institution also had a chapel.

The buildings were designed in the shape of an *H*. There was a central section that held the staff offices and sleeping chambers, and then there were two wings on either side of that middle block. One wing was for the boys and one wing was for the girls. That way they couldn't mix.

Many schools had an "Indian Parlour." That was the name given to a room where families could visit on the weekends, if they were able to. The parlours were designed so that the parents came in through an outside door, while their son or daughter entered through an inside door. That way, the parents and family were kept away from the rest of school, and the visit could be monitored by the school staff. The staff were there to make sure that English was the only language spoken during the visit.

The Indian Parlours weren't the only place in the school where the students were watched. Most schools also had something called "monitor rooms" in each wing. They were small rooms usually between the dormitory and the washroom. A staff member or supervisor could watch the kids from that room, sometimes through a small square hole in the wall between the two spaces. Many residential school Survivors remember those windows cut into the brick walls.

When I think about the way residential school buildings were designed and contrast their purpose against a traditional structure like a Big House, tipi, lodge

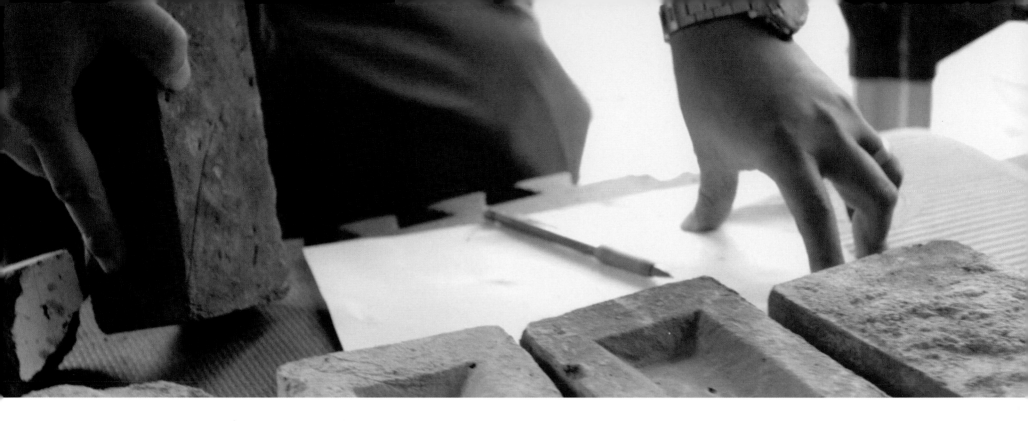

or even my own home, what sticks with me is the absence of comfort. Different Indigenous cultures have different buildings, but the one thing they all share is that they foster a sense of community. That connection among community members was damaged by separating families and taking children away from their homes, and the damage was reinforced by making sure that the residential school buildings themselves felt like institutions instead of homes.

Carey working with the donated bricks.

THREE WHITE BRICKS AND A BRASS DOORKNOB

There are three white bricks mounted on the Witness Blanket. They were donated by Chasity Delorme, and they came from the Marieval residential school in Grayson, Saskatchewan. Chasity didn't go to the school, but many of her relatives did, including her grandmother, Marybelle Tanner.

The residential school was on the Cowessess First Nation and was open from 1899 until 1997. It was torn down a couple of years after it closed, a decision not everyone in the community agreed with. The bricks are among the last physical

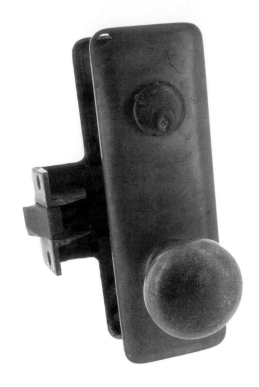

A brass knob from St. Paul's in Cardston, AB.

Students in a classroom at St. Mary's residential school on the Blood Reserve in Alberta.

reminders of the Marieval residential school. Marybelle Tanner had scratched her name on one of them.

"My brother and uncles were a part of the demolition of Marieval residential school," Chasity said. "They found many bricks with signatures of the school Survivors. I kept the brick with my grandmother's signature."

Along with the bricks, wood and cement, we gathered many different pieces from inside the buildings as well. There's an electrical panel from the McIntosh residential school in Kenora, Ontario, a light fixture from the Yale School in North West River, Newfoundland and Labrador, and a brass doorknob from St. Paul's residential school in Cardston, Alberta.

That simple brass doorknob was one of the pieces we collected early on. It came from the boy's dormitory. I remember the first time I held it my hands. I thought about all the boys at that school who had turned that doorknob and how many small hands had left their fingerprints on it. It also made me think about all the doorknobs and doors at all the residential schools across the country. I pictured all the boys and girls who had been taken from their families and forced to go to schools that were far away from their homes and communities.

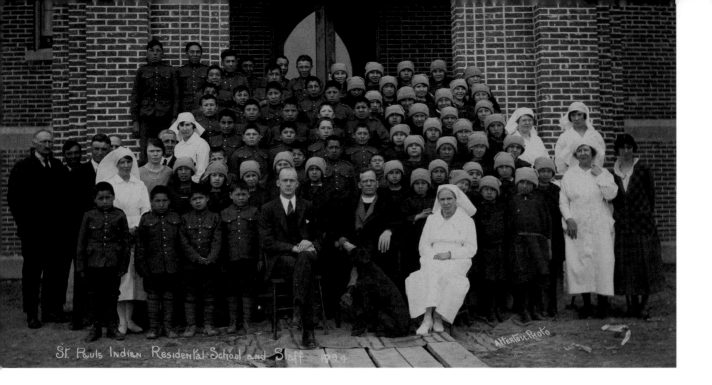

St. Pauls Indian Residential School and Staff 1924

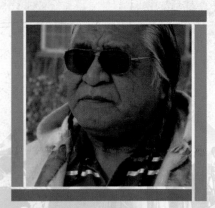

Above left: *Students and staff in front of St. Paul's residential school on the Blood Reserve, 1924.*

I imagined all the doors that opened and closed for them as they made that journey. I thought about all the experiences those kids had at those schools: the abuse, the neglect, the loneliness they felt. I thought about how going to residential school took them away from the only life and family that they had ever known.

When those kids turned that doorknob, what did they think? Did one side of the door feel safer than the other? Did they look through the keyhole to see who was coming or to find out if the coast was clear?

St. Paul's was the school that Keith Chief Moon went to. He's from a big family; twelve of his relatives went there. When he was little, before he had to go to St. Paul's, he remembers his brothers running away from the school. They would tie bedsheets together, throw them out the windows, and then use them to climb down the side of the building before running home.

"They would show up at two or three in the morning and we would be so glad to see them," Keith said. "But my dad would know that the **Indian agent** or the police would be here later in the day to bring them back."

Keith can still remember his first day at the school. He was led through the big front doors and then shown where he was going to sleep. He said his first thought after seeing the dormitory was "Who can I ask to help me?"

"When you can't talk is when you want to say something. I learned not to talk, [not to] to feel."

SURVIVOR MARY COON

Opposite: The round vent cover in this panel on the Witness Blanket came from St. Michael's residential school in Alert Bay, BC. It was donated by William Cranmer, a hereditary chief of the Namgis First Nation.

A FIVE-DOLLAR BILL

Mary Coon remembers her first day at Bishop Horden Hall residential school in Moose Factory, Ontario. She was the oldest child in her family and the first to go away to residential school. Her mom didn't want her to go, but her dad would have gone to jail if he refused to send her. He didn't have a choice.

Before she left, her dad took her to the Hudson's Bay Company store to buy a new dress for her first day of school. The next day, with her suitcase clutched in her hand, Mary left her village, packed in a canoe with many of the kids from her community. When the canoe got to the middle of lake, she was finally able to look back at the shore. She still remembers seeing her mom running along the water's edge, waving and crying.

When the canoe reached the other side of the lake, it was just the beginning of Mary's journey to residential school. She got on a plane, and after that into a truck, which finally took her to the doors of Bishop Horden. When she arrived at the school in her new dress, her suitcase was taken away from her. It was tossed in a huge pile with all the other suitcases. Looking at the stack, the first thing she thought was "How am I going to find my suitcase?"

"[That] first day they took our clothes," Mary said. "There was a big plastic pail and we had to throw our clothes in there. My new dress, I threw it in there."

Mary never saw that dress again.

She didn't understand what was happening. Her cousin told her to keep quiet. "You can't speak Cree here," she said. If Mary spoke Cree, her mouth would be washed out with soap.

"My throat was so sore," Mary said about not speaking her language. "When you can't talk is when you want to say something. I learned not to talk, [not to] to feel."

Mary's dad had given her a five-dollar bill to take to school with her. She hid it under her pillow so no one could find it. It was the one small piece of her life before residential school that she managed to hold on to.

"When I got lonely, I would take it out and smell it," she said.

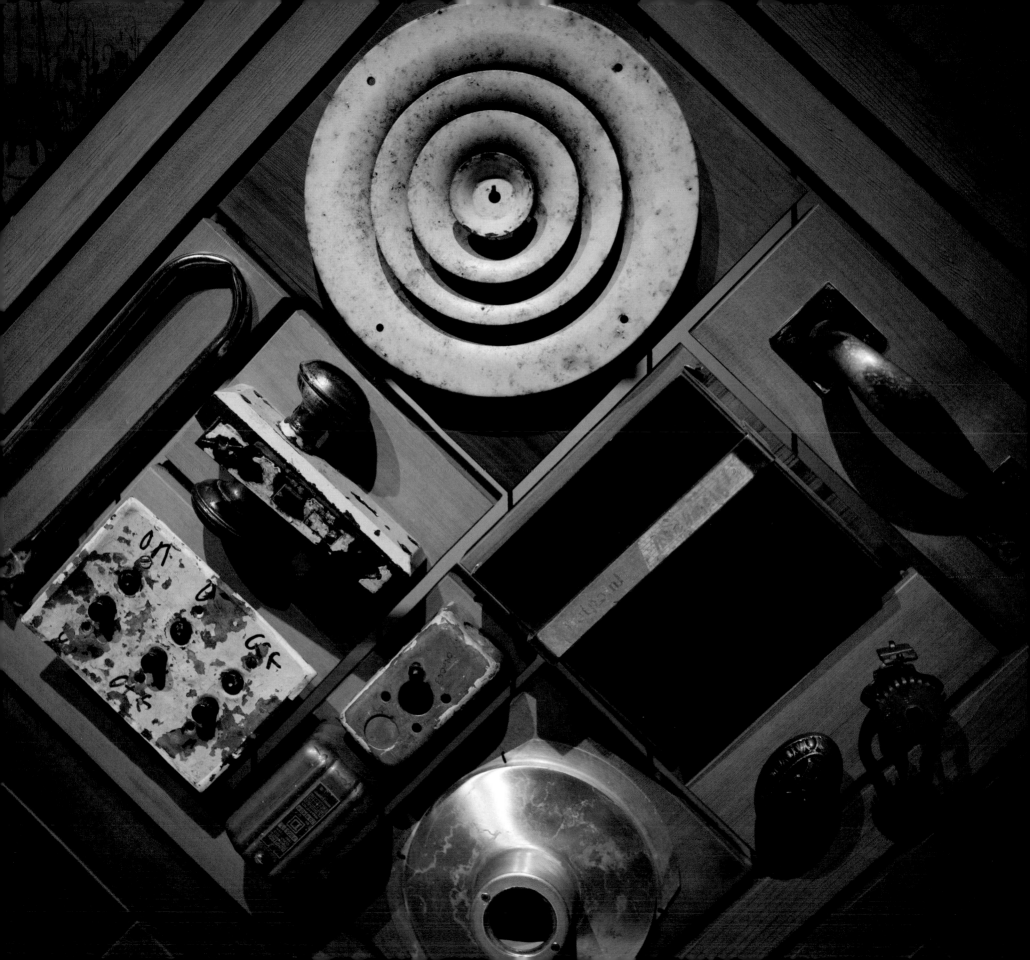

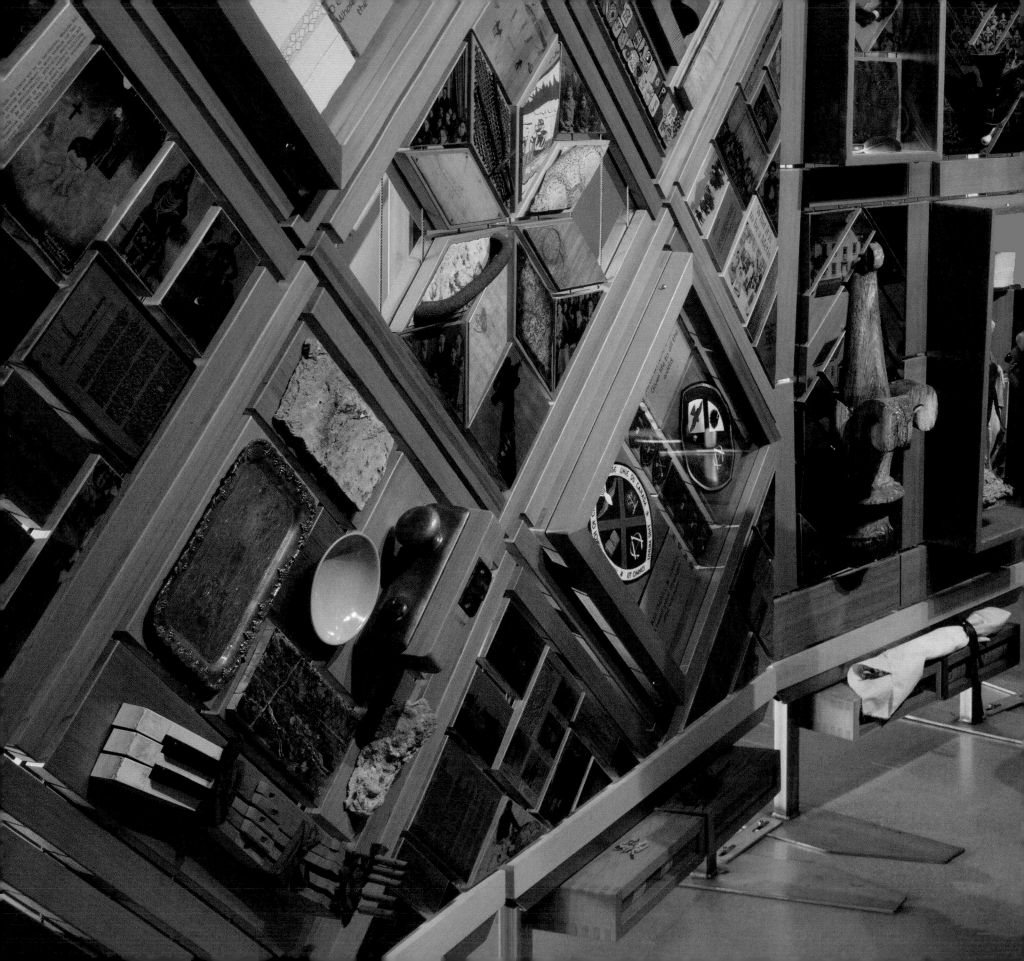

NEVER ENOUGH

IN HIS ROLE AS CHAIR of the Truth and Reconciliation Commission, Senator Murray Sinclair has heard a lot from Survivors about what day-to-day life was like at Canada's residential schools.

"They didn't talk in broad strokes about the schools," Sinclair said. "They often talked about the simple little things. A piece of food, a plate, a dish—stealing an apple in order to feed themselves or somebody else, a crust of bread."

There are two yellow bowls on the Witness Blanket. They are small, but these simple dishes tell a bigger story. It's a story about what food represented at residential schools across Canada—not just the quality of the meals that were served but, in many cases, whether there was even enough food to go around. This is a topic that comes up again and again when Survivors talk about their experiences.

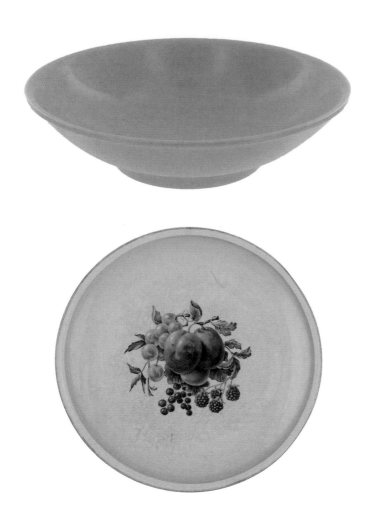

Students used mush-hole bowls (top).
Staff ate off fancy porcelain dishes.

One of the bowls is made out of plastic. It comes from the Mohawk Institute residential school in Brantford, Ontario. Students who went to that school called it the mush-hole bowl. Mush is a type of thick porridge that was regularly served to the students who went there. And because of that, "mush hole" also became the nickname of the school. The second yellow bowl is ceramic and comes from the Yale School in North West River, Newfoundland and Labrador.

Ornate dishes were also contributed to the Witness Blanket, including a silver sugar bowl and creamer, also from the Mohawk Institute. There are two cake plates from the Sechelt residential school in British Columbia. One has a strawberry design, the other a plum design. These ornate dishes weren't used by the students. I wanted to show the difference between the institutional dishes that were used by the children at the schools and the fancy dishes that were used by staff, priests, nuns and supervisors. When I was designing the Blanket and deciding where and how to use each piece, I chose to keep the humble bowls intact and to cut the cake plates into pieces. I am not sure if it was a conscious decision, but when I look at it now I can see that by keeping the bowls whole and cutting the fancy plates apart, I was expressing my disapproval of the unfairness that they symbolized. I was also honouring the true experience of the students.

While I was putting together the Witness Blanket, a food historian named Dr. Ian Mosby released documents he had uncovered about nutritional testing that went on at residential schools in Canada starting in the 1940s. The documents show that government officials experimented on at least 1,300 Indigenous kids. In some of the studies, one group of kids would be given vitamins, while another group would not get them. Other studies involved rationing milk or feeding children a "special" flour that was not legal in the rest of Canada.

Prior to that, in the early 1900s, Dr. Peter Bryce was hired by the **Department of Indian Affairs** in Ottawa to report on health conditions at residential schools in western Canada. His report, which was critical of the schools, was never released. He was fired from his job, but he published his findings in another report, *The Story of a National Crime: Being a Record of the Health Conditions of the Indians of Canada from 1904 to 1921.*

Both of these examples show the way the government viewed Indigenous children. Not only were they dehumanized through medical testing, but their health and nourishment were dismissed by the very department that was meant to look after them.

This is the plum plate cut and mounted on the Blanket.

"The food that they [fed] you—it was slop. We had porridge that used to have maggots. They used to feed us bread that was mouldy. And we used to have to eat it."

SURVIVOR NANCY WAMISS

ROTTEN FRUIT

Nancy Wamiss remembers trying to pick the greengage plums, cherries, crabapples and berries in her grandmother's garden in the summer when she was a little girl.

"She used to get so mad at us," Nancy said. "She used to come out with this little broom and run after us. 'You kids get out of those trees.' We'd do this to her every year because we knew she was going to chase us."

Food is a big part of our daily lives. Many of us associate the smell of a particular food with memories of people, places or experiences we've had. The students who went to residential schools across Canada are no different. And just like Nancy, I have my own memories about food, a legacy of my dad's experience at residential school.

Although he didn't talk a lot about his experience, when he did, one thing he would talk about was the food. As a child, I saw how the sight and smell of certain foods could bring back unwanted memories of my father's time at residential school. To this day there are certain things he can't or won't eat. For example, he hated the scalloped potatoes at the school because they were made with sour milk and weren't cooked properly. Today, even if they are perfectly cooked, with the freshest ingredients, what they represent to him is so negative that he still won't eat them.

I have one memory that helps me understand the difference between my father's childhood experiences and mine. When I was a kid, for a treat my mom would let my sisters and me make rice pudding for dessert by putting out milk, brown sugar and raisins for us to mix into leftover rice. We loved it, but whenever we made it my dad would leave the room. He said that eating rice pudding at residential school had ruined it for him. For him it wasn't a treat—it was a painful memory. I don't think I understood it back then, but when I think about it now, I can see how memory even affects what we like and don't like to eat.

My dad's experience with food also affected me as a child. At residential school, students were often forced to finish everything on their plates.

That's how it was at my house, too, when I was growing up. I was told that if I didn't eat my dinner, I would be served the same food for breakfast.

When I was four or five, I ran away from home because I refused to eat liver. At that age, running away meant packing my Hot Wheels cars in my backpack and riding my bike to the end of the driveway, because I wasn't allowed out of the yard. Although I laugh now when I tell that story and describe my older sister, Marion, running after me and yelling "Don't go, don't go," I also see how that experience shaped my relationship with food for years to come.

For Nancy Wamiss, that memory of sneaking fruit out of her grandmother's yard helped her get through her time at St. Michael's residential school in Alert Bay, British Columbia. And it's that memory that helps her now, when she talks about her experience there. She was just eight years old when she went to the school. There had been fresh food, including fruit and fish, in her community every spring, but there was very little to eat at the school.

"Some of the kids were a lot more hungry than others," Nancy said. "The food that they [fed] you—it was slop. We had porridge that used to have maggots. They used to feed us bread that was mouldy. And we used to have to eat it."

Nancy said it was the same with dessert. The apples, oranges and bananas they were supposed to eat were often rotten.

MOULDY BREAD AND WATERED-DOWN SOUP

Richard Lucas said it didn't matter what school you went to, the food—or lack of food—was the same. He went to Christie residential school in Kakawis, British Columbia, when he was seven. And even as an adult, he still can't eat certain foods.

"I never ate oatmeal for thirty years," he said. "I wouldn't eat bean soup for longer. I just started eating it again. I wouldn't eat fish hash."

> *As a child, I saw how the sight and smell of certain foods could bring back unwanted memories of my father's time at residential school.*

Examples of silverware used by staff at residential schools.

"If you worked in the kitchen, you'd go hide a box of apples and oranges so you could get it at night. We'd call all the boys and say, 'Here's a couple of apples.'"

SURVIVOR RICHARD LUCAS

Opposite: The silver sugar bowl in this panel was contributed by Amos Keys. It was used at the Mohawk Institute residential school in Brantford, ON.

He said if the boys got an orange, they would all eat the orange peel. Even though it tasted awful, at least they were able to get something in their stomachs.

In many cases, it became necessary for the kids to learn how to steal food to survive. Often they weren't just stealing for themselves, they were looking out for each other, making sure everyone had something to eat, at least enough to survive.

"We knew the way to the kitchen porch where the carrots [and] turnips were," Richard said. "If you worked in the kitchen, you'd go hide a box of apples and oranges so you could get it at night. We'd call all the boys and say, here's a couple of apples."

The dining rooms at most of the residential schools across the country were the same. They were divided—the boys sat on one side and the girls sat on the other. Even though the boys and girls weren't allowed to talk to each other, they would often secretly pass food across the hall. And sometimes, the dessert or a piece of bread would get eaten before it made it to the right person.

Richard says he can't smell a hot breakfast cooking without thinking of his time at Christie.

"You could smell the bacon and eggs cooking, you could smell the toast and the coffee," Richard said about the food the staff ate . "We never had that at Christie, not once. We never had bacon and eggs. We never had any kind of meat, like pork chops, steaks or stew. The closest we got to meat was that Spam, that World War II surplus. We had cases and cases of it brought to the school."

While the students were doing what they could to get enough to eat, many Survivors say the people working at the schools had a very different diet. All the beautiful food that was being grown on the industrial school farms, including fresh vegetables and fresh meat, would pass by the students' dining halls on its way to the nuns, priests and staff. Meanwhile, the students were served mouldy bread, cold food and watered-down soup.

"During your meal you could reach under the table to get extra bread."

SURVIVOR STANLEY HUNT

Above right: *Girls and boys sit at separate dining tables at Little Buffalo residential school at Lubicon Lake, AB.*

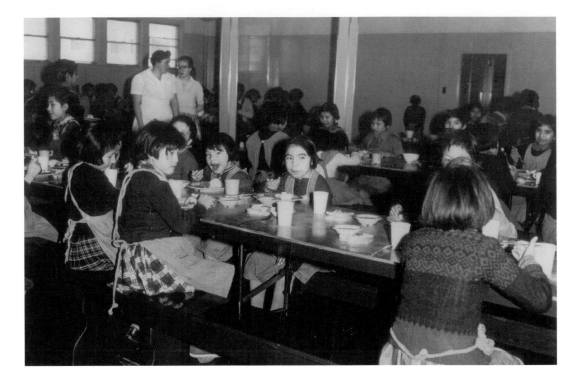

◆ ◆ ◆

Stanley Hunt spent ten years at St. Michael's residential school in Alert Bay, British Columbia. He said the girls working in the kitchen would sneak food to the other students.

When they were setting up the dining hall, they would use a knife to wedge three or four pieces of bread into the underside of the table. "During your meal you could reach under the table to get extra bread," Stanley said.

◆ ◆ ◆

Even now, my dad's experience with food at residential school affects me and my family. Because of the rules I grew up with, it's still hard for me not to finish everything on my plate. At a restaurant, if there are six french fries left on my plate, even if I am completely full, I feel like I have to finish them because I've always had to clear my plate.

It was only when I had a child of my own that I realized I was passing along those same food lessons to her. Through talking with my wife, Elaine, and reading about parenting, I began to understand that I wasn't teaching our daughter to listen to what her body needs and to know that when you're full, you're full. I also learned that giving her all the unhealthy food she wanted wasn't good for her either and could lead to poor eating habits as an adult. It hasn't been an easy lesson for me to learn, but thankfully—for both her health and mine—we are figuring it out as a family.

BERRY PICKING

Remember Nancy and her memory of getting chased out of her grandmother's fruit trees? That's what she called her "safe place" when she thought about her own residential school experience. Nancy remembers her grandmother and the things they used to do when she was a little girl— simple things, like baking bread or making a game out of sneaking apples and plums, or going berry picking together.

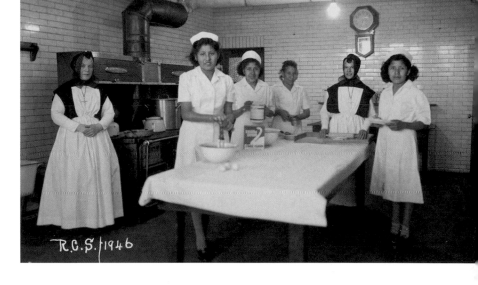

Sisters and students in a cooking class at St. Mary's residential school on the Blood Reserve near Cardston, AB.

And now, all these years later, Nancy has made two little berry baskets for her own kids.

"I'm going to give [them] to them when they have their first babies and say, 'Here, teach your children how to pick berries.'"

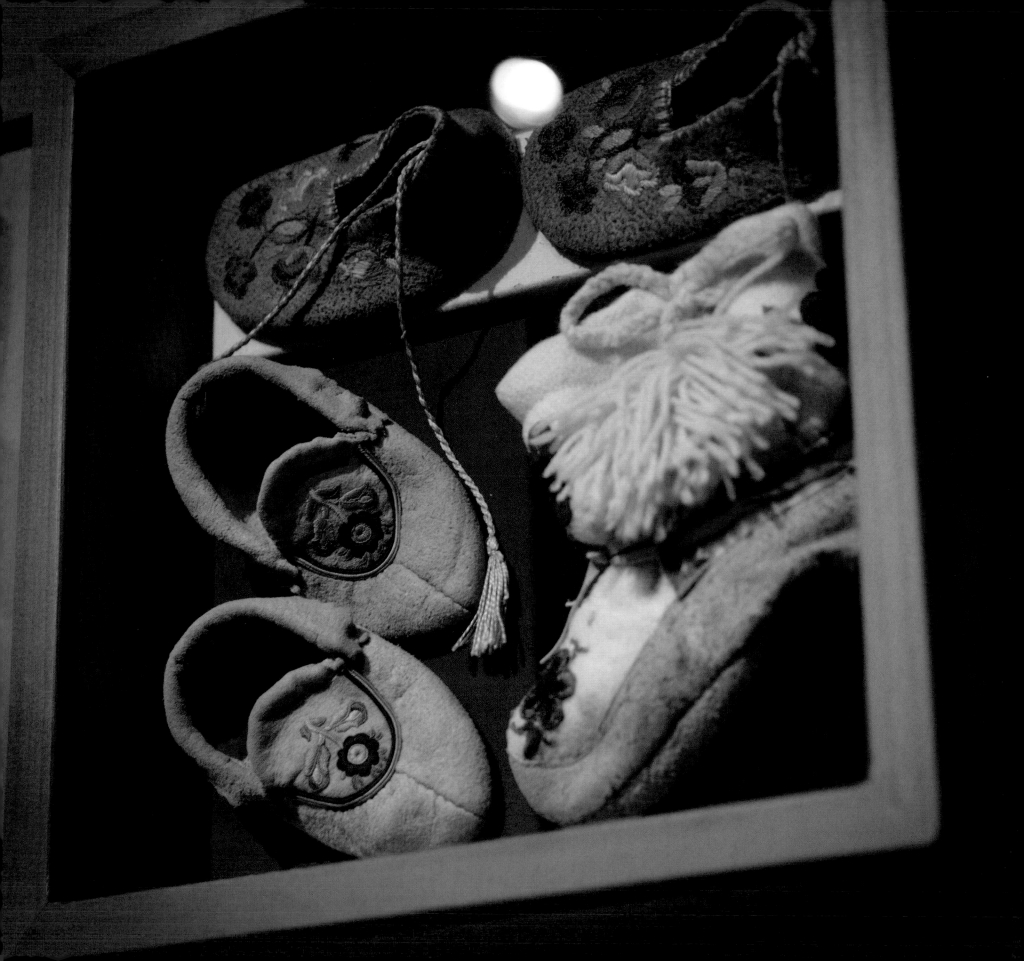

STITCH BY STITCH

A COLLECTION OF BABIES' MOCCASINS is mounted in one small box on the Witness Blanket. I wanted to group the textiles—things made out fabric, cloth, animal hides or other soft material—all together on the Blanket. There's an embroidered caribou-hide mukluk from Stoney Lake, Saskatchewan. A mukluk is a soft, high-top boot. This one has purple and pink flowers embroidered on it and a light pink wool tassel.

The mukluk came from Marianne Robillard. It belonged to her mother when she was a girl. She went to residential school at the age of three, Marianne wrote in a note that came with the boots. She said that, even though the school tried to erase Indigenous language and culture, "it wasn't all lost in the end."

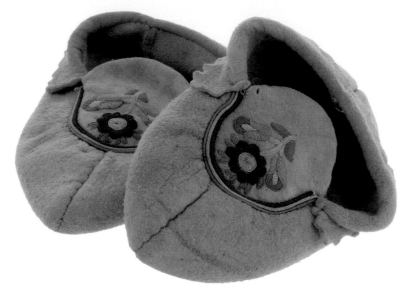

Girls at industrial schools created items like moccasins and tea towels, which were sold to profit the school.

Opposite: *This eight-sided star pattern is repeated four times on the Witness Blanket. It's inspired by the traditional star quilts used in some Indigenous cultures.*

There is also a pair of tiny moccasins made by girls at the Edmonton industrial school in St. Albert, Alberta. Anne Nelson donated them to the Blanket. Anne's grandfather was the principal at the school and her mother was a student there for six years. Anne's mother was given the moccasins, which she then gave to her daughter. Anne also gave a handmade tea towel to the Blanket. Like the moccasins, it was made by girls at the Edmonton industrial school. It is made of white linen and has a light blue line of delicately embroidered detail.

Some residential schools were called industrial schools. Industrial schools were designed to prepare students for jobs as menial labourers. As part of their training, the girls would spend half their school day cooking and sewing, while the boys would spend the same amount of time working the fields or tending the livestock. Much of what they produced was then sold to help pay for the operation of the school, so although these moccasins and tea towels are beautifully crafted and represent the skill of the students who made them, they also represent the sombre fact that these children were used as unpaid labourers. Even though they were making something connected with their culture, they were making it for the school to sell.

Anne's grandfather was the first principal of the Edmonton industrial school, which sat on a 346-hectare (855-acre) farm. It was open from 1924 to 1966, and the kids who went there had school in the morning and farming and housework in the afternoon. The work the kids did running the farm produced most of the food they ate there.

PROTECTING THE PAST

Once I had a collection of different textiles, I had to think about how to include them on the Witness Blanket. I wanted people to touch and feel the objects, but

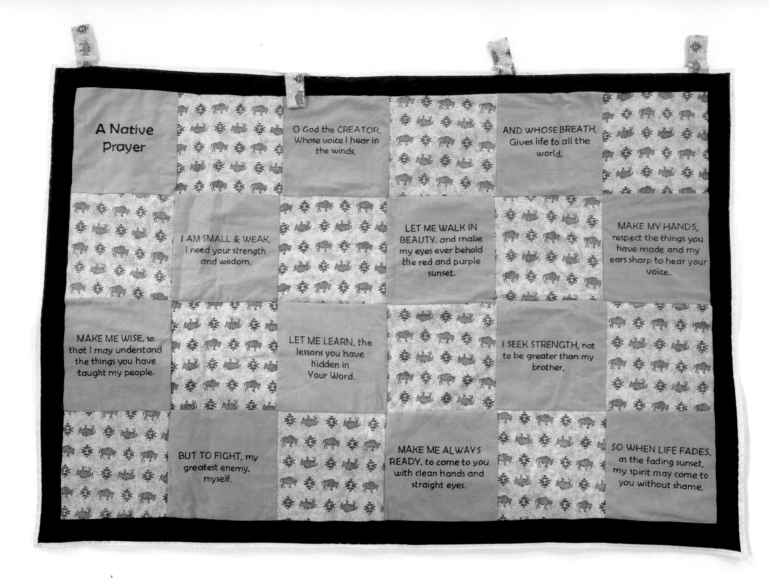

The quilt contains the following text in its squares:

A Native Prayer

O God the CREATOR, Whose voice I hear in the winds,

AND WHOSE BREATH, Gives life to all the world,

I AM SMALL & WEAK, I need your strength and wisdom.

LET ME WALK IN BEAUTY, and make my eyes ever behold the red and purple sunset.

MAKE MY HANDS, respect the things you have made and my ears sharp to hear your voice.

MAKE ME WISE, so that I may understand the things you have taught my people.

LET ME LEARN, the lessons you have hidden in Your Word.

I SEEK STRENGTH, not to be greater than my brother,

BUT TO FIGHT, my greatest enemy, myself.

MAKE ME ALWAYS READY, to come to you with clean hands and straight eyes.

SO WHEN LIFE FADES, as the fading sunset, my spirit may come to you without shame.

This quilt was carefully taken apart so that it could be represented on the Witness Blanket.

I didn't want the delicate things like moccasins and tea towels to be harmed by the dust of travel and the oil of curious hands as the Blanket toured the country.

That is where Jane Hutchins came in. Her expertise as a textile conservator was invaluable in figuring out how to display these beautiful objects and protect them at the same time. I designed shadow boxes with plexiglass windows to display the most fragile items, and Jane explained the best way to mount the items inside the boxes. She taught me to use stainless steel staples when the fabrics needed to be stapled and how to coat the cedar box so that it wouldn't eventually stain or damage the fabrics. She also showed me several different techniques for sewing or securing things in place.

My plan for including the textiles was coming together perfectly, but one piece presented a particularly difficult problem. It was a large quilted wall hanging made and donated by an Elder at the High Prairie Native Friendship Centre in Alberta. Every other square had part of a prayer written by residential school Survivors.

I couldn't use the entire quilt on the Blanket in one piece; it was too big. Most of the textiles had either been small enough to include whole or, if they were larger, had one particular focal point that I could use. I wanted to honour the trust I had been given with every object that was donated to the Blanket. I had a responsibility to treat every piece with respect, but I also had permission to change and adapt items to fit with my vision.

In chapter 4, I talked about how I dealt with some fancy cake plates from the staff quarters, and how in my mind cutting them up was about righting an injustice. With this quilt I was faced with a similar decision. After a lot of thought, I realized that the only way I could use the quilt was to take it apart. But this time my motivation was different: to include the quilt and use the entire prayer, I had to use each square individually.

Very carefully, my mom and the sewing team used stitch-rippers and slowly unravelled each stitch that held the quilt together. I then took those individual squares and laid them out chronologically across the Blanket, in the same order they were in when the quilt was whole. By focusing on the poetry of the prayer, I think I stayed true to what the Elder and the residential school Survivors were saying with their quilt. This time, by taking something apart, I was holding on to the heart of it.

There was one textile item that I couldn't change or take apart to fit the Blanket—a girl's sweater from a residential school uniform. It's one of the few remaining parts of a uniform.

I couldn't cut it. That sweater had warmed a young girl at a residential school somewhere in Canada. If I had cut off an arm or even part of sleeve to fit it on the Blanket,

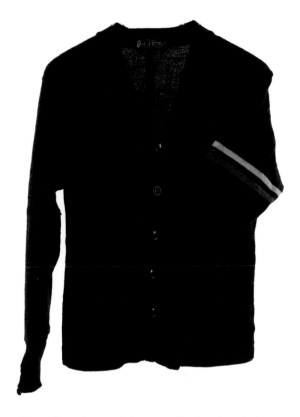

Carey found a special way to display the whole sweater as part of the Witness Blanket exhibit.

The only way to understand the power or importance of that sweater was to see it as a sweater.

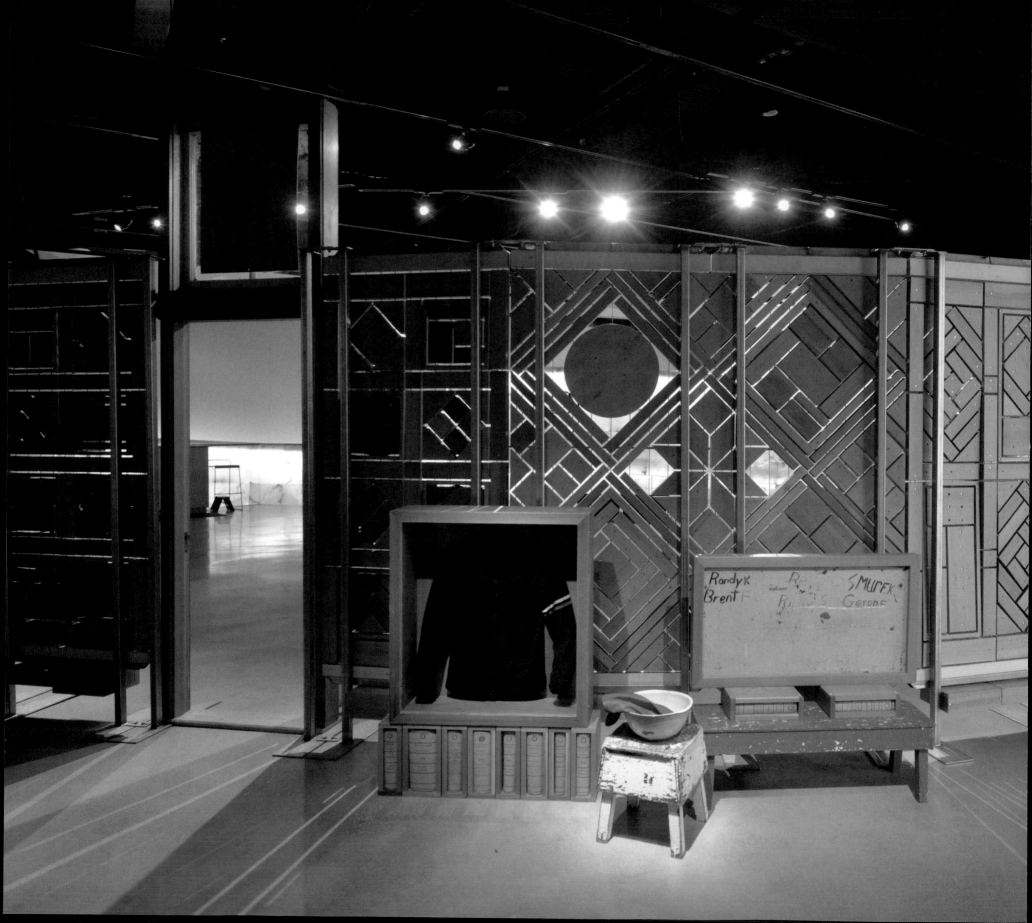

it wouldn't have meant the same thing. It needed to stay whole. The only way to understand the power or importance of that sweater was to see it as a sweater.

I made a special box for it so that it could travel as part of the Witness Blanket exhibit, with a few other objects that were too big to fit on the Blanket.

ALICE'S MOCCASINS

Florence Mary Dodman was born in 1927. She went to Fort Resolution residential school, also known as St. Joseph's, in the Northwest Territories in the late 1930s. In 1936, her brothers Robert and Frank started school there.

Her mother died while giving birth to her seventh child, and her father, Robert W. Dodman couldn't look after the rest of the kids on his own and manage the Hudson's Bay Company store.

He sent baby Jimmy, three-year-old Alice and Florence to St. Joseph's. The eldest son, Arthur, stayed behind to help his father in the store. Florence started at the school when she was about nine years old, and she stayed there until she was fifteen.

According to her daughter, Marilyn (Murray) Allison, Florence did not share a lot about her time at the school, just a few stories over the years, including one about her first day.

"Her first experience when she entered the residential school was [of] all these children crying and crying and crying," Marilyn said. "[They were] all lined up in beds, just like you see in the pictures." Over the years she spent there, Florence didn't get into a lot of trouble at school because, as her daughter said, she behaved herself, did as she was told and tried not to cry.

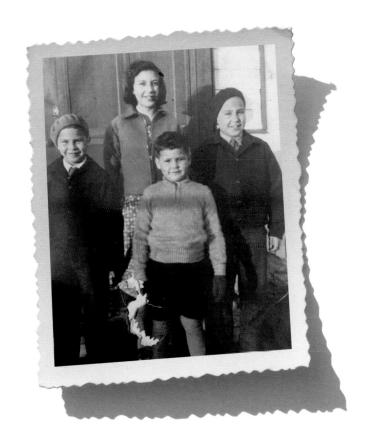

Florence Mary Dodman with three of her siblings.

Opposite: *The Witness Blanket from behind shows all the donated objects that Carey wanted to keep whole and travel with the exhibit.*

One of the memories of residential school that Florence liked to share with Marilyn was of picking berries. They were very plentiful in Fort Resolution in the summer. Marilyn remembered her mom talking about how she and the other girls loved the berry picking "because they were all together and outside and they got to nibble a few themselves." And even though the berries they picked were for the nuns, not the children, Florence would talk about that experience fondly. Marilyn said that, to her mom, what the girls did was okay because they were helping to feed the people who looked after them.

"She spoke about those things as if they were just normal behaviour," Marilyn said. "My mom was kind of naive in a way, a beautiful way."

One cold day in Fort Resolution, Florence and six-year-old Alice, along with all the other kids at the school, were locked outside to play. This was a common occurrence at St. Joseph's, but on this day Alice was very sick, and it was extremely cold outside. She was feverish and couldn't stop coughing. Florence pounded on the doors for help. Finally one of the nuns opened the door and let Alice inside. That was the last time Florence ever saw her little sister.

That day haunted Florence for the rest of her life. No one ever knew exactly what had happened to Alice. It wasn't until a long time after the day she was locked out of the school that the family was finally told that Alice had died. Even then, they didn't know what Alice died of or where she was buried.

When Florence was in her eighties, Marilyn told her mom to watch a news program she had heard was coming up on the CBC. It was about residential schools in the Far North. Marilyn said the camera panned through a graveyard. It focused on one gravestone in particular. That gravestone read "Alice Dodman."

"I couldn't believe it," Marilyn said. "I phoned my mom and I said, 'Did you see that?'" Florence, who was watching the program with one of her brothers, was overwhelmed by what she had seen.

"They couldn't believe it," Marilyn said. "That was quite an ordeal, very sad for my mom and her brother."

A year before Florence died, she pulled out an old shoebox of keepsakes to show Marilyn. Inside was a tiny pair of moccasins, small enough for a baby.

They were embroidered with purple, pink and white flowers. Each moccasin had a pair of white braided tassels. Florence said they were made by her own mother or even her grandmother, for the first-born child in her family.

"They were passed down to each child," Marilyn remembered her mom saying. "Every child wore those moccasins, down to the youngest child."

That meant Florence would have worn them, and Alice too, and every family member who went to residential school wore them. Marilyn held on to those moccasins until she contributed them to the Witness Blanket in honour of her mother.

Alice was just one of the thousands of kids who died at residential schools across Canada—so many kids, in fact, that having a graveyard next door to your residential school wasn't that unusual.

I like to think about that little pair of moccasins as a reminder of life and culture before residential school. They reach across time and speak to the love and comfort of family. While they provide a heartening contrast to the often tragic stories of residential school experience, they also remind me of what was lost when so many Indigenous families were broken apart.

These tiny moccasins were passed down from generation to generation.

BADGES FOR ASSIMILATION

There are all kinds of textiles on the Witness Blanket. Eight merit badges, four red and four green, tell another kind of story of life inside residential school—a story of Indigenous children being forced to master skills that bore no relation to their culture.

Emma Gladue earned those badges when she was at the Blue Quills Indian residential school in St. Paul, Alberta. There are badges for cooking, sewing,

Merit badges had nothing to do with students' cultural heritage.

Students working in the fields at an industrial school.

cleaning and knitting. They look like the badges you earn at Brownies or Scouts, but they're not the same. These badges came with the goal of turning Indigenous kids, who might make cultural items or moccasins for their families, into children who would sew things like tea towels for commercial sale. Emma said she kept the badges all this time because they were proof of what she considered slavery. Not only did she not choose to go to residential school, but she also resented being rewarded for things that she was forced to do against her will.

The merit badge system started in 1942. There's a whole series of documents that are part of the Witness Blanket that show how this program came to be.

The first letter, dated October 13, 1942, describes what the badges should look like. They should be green, the beaver should be a darker brown and the badges should include the letters *I* and *A* for Indian Affairs. There were badges for cooking, knitting, carpentry, sewing, housekeeping and dairy work, as well as poultry-keeping, gardening, leatherwork, metalwork and weaving.

Another letter, sent to the principals and teachers of residential schools across the country, lays out how the merit badge system should work and breaks down the different skills the students would need to master to get each badge in the first year, second year and third year of the program. If students wanted to qualify for the poultry badge in the first year, they needed to know things like how to feed a small flock, how to gather eggs and how to pluck a hen. In the second year, they had to master how to feed broody hens, how to grade eggs and how to disinfect a poultry house. By the third year, students would need to know how to grow and store feed for the winter, how to calculate profits and how to rear turkeys, geese and ducks.

In the final document in this series is a memorandum that breaks down exactly how many badges were awarded. Two years into the program, 1,493 badges had been issued. Eight of those badges ended up on the Witness Blanket.

As Emma said, the badges are proof that residential schools existed to take the Indian out of the child. Kids at residential schools were taught how to sew, but they weren't sewing moccasins for their families.

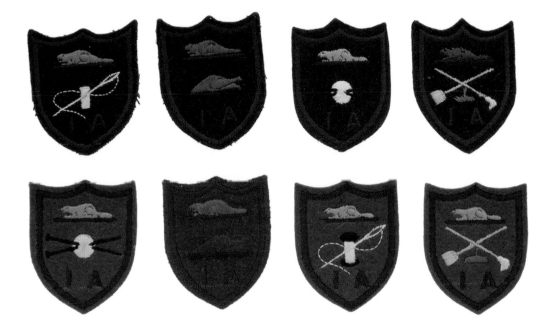

Each residential school student had to master 20 skills to qualify for a merit badge. When they had completed the first group of skills, they would get a green badge, and after the second group, a red badge.

NEVER FORGET

THERE ARE MANY PHOTOGRAPHS on the Witness Blanket. Some of them are class photos, just like the ones taken at any school today. Most of them are in black and white and show students and scenes at residential schools across Canada. Although I can see by the images themselves that they represent many decades of history, I don't know exactly when a lot of them were taken. I can only guess by the quality of the image and take clues from the clothes the kids are wearing.

One of the oldest ones comes from Coqualeetza residential school in Chilliwack, British Columbia. The ten boys in the photo are dressed in three-piece suits with ties or bow ties. Their hair is parted in the middle, a style that was popular in the 1920s. The two girls are in long skirts and double-breasted jackets.

This is an undated class photo from the Coqualeetza residential school.

Opposite: This photo, dated 1938–39, became part of a Christmas card from St. Paul's residential school (Blood Reserve) in Alberta.

Another photo shows a group of younger kids bundled up against the cold at Whitefish Lake residential school in Alberta in 1937. The girls are wearing toques, but the boys aren't. They have their scarves criss-crossed across their bodies.

In a photo from Lesser Slave Lake residential school in Alberta, twenty-five kids of different ages are standing in front of a school with three of their teachers. The girls are wearing collared dresses and they all have a similar bob haircut. The boys are in shorts, leggings and boots. Some of them are wearing blazer jackets. Their heads are shaved.

All of the kids are looking at the camera except one—a boy of about eight or nine who is off to one side. His head is down, shoulders hunched, and he is looking at the ground. When I was fitting the images onto the wood blocks for the Blanket, that's the part of the picture I focused on.

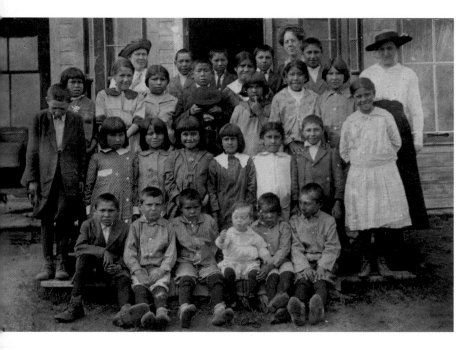

A close-up of the boy on the far left ended up on the Blanket (right).

An example of a tent hostel in northern Canada.

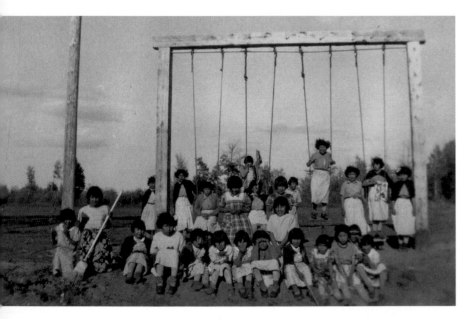

A group of students at Assumption (Hay Lakes) residential school, AB.

There are more than 161 photos on the Witness Blanket. Each one represents some part of the residential school experience. I chose them based on the story they could tell.

There's a photo of the Federal Tent Hostel in Coppermine, in what is now Kugluktuk, Nunavut. The tents are laid out side by side, with snow piled up against them. There are oil barrels and shacks in front of the tents. The hostel opened in 1955 and had space for thirty Inuit kids who were billeted in eight tents. Permanent schools weren't often built in the Arctic because foundations couldn't be dug in permafrost, so this photo is one of the few remaining records of that school.

A photo of a swing set in front of the File Hills residential school near Balcarres, Saskatchewan, is from the 1940s. I put it beside a piece of wood from that same swing set.

In another photo, a group of men stand and sit in a line behind a fence, facing a residential school on the Blood **Reserve** in Alberta, waiting for their children. When I look at this photograph, I try to imagine what these fathers are seeing and feeling. Many of them are dressed in traditional *regalia* and holding Eagle Staffs, long thin poles wrapped in hide with feathers hung from them. A kind of sacred traditional flag, these staffs existed long before the first settlers appeared on the continent.

Men in regalia wait outside a residential school on the Blood Reserve.

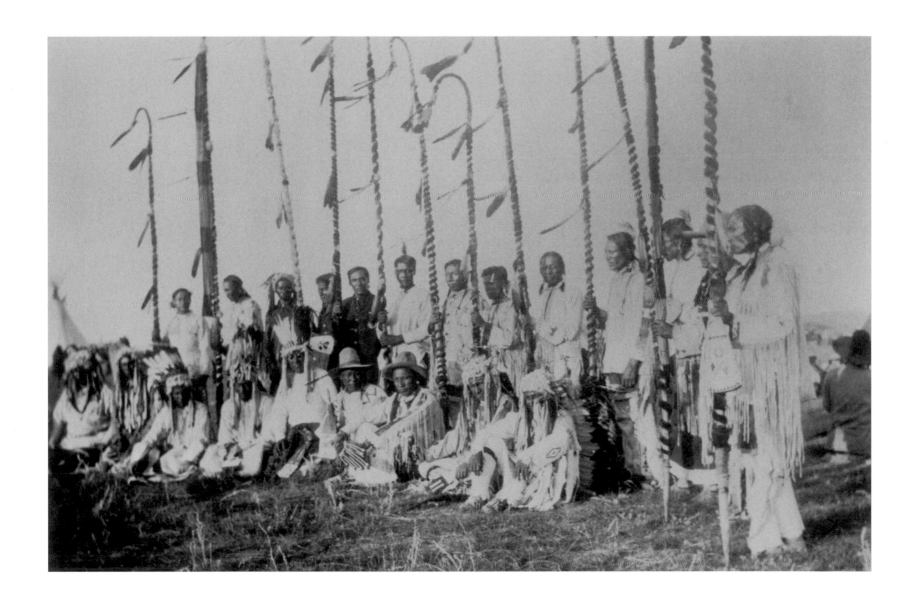

THE SADDEST DAY

In the 1920s a boat called the *Bonita* (which is Spanish for "beautiful") travelled back and forth across Lac La Ronge in northern Saskatchewan. It was 6.7 metres (22 feet) long and ferried up to forty Indigenous kids from one side of the lake to

The only way to get to the residential schools on Lac La Ronge was by boat.

the other. Every September for decades, kids as young as five or six climbed into the boat and left their communities behind for another school year. They were all going to the same place, Lac La Ronge (All Saints) residential school, on the south side of the lake.

Tom Roberts said back then it would take some families half a day just to make the journey to where the *Bonita* or a boat like it picked them up. The route they took had four **portages** along the way. At every portage, the families would climb out of their boats, carry them over land to the next beach and continue on the next leg of their journey.

"At the end of that last portage, they'd put their kids into this big boat, never to see them again for ten months," Tom said. "How sad that journey must have been for the parents, when they went back home, with no kids in their boat. It's like the Pied Piper who took all the kids away from that one little village."

The *Bonita*, and many other boats like it, would ferry the kids back to their families the following spring, when the school year was done. The boats carried kids to and from the residential school on Lac La Ronge starting in 1907 and continued until the school burned down in 1947 and the students at All Saints moved to a new school in Prince Albert, 200 kilometres (124 miles) away.

Tom said his first day at All Saints was the saddest day of his life. He went there when he was seven or eight years old.

"My mom and dad weren't there," Tom said. "I couldn't talk to my brother, I couldn't talk to my sisters. I wasn't the only one crying, there were lots of kids crying, wanting to go home, not tomorrow or next week, but right now."

Tom said he got very, very lonely.

"You don't know until you get there that your mom and dad aren't there to tuck you in at night," he said. "After two or three years, you start to get used to being in a residential school. You start to know the ropes, [you] know what not to do, or what to do and not get caught."

One of Tom's lasting memories from All Saints was being told that, because he was Indigenous he couldn't do certain things. He said the staff at the school would say to him, "You're nothing but an Indian, you'll never be able to do it." Tom said he and his friends would play games of cowboys and Indians, but no one ever wanted to be the Indian.

When Tom talks to young Indigenous students now, he always takes the black-and-white photo of the kids packed into the boat with him. The photo tells a story about one residential school in northern Saskatchewan, but it's just one of the many photos that were donated to the Witness Blanket. And like Tom's photo, each of them came with their own story to tell.

It took a long time to work out how to include the pictures, and the memories they represented, on the Witness Blanket. I wanted to find a way to include them without damaging any of the originals. There's a photo of a boy dressed in full regalia, kids on a playground, young girls working in a garden, a group of boys brushing their teeth in a washroom. There are archival shots of schools, snapshots of mealtimes in dining halls and pictures of hockey teams.

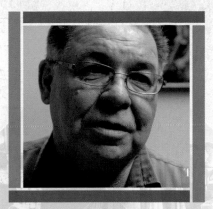

"I wasn't the only one crying, there were lots of kids crying, wanting to go home, not tomorrow or next week, but right now."

SURVIVOR TOM ROBERTS

Boys in the washroom at Deh Cho Hall (Lapointe Hall) in Fort Simpson, NWT.

Above and opposite: Acetate images were rolled onto wooden blocks of various sizes.

I knew how much the photos would add to the Blanket's meaning, but at first I didn't know how to include them. How would they fit with the physical objects I had been given, the bricks, bowls, dolls and trophies that I was also going to include? People hold on to memories in different ways. Unlike the Survivors who donated physical objects to the Blanket, in a lot of cases the people who donated photographs wanted the original pictures returned. Another concern was that photographs are fragile, so how could I use the images without damaging the originals?

It took me months of experimenting in my studio to come up with a way to make the photos part of the Blanket. I scanned and saved every single one of the photographs and then returned the originals to their owners in the mail. After that I spent days in the studio, printing out photos and looking for a way to transfer the images directly onto the wood.

Eventually, I found a way to make it work. I used something called acetate, a clear plastic material that is treated on one side to hold ink from a printer.

If I printed the photo on it, rolled it face down onto wood wet with acrylic paint, and slowly peeled it off, the image would stay on the wood. I would leave it to dry and then sand the edges of the wood and seal the surface with a clear coat. Only then was that one photo, now attached to a cedar block, ready to be fitted on the Witness Blanket.

Every surface in my house—the dining room table, the couch, the bed in the guest room—was covered in wooden triangles and squares. Each block had a different photo transfer with a code on the back so I knew where it would go on the Blanket. The code also linked with information about where the photo came from and who donated it. It was a big job just to keep track of all the photos.

The finished image blocks were mounted on the Blanket.

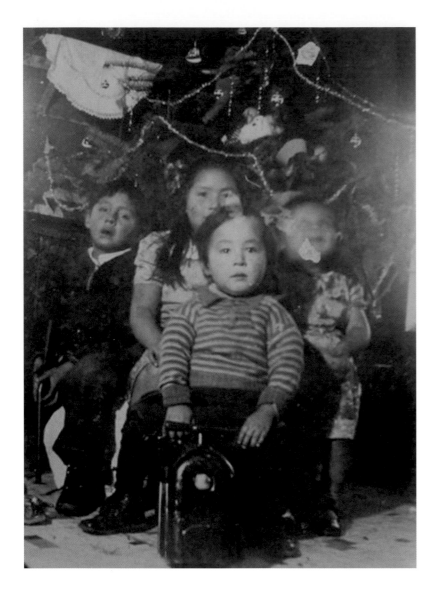

Victor Newman (front) spends his last Christmas at home before going to residential school.

I wanted the pictures to add layers to the stories on the Blanket. When I was choosing and preparing the images on my computer, I coloured some of them in ochres (brownish yellows) and reds and blues, so they would complement the bigger and brighter physical objects. Figuring out where to put the photos on the Blanket was like putting together a giant puzzle, just as it had been with the physical objects.

I felt that it was important for me to include photos of my own family. There are pictures of my aunts and uncles and grandparents. There's a black-and-white photo of my dad. He's sitting under a Christmas tree, between his brothers and sisters. He told me that he was about five or six in that photo, and it was from the last Christmas he spent at home before he went away to residential school. When I look at it, I imagine what it would have been like for him to leave his family and have his life so completely changed in Grade 1 or 2. I think I can understand why he doesn't want to talk about that last Christmas at home.

As the team travelled the country gathering objects for the Blanket and talking to Survivors, we found many people who were willing to share their stories about residential school. They often shared experiences and memories that, like my father, they couldn't or wouldn't share with their own families, their own kids. Maybe it's better that I don't know exactly what happened to my dad. Maybe it's easier for my soul to hear about the kinds of things that happened to him through the words of other Survivors.

◆ ◆ ◆

Tom Roberts said he went to residential school as a child and came back as an adult, just like his grandfather, mother, uncles and aunties before him.

Many people still don't know there was a residential school on Lac La Ronge. In fact, there wasn't just one—over the years there were many in that area.

Even though it's part of Tom's own story, he still can't imagine kids being taken away from their families at such a young age. "Mom and Dad there sitting at home, couldn't do nothing," Tom said. "Indian agent walks in, 'Okay, this one, this one, let's go.' And you don't see your babies for ten months."

His only wish is for people to understand what happened at residential schools.

Maybe it's easier for my soul to hear about the kinds of things that happened to him through the words of other Survivors.

"When I went to school you were told what to do, when to do it and how to do it," Tom said. "I wish for the people who were abused, mentally, physically, to learn to heal and learn to forgive. They'll never forget, but they can forgive."

For now, he says, like many Indigenous people who went through the residential school system, he's caught between two cultures—"the Native culture and the non-Native culture. I'm not sure which way to go."

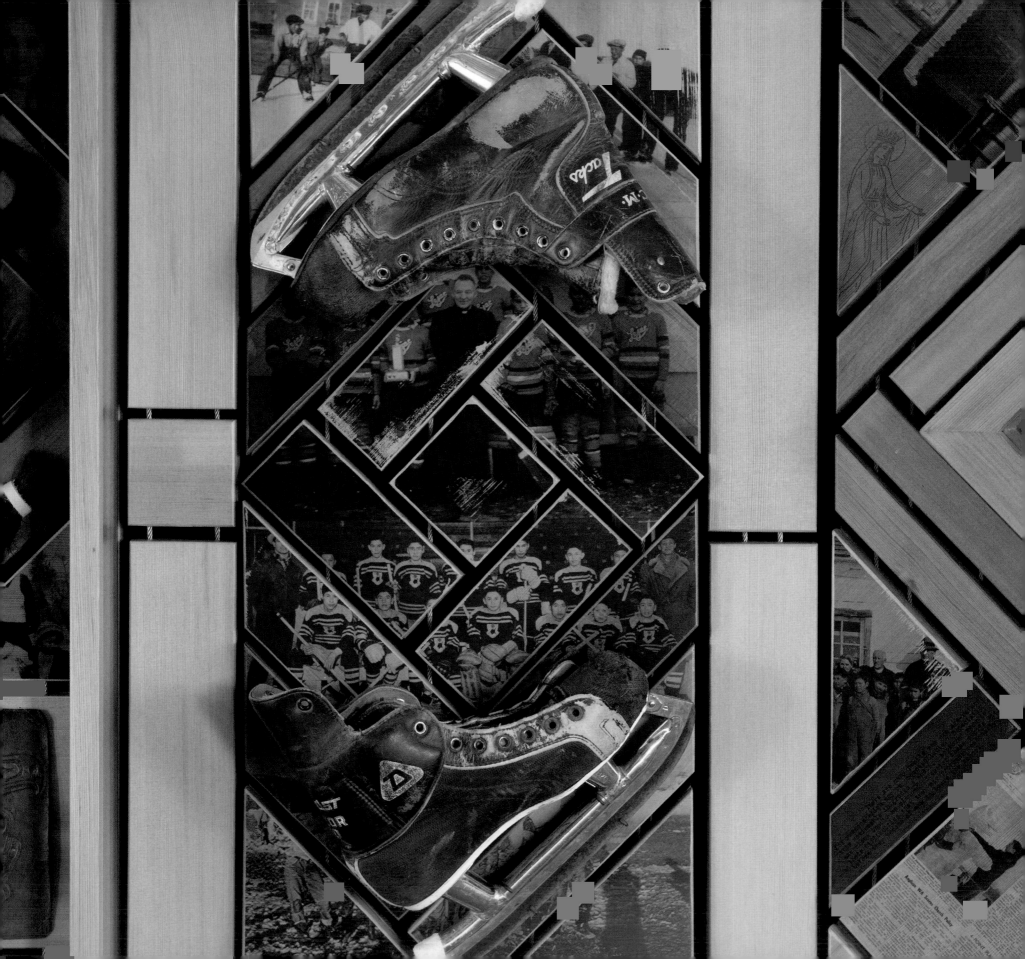

CHAPTER SEVEN · MOMENTS OF HUMANITY

LIFE AT RESIDENTIAL SCHOOLS across the country followed a similar pattern. The days were typically made up of school, chores and church. If there was time left over at the end of the day, that's when the kids could sometimes just be kids, even if it was only for a little while.

Many Survivors share stories of how sports—hockey, baseball, skiing, running—helped them get through their time at residential school. Many of the objects we collected for the Witness Blanket tell that part of the story. Children at the schools could sometimes have fun playing sports, creating art, making music, inventing imaginative games or doing something else that allowed them to escape their harsh reality.

71

Above: *Athletes at residential schools excelled in all kinds of sports.* Below: *A boys' hockey team from the Lejac residential school in Fraser Lake, BC.*

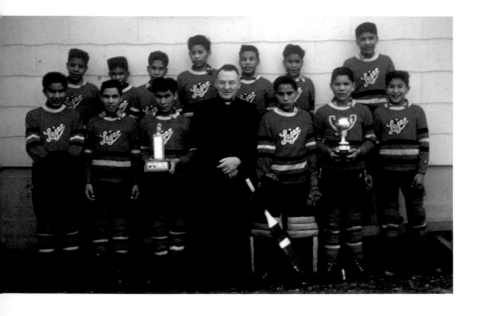

One piece that stands out for me is the Gordon's Golden Hawks Ladies Hockey Tournament championship trophy. It came from Gordon's residential school in Punnichy, Saskatchewan. The trophy is from 1996, the last year that school was open, making it one of the newest objects from a residential school on the Blanket.

There's another plaque from a different hockey trophy. This one comes from Inuvik, Northwest Territories. It's for the Grollier Hall Junior Boys Red Wing team in 1966/67. It even names all the players. The Captain was Turpin Cockney and the players were Francis Ruben, Ernie Lennie, Andy Green, Patrick Kudluk, Kenneth Benoit, Henry Charney, Gregory Cardinal and Danny Yakaleya.

There are four other photographs relating to hockey. Two of them are formal team photos with the players lined up, wearing uniforms. One team is from the Lejac residential school in Fraser Lake, British Columbia, and the other is from southern Alberta. Somewhere in a box of childhood keepsakes, I have a similar photo of me playing hockey as a boy.

There is also a black-and-white photo that shows a group of boys standing on the ice in their skates, holding their hockey sticks. Although they are all wearing newsboy caps instead of helmets, they look like they're getting ready for a game. The photo doesn't have a date on it, but you can see the Edmonton industrial school in the background.

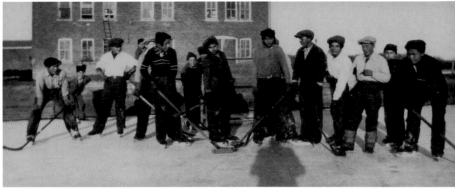

There are even two old-fashioned hockey skates on the Witness Blanket. I mounted them in front of pictures of hockey teams. From the style of the skates, it looks like they're from the 1970s. They came from the abandoned Muscowequan residential school in Lestock, Saskatchewan.

Above: Boys at the Edmonton industrial school get ready to play hockey. Below: Marek found these skates in the hallway of the residential school in Lestock, SK.

The first school opened there in 1889. It finally closed its doors in 1997. Since then the building has been used off and on, but for the last few years it has sat empty and forgotten. The windows are broken and snow is piled up in the corridors in the winter; wires from the school's electrical system hang like tinsel from the ceiling.

Girls at a residential school on the Blood Reserve get together for some carol singing.

When Marek walked through the building to collect objects for the Blanket, he came across a room that used to be the chapel, with a broken-down piano lying on its side. Five of the keys from that piano are mounted on the Blanket. When I look at those keys, I imagine the times when kids were transported to a different world by the music they made. I use music as an escape, whether I'm playing the piano or singing or just listening to my favourite band; it takes me to a different place. I wonder how many songs those keys were part of? How many students ran their fingers across the keys, making their own kind of music?

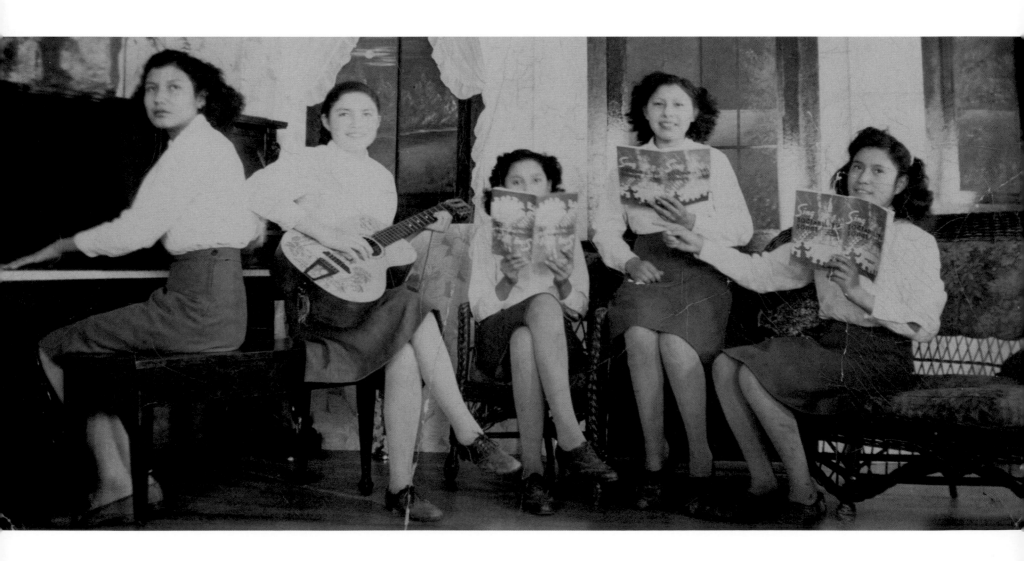

HOMEMADE SKIS AND HOCKEY SKATES

There weren't a lot of toys for the younger kids to play with at residential school, so they had to make their own. When Bob Charlie attended the Whitehorse Baptist Mission residential school in Whitehorse, Yukon, from 1950 to 1956, the other kids who were there came from all over the territory.

"Some of the boys that came from towards Carmacks, Pelly and Mayo used to see those big ore trucks go by and they would carve these little trucks and trailers out of wood," Bob said. "They had really elaborate little springs on them, steering and trailer hook-ups. You had to create your own entertainment."

In the winter, they made their own skis and toboggans. "You'd get planks of wood, sand them down, put them on the barrel stoves and bend them," Bob said.

Because the hill they zoomed down ended up on the road, they had to watch for cars. One boy would always be the lookout, stationed at the bottom of the hill. If a car was coming, he would warn the boys at the top of the hill.

"I entered the school as an orphan," Bob said. His mother had died when he was six months old. He lived with relatives for few years, but when he was four he went to the orphanage at the residential school. And when he was six, he started school.

"I flunked Grade 1," Bob said, "probably the only person ever to have done that."

The six years Bob spent at the school weren't easy. He had some bad experiences there and sometimes, even all these years later, he remembers things that he'd rather forget.

But there were moments when Bob could just be a kid, playing with toy trucks and flying down the hill on homemade skis. Those are the memories that he focuses on. He did his school work during the day and then did chores, like chopping wood and carrying it to feed the double-barrelled stoves in the dormitories. After that, he would lace up his skates.

"You would play hockey for hours," Bob said. They had organized teams that were so good they were unbeatable for years in a row. The teams in Whitehorse used to get frustrated because they couldn't beat the boys from the residential school.

"You had to create your own entertainment... [We] would play hockey for hours."

SURVIVOR BOB CHARLIE

"It was someplace I could play hockey and ball and the stuff I wanted to do...[We had] some of the best hockey players you never heard of."

SURVIVOR LEON WOLFE

Thirty years after Bob Charlie finished his time at residential school in Whitehorse, Leon Wolfe went to Muscowequan residential school, 2,750 kilometres (1,700 miles) away in Lestock, Saskatchewan. He started Grade 2 in 1986 and stayed there until Grade 8.

Like Bob, Leon said sports, especially hockey, helped him get through his time there. He said the outdoor rink was always full. Kids skated after school and in the evening almost every day.

"It was someplace I could play hockey and ball and the stuff I wanted to do," Leon said. "On reserve they didn't have that kind of stuff." And some of the hockey teams at Muscowequan, just like the teams in Whitehorse, were really good.

Leon said one of the stories people talk about is from the 1940s or 1950s. Some of the boys from the residential school had a chance to play against the Regina Pats from the Western Hockey League.

"[But] the team didn't want to show up and play against them because they would have got beat," Leon said. "[We had] some of the best hockey players you never heard of."

Leon said the trophies and plaques that we collected at the school for the Witness Blanket proved that the kids who went there were excellent athletes.

GOING FOR GOLD

When Lucy Kuptana went to Grollier Hall, part of the residential school in Inuvik, Northwest Territories, it wasn't hockey that got her away from school and chores, it was cross-country skiing. The ski club was her second home. That's why she donated what she called a ski wax slider for the Witness Blanket.

"We skied every night in the winter, even in minus forty [degrees]," she said. "It was mandatory."

They would put on their standard blue parka with yellow trim, pick up poles and skis, wax them up and hit the trails around the school. Lucy said they trained so hard and in such extreme weather that they did really well

at competitions. Kids from the residential schools went to territorial and national championships. They competed at the Arctic Winter Games. A couple of the girls even ended up going to the Olympics. Twin sisters Sharon and Shirley Firth, like Lucy, were originally from Aklavik and went to Inuvik as small children to go to residential school. The Firth twins went to four Winter Olympic Games, and both have been inducted into Canada's Sports Hall of Fame.

Cross-country skiers Sharon and Shirley Firth competed in Winter Olympic Games four times.

Lucy remembers when the twins came back to Inuvik to practise and train.

"They would show us the latest skiing techniques, how to pole properly, how to do a different glide, a different kick," Lucy said. "We got to work with Olympians. It was pretty amazing."

By the time Lucy left Grollier Hall, she was competing in the five-kilometre (three-mile) race.

ART FOR ART

As an adult, Art Thompson was an internationally known artist and master carver. Displayed prominently on the Witness Blanket is a large painting that he did when he was just a boy at the Alberni residential school in Port Alberni, British Columbia. It might be his earliest surviving work of art.

His instructor there was a man named Robert Aller, who taught painting in a few different residential schools across Canada. The reason why some of those paintings are still around is that Mr. Aller, who kept meticulous records, saved them.

I wonder what those classes were like for young Art Thompson. I have seen photos of Mr. Aller's classes, with all the desks pushed aside, large sheets of paper laid out on the floor, big pots of brightly coloured paints everywhere and the kids completely engrossin the artistic experience.

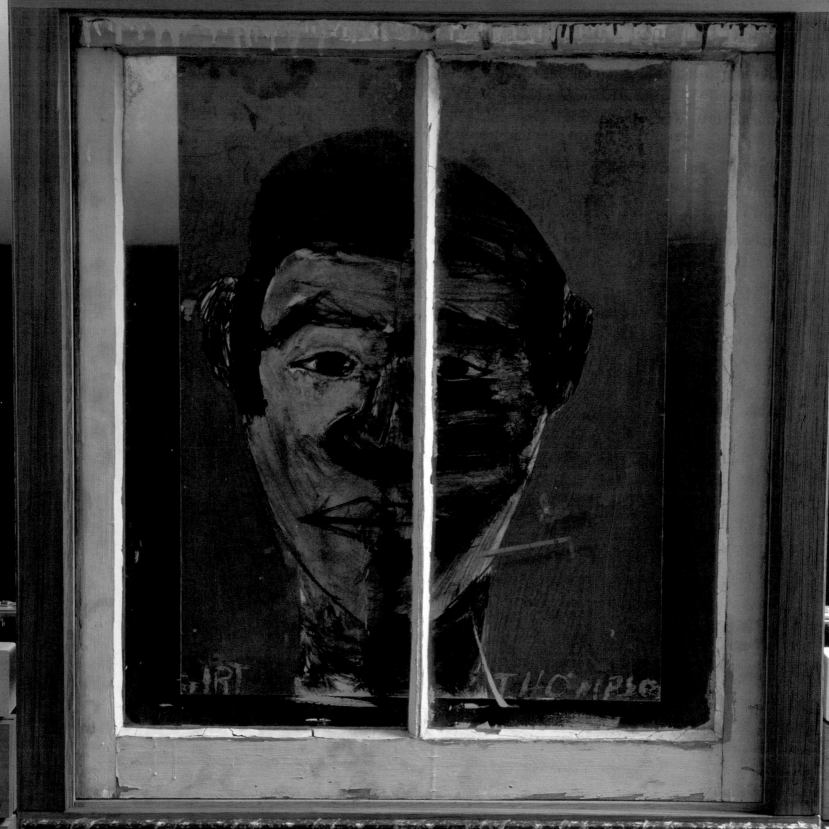

I know how the process of making art is for me. I start to create and everything around me disappears. My world is only as large or small as whatever it is I am making, and my everyday problems melt away. Mr. Aller's attendance records show that Art Thompson never missed a class, and I like to think that it was a small bright spot in his time at residential school.

Art Thompson was one of the first people to describe his residential school experience in the Supreme Court of Canada. What he and a few other Survivors shared with the judges opened the door for more Survivors to come forward and share their stories. Those efforts pushed churches and the Canadian government to finally acknowledge their role in what happened at those schools. This eventually led to the **Indian Residential School Settlement Agreement (IRSSA)**.

The IRSSA is a legal agreement between residential school Survivors, churches and the Government of Canada. The largest class-action settlement in Canadian history, it came into effect in 2007 and led to the creation of a multi-billion-dollar fund to help residential school Survivors with their recovery. From that fund, Survivors could be compensated for their residential school experience through the **Common Experience Payment**. If Survivors were willing to share their story, they could also go through the Independent Assessment Process, by which they could qualify for more compensation based on the level of abuse and trauma they experienced.

The IRSSA also called for the formation of the Truth and Reconciliation Commission. Since the TRC administered money that Survivors had designated for commemoration projects like the Witness Blanket, the Blanket was actually funded by residential school Survivors themselves.

Robert Aller surrounded by art students at a residential school.

Opposite: *This painting was created by Art Thompson when he was a student at the Alberni residential school in BC. After nine years at residential school, he went on to study art. Today Thompson's work is displayed in museums and galleries around the world.*

"We put things on a note, like I-T-A-L-Y: I Truly Always Love You. H-O-L-L-A-N-D was another one: Hope Our Love Lasts And Never Dies."

SURVIVOR STAN WAMISS

MEDICINE FOR OUR HEARTS

Stan and Nancy Wamiss met at St. Michael's residential school in Alert Bay, British Columbia. Stan said he lost much of his childhood in his time at the school.

"I was deprived of my dad," he said.

When he went home from school in the summer, his dad would be carving canoes. But Stan chose to play with his friends rather than learn from his dad.

"We never paid attention to our culture," Stan said. "When I left residential school, my dad died and took everything with him, his knowledge. What I'm learning now in our culture, I should have known when I was ten or twelve years old, you know?"

All these years later, Stan and Nancy are married, and Stan is reclaiming his culture. He has even made his own canoes, just like his dad did. Whenever Stan thinks about residential school now, he tries to focus on the good memories, especially the ones that include Nancy and the times when they could just act like kids together.

"I used to send her love notes," Stan said. "We put things on a note, like I-T-A-L-Y: I Truly Always Love You. H-O-L-L-A-N-D was another one: Hope Our Love Lasts And Never Dies."

Sitting with them, listening to them talking, I noticed that when they shared difficult stories they were sombre, their eyes cast downward, but when they told us about those notes, they looked at each other and I could see the love sparkle in their eyes. We all laughed together, and it was like medicine for our hearts.

Earlier in this chapter, I mentioned that there are four photographs on a panel with the hockey skates. The reason I described only three of them is that I was saving the last one, my favourite, for the end of the chapter. It is a colour photo, peeking out from behind the lower of the two skates. In it, there is a group of boys in a field of slush and melting snow. They are all wearing gumboots and holding sticks and brooms, and they're covered in mud after what I imagine was a spirited game of broomball.

When I was making the Witness Blanket, I was often overwhelmed by the sad and tragic stories I heard. In those moments, when I felt my mood darken, I would look at that picture, and those beaming smiles were sunshine for my soul.

Collectively, these stories are little pieces of humanity amid a lot of despair. I love how they illustrate the incredible resilience of human nature and remind me that kids will always find a way to be kids, even in the most difficult of circumstances.

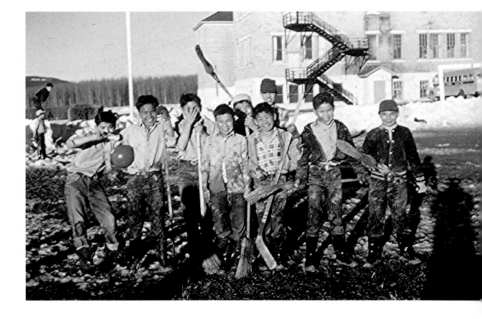

Someone wrote on this photo, You were a hard bunch to keep clean, but you knew how to have fun.

Opposite: *Nancy and Stan Wamiss at home on the Quatsino First Nation on northern Vancouver Island.*

CHAPTER EIGHT · OUT OF THE ASHES

THERE'S A WHITE ANGEL FIGURINE mounted on the Witness Blanket. It's broken and blackened by fire. We pulled the small statue out of the ruins of a residential school building in Cluny, Alberta, that had burned down. Angeline Ayoungman went to both the Crowfoot and Old Sun residential schools in the area and took us on a tour of the sites.

I thought a lot about this little figure and how to include it on the Blanket. Even though we had managed to salvage some broken pieces from the ashes, I chose not to put the statue back together or to completely fix it. When I mounted it on the Blanket, I kept the little broken pieces slightly apart from the rest of the figure.

Carey wanted to keep this figure broken and blackened, as it was when it was found.

The white angel figurine wasn't the only object on the Blanket that came from a fire. We collected other burnt pieces from residential school sites. As with other objects that were related to one another by material, I knew I wanted to group them together on the Blanket. Everything that was melted, charred or burned in a fire is included in the same little box.

In Cluny we also found pieces of melted glass that had been fused together by the fire. There's a piece of burnt wooden siding and a shingle from the Federal Hostel at Frobisher Bay (Ukkivik) in Iqaliut, Nunavut. There's also a piece of burnt wood from

> **Everything that was melted, charred or burned in a fire is included in the same little box.**

the U'Mista Cultural Centre in Alert Bay on Cormorant Island, off Vancouver Island, British Columbia. A fire there in 2013 damaged dozens of artifacts, including masks and regalia.

Pieces of melted glass from the Crowfoot residential school in Cluny, AB.

When I held all those objects for the first time, soot would come off on my hands. I had to find a way to seal the charcoal and charred pieces before mounting them on the Witness Blanket. It wasn't easy to do, because charcoal absorbs anything that you put on it. So once again I had to start experimenting. In the end I lined up all the blackened pieces and sprayed them with coat after coat of clear acrylic, until the charcoal finally stopped absorbing it. The dozens of coats of acrylic left the pieces a little shinier but intact. Treating them that way meant I could touch the board or the shingle without getting my hands black. It also made the pieces much stronger, so they wouldn't crumble away over time.

The angel figurine is in the middle of the box of burnt items. It's mounted in front of a photograph of a burning school building. The photo was taken on February 26, 1913, at Norway House residential school in Rossville, Manitoba. The school burned to the ground in the fire that day. Luckily, there were no reports of children being hurt in that fire. But many other residential schools burned down over the years, and many children died in those fires because there were none of the fire safety measures that we take for granted in schools today.

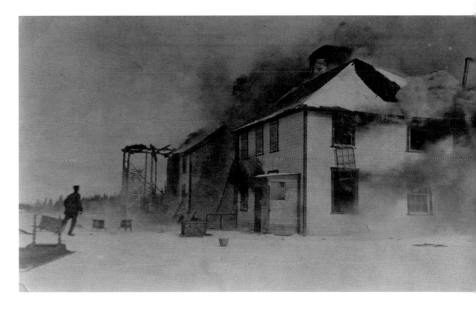

No students were hurt in this fire at Norway House residential school in Manitoba, but children in other schools were not so lucky.

Fires hold a special significance in many Indigenous cultures. In my Kwagiulth and Coast Salish cultures, fire is tied to ceremony. During Potlatches we have large fires in the middle of our Big Houses that are used for cooking, dancing around and warmth. When someone dies, we hold ceremonies where we burn various things that our loved ones might need in the next world, like their favourite food or their traditional regalia. The people who perform those ceremonies say that the spirit of the person who has passed on is with us at the fire, and sharing our memories helps us let go of them and helps them prepare for their next journey.

"We couldn't even talk to the boys. I'd sneak a smile at my brothers if I met them in the hallway. We weren't a family."

SURVIVOR ANGELINE
AYOUNGMAN

Fire is also a part of smudging, a ceremony where you take traditional medicine like dried sage, braided sweetgrass, crushed cedar or tobacco, place it in a shell and burn it in a slow smoulder. The smoke is called the smudge, and you draw your hands through it and pull it over your body, almost as if you're washing yourself. You pull it over your head if you need to calm your thinking, or up to your heart if that's where you need strength.

I use smudging to help me get in the right frame of mind for work. Sometimes I will do it at the end of the day as well, to help me separate my work life and my family life. Smudging can also be used as a blessing for objects. When I've finished a piece of art, I will ask a spiritual person to perform a smudge on it to prepare it for the next part of its journey. When the Witness Blanket travelled from one place to another, we followed the traditions of whichever community we were in. Often someone would do a smudge before it went back into the boxes, ready for the next stop.

For me, whether in a burning ceremony, in a smudge or at the heart of a Big House, fire represents change. I think of it as being like the renewal that comes after a forest fire, when new foliage begins to spring from the ashes, filling up the void the fire left behind. That is what I think of when I look at the box that holds all the burnt objects on the Witness Blanket—the rebirth that comes after the fire and its connection to culture and ceremony.

WE WEREN'T A FAMILY

Angeline Ayoungman looked through a window on the second floor of what used to be the junior girls dormitory at the Old Sun residential school. She said when she was a girl she would stand in that exact spot and peer through the screen, looking for her family home.

"It's about twelve miles from here," Angeline said. "For me, one of my memories [was] being so lonely, coming from a loving home and then to be placed here.

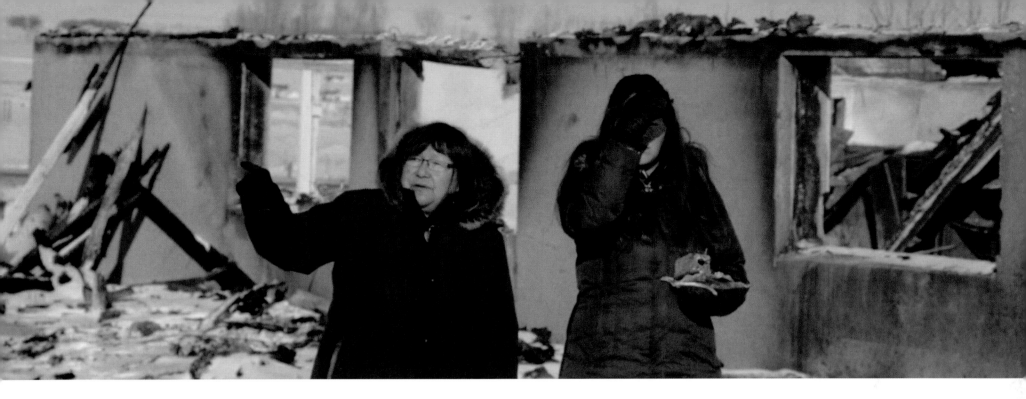

Angeline Ayoungman (l) and Rosy Hartman, facing the bright sun, collect objects from a burned out residential school in Alberta.

I know there were nights when I used to look out and look way in the distance, wishing I was home."

She came to the school when she was seven. She started in Beginners. That's what they called Kindergarten when Angeline was there. By Christmas of that first year, she had learned enough English to move up to Grade 1. Angeline lived at the Old Sun residential school for seven years. Then she went to Crowfoot. She was finally able to go back home after Grade 8.

"There were people even younger than me, but when I was brought here, I didn't want to be here," Angeline said. "Being in this room brings back that lonely feeling, wishing I was home, just being with my family."

Angeline remembers overhearing the staff members saying that they and the students were one big, happy family, but she disagrees. When she was at residential school, she was there with her three older sisters and two older brothers, but she couldn't be with them.

"We couldn't even talk to the boys," Angeline said. "I'd sneak a smile at my brothers if I met them in the hallway. We weren't a family."

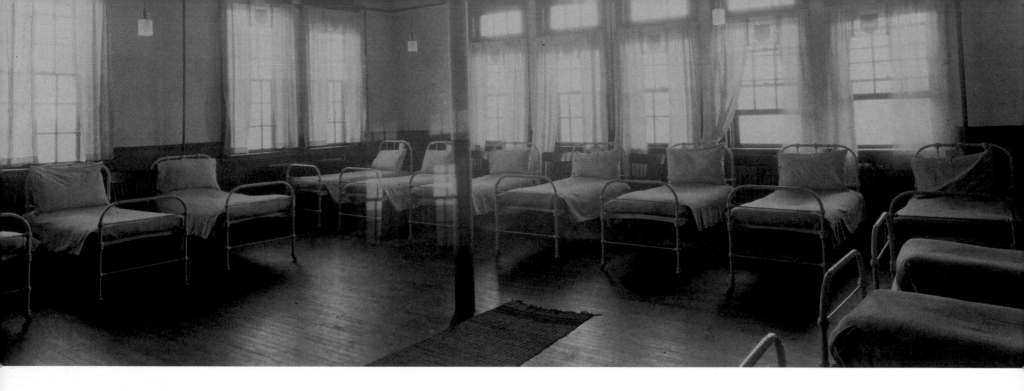

Empty dormitory in one of the Blood Reserve residential schools in Alberta.

Angeline's mother had gone to the same school when she was a little girl. Angeline remembers that her mother often talked about the sun room at Crowfoot. It was a small **infirmary** where kids went when they were sick. Angeline's mother said she used to spend days in that room, isolated from the other children because she had tuberculosis, a common illness at residential schools right across the country starting in the late 1800s. More than 6,000 students died in residential schools, many of them from diseases like tuberculosis and influenza.

Even after all these years, Angeline can still picture the dormitory, with its concrete floors, exposed brick walls, and rows and rows of single metal beds. There was one washroom and one sink for each dormitory. The supervisor had a monitor room next door. It had a small window that looked into the dormitory so the supervisor could check on the girls.

Angeline's bed was near the door. She remembers a night when a group of girls in the dormitory were making a lot of noise while she was in bed.

"They were running around," Angeline said. "It was very noisy and the supervisor came charging into the room and she came straight to my bed and the girl next me and she lifted our nightgowns and really spanked us. We weren't even out of our beds." She said that's just the way it was there.

When it was too cold to go outside, the girls had a playroom they could use. And like the dormitories, it had a cement floor. Angeline said it was one of the few places where she and her friends could secretly speak their own language.

"A bunch of us would be playing and we would have someone watching out," Angeline said. "As soon as they saw the staff coming, they would signal us and we would switch to English, so we wouldn't get punished."

The Gilmore Memorial Ward at the Shingwauk residential school in Sault Ste. Marie, ON.

Both Old Sun and Crowfoot closed in the late 1960s. Old Sun Community College opened in 1971. It's still running as a college today. Angeline took a few classes there as an adult, including one in what used to be the girls' playroom, that one place where she could speak her own language.

"I remember sitting in my class, looking around, thinking, 'Imagine, I used to go here when it was a res school, as a little girl,'" she said. "'Now I'm sitting in here taking a university course.'"

Angeline said she's thankful that the building is being used as a college now, but it doesn't mean her memories of residential school are gone. As she leaned against that white wooden window frame on the second floor, where the girls dormitory used to be, and where she had searched the barren landscape for her family home, her life at residential school came back to her in sharp detail.

"I guess it never really goes away," Angeline said. "You think you're over it, but when you're looking at these things, it brings back those memories…"

THE PERMANENT RECORD

I WANTED THE WITNESS BLANKET to include one thing from every residential school in Canada. According to the Truth and Reconciliation Commission, that's 139 schools, spread out across the country. (That number doesn't include day schools or schools that were run provincially.) At the end of our travels, though, after collecting pieces for the project from coast to coast to coast, we were still missing items from about twelve schools.

There were any number of reasons why we couldn't track down any objects from or memories of those schools. Some of the schools were hard to get to because they were in remote places—or it was hard to find people who had gone to them. In some cases, the actual buildings that housed the schools just didn't exist anymore—or there had never been permanent buildings.

So how would I manage to include one object from every residential school on the Witness Blanket? We had to get creative.

Peter Silastiak
"The meeting will come to order" That has to be Sloosh at another of his constant conferences. As Student Council President, Pete is always going from one meeting to another at least. On the side he is a dedicated basketball player, sometimes folk singer, and of course, questing student. Pete can even do quadratic systems in h sleep (such dedication). Actually he is just putting into practice wha he learned last year at a Recreational Leadership Course in Drumheller.

A 1967 yearbook entry from Fort Smith (Grandin College) residential school in NWT.

We had been given documents like school records and graduation certificates. We were also fortunate to have been given a few yearbooks by contributors who scanned the whole book so we would have a complete record. Yearbooks became popular toward the end of the residential school era, when those who ran the schools were attempting to make them more like other schools in Canada. The yearbooks are a window into the experience of the last generations to go through the system.

Documents like these gave me the idea of finding other documents in government and church archives. Our team divided up the work of searching through thousands of documents in dozens of online archives, looking for any references to the remaining schools. We then flagged any documents containing those references and filed them away to be used on the Blanket.

It was challenging work. The documents in these archives often aren't searchable in any way—you just have to scroll through and hope you catch a mention of a specific residential school.

The documents themselves could be about anything. We came across building inspection reports, memorandums listing school supplies for the coming year, letters from students, and pamphlets outlining school rules. In the case of one school, we found only one mention of it in all of our digging. It was a waybill invoice for coal to heat the school in the winter. That was the only piece of evidence we could track down.

Images from residential school yearbooks.

When the Blanket was almost done, we were still missing pieces from six schools. We knew they had existed, but we couldn't find any physical objects, photos or documents mentioning them. However, it was important to have representation from every single residential school in Canada, because when the buildings that housed those residential schools are torn down or crumble into history, the Witness Blanket will remain as part of the permanent record. In the end, I left a few sections empty to hold space for the stories yet to be told.

Eventually, we got help from the research team at the **National Centre for Truth and Reconciliation**. They were able to find something we could use from each of the six missing schools. But those final pieces came after the Blanket was done. To include them, I decided to create a slideshow of documents and photos. Wherever the Witness Blanket stands, those images, along with all of the other images and documents that didn't fit on the Blanket, are projected on an old wooden school desk, another of the items that I couldn't bring myself to cut apart.

A slide show that runs behind the Blanket projects hundreds of other donated images.

DROWNING IN PAPER

Some of the documents are a single page, but others come from much larger collections, like the group of letters about the drownings in the Moose River in northern Ontario.

On June 29, 1919, twelve young boys from Bishop Horden Hall residential school in Moose Factory, Ontario, climbed into one canoe. They were trying to cross the Moose River to Hazey (now Hayes) Island to go berry picking, a distance of about 500 metres (547 yards). The canoe accidentally flipped over in the river, and seven of the boys drowned. Their names were Alfred Loutitt, Thomas Loutitt, Arthur Sutherland, James Sutherland, Harry Wesley, John Sailors and Sinclair Nepaneshkum.

Chief Woomastoogish of the Moose Band wanted answers as to why and how so many small boys from his community had died. He wrote a letter in his own language, using **Cree syllabics**, to a man named Duncan Campbell Scott, who was the deputy superintendent general at the Department of Indian Affairs. The letter was translated into English and sent to Ottawa.

Chief Woomastoogish wanted to make sure Scott knew a few key things about this tragic accident: that the twelve children were alone in the canoe, without any adult supervision, and that the canoe they were using was in rough shape. He said it wasn't fit for anyone to use, much less a large group of young boys.

"These children were allowed to go crossing the river every day in it and very often twice in one evening," wrote Chief Woomastoogish in his letter. "The canoe which they were using was very bad. The canvas of the canoe was half ripped. The canoe was that far gone that the thwarts were just nailed on top of the gunwale."

Chief Woomastoogish's letter to Duncan Campbell Scott.

One of the letters in the correspondence regarding the drowning at Bishop Horden Hall residential school in Moose Factory, ON.

The canoe should not have been out on the water in that condition, so it's not surprising that it flipped when it was overloaded with twelve boys.

The story of the seven boys drowning was well documented, with letters going back and forth between the school in Moose Factory, the Canadian government in Ottawa and the Royal Canadian Humane Association in Hamilton, Ontario. But what's missing in the correspondence is any recognition of Chief Woomastoogish's letter and the concerns he raised about why those boys were in that canoe on that day in the first place. Instead, government official A.J. MacKenzie wrote to the principal of the school that the deaths of the boys were regrettable. He agreed that that many kids shouldn't have been in one canoe but concluded that the school staff weren't to blame for the accident.

"It is hoped that this accident will not result detrimentally to the future recruiting of pupils for the school," MacKenzie wrote.

The documents also refer to the actions of a fourteen-year-old boy named John Carpenter from the Fort Hope Indian Band. He saved the life of an eight-year-old boy by holding him above the water until help arrived. The Royal Canadian Humane Association awarded Carpenter a medal for his bravery.

"It is considered that recognition by your society of the bravery of John Carpenter would be an incentive to the Indians of that northern country," wrote MacKenzie. "And a reminder that such acts do not go unnoticed or unrewarded."

This series of letters was contributed by the Shingwauk Residential Schools Centre at Algoma University in Sault Ste. Marie, Ontario. They are kept in the archives there. As I read through them, I was struck by the difference between how Chief Woomastoogish saw the tragedy and how the officials in Ottawa handled it. The point of the chief's letter was that the canoe wasn't safe.

He felt that it was up to the adults to know that, and that because they allowed regular, unsupervised use of an unsafe canoe, seven boys in their care drowned on that summer day.

I often think about Chief Woomastoogish's letter to Duncan Campbell Scott at the Department of Indian Affairs. What was he thinking as he wrote it? How was his community coping with the deaths of not one but seven young boys?

"There was not one boy big enough to have any sense," Chief Woomastoogish wrote in his letter. "I don't know if this report was sent in yet or not, but this which I say is exactly what happened, and this is the weight which I am carrying."

I was struck by the difference between how Chief Woomastoogish saw the tragedy and how the officials in Ottawa handled it.

John Carpenter was every bit the hero described in the correspondence, and valour like his deserves recognition. But instead of stopping at a letter of commendation and a medal for bravery, perhaps the government officials in Ottawa should have implemented a safety plan or held the staff at Bishop Horden accountable. At the very least they could have provided a safe canoe.

MISSING HOME

That was just one set of letters out of more than 102 documents that we included on the Witness Blanket. There are hundreds more in the slideshow. There's a letter from a girl called Sue, written to her parents, that stands out in my mind. She sent it from the Kamloops residential school in British Columbia. In the letter, Sue tells her family about the Yale-Cariboo Musical Festival and how her dance group brought back two shields, three cups and a pin from the competition.

But she also talks about missing home. "I surely wish that I could have gone home but I guess the Lord wants me to stay here," Sue wrote. "After Easter we will look forward to May 30. I hope you people will come up here then."

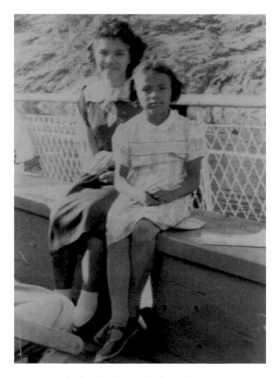

Susan and Elizabeth Mitchell on the Union Steamship Company boat, going back to residential school.

Dear Mr and Mrs Champion,

Thanks for letting me stay at your house for the Christmas Holidays. I also thank you for the thing that I got for Christmas. also thank you for letting me go sleigh riding and toboggon riding with the Auberts. The boys did not believe me that I had a real watch.

May God bless you and keep you in His Year

Your Friend
Ambrose Edmond

Ambrose Edmonds wrote this thank-you letter from his residential school in Mission, BC, in 1965.

There's an exchange of letters dated January 1971 about a fourteen-year-old boy called Robert Alexie, who went to residential school at Stringer Hall in Inuvik, Northwest Territories. A nurse named Miss B. Hulsmans wrote a letter to the school on behalf of Robert's parents.

"I have been talking with Robert's parents and they are concerned about Robert," she wrote. "They state that Robert's grades and sports activities have fallen down this year from last."

The nurse said the parents were also worried about his vision and she asked the school to look into it. She continued, "I realize it might just be his age but if you enlighten me as to how he is doing, I could pass it on to the parents."

A few days later she got a response from Leonard P. Holman, an administrator at Stringer Hall who wrote that Robert was on a list to get his eyes checked. He went on to say that since the start of school in September, Robert had grown one inch and gained six pounds and was playing basketball, volleyball and floor hockey, as well as doing track and field and dancing.

"As far as school work goes, other than science, he has a 68% average in the other 8 subjects," Holman wrote in his letter. "For some reason or other a number of students from the settlements seem to stumble and fall flat on their faces in their first encounter with Grade 9 science."

There is another letter that was sent from a student to his headmaster. In it the boy expresses his gratitude to the headmaster for bringing him home for Christmas and giving him a wristwatch. Another letter is signed by several female students and exposes the abuse they were suffering. On the recommendation of the headmaster, one of the girls was moved to another school.

Also included on the Blanket is a report from 1947 that talked about the food served at Chapleau residential school in Ontario and compared it with the Canada Food Rules from that time. The report concluded that "the servings fall very short in respect to eggs, cheese, liver, citrus fruit or tomatoes, the use of whole wheat or Canada Approved bread, butter and iodized salt." It also mentioned that fresh fruit was sometimes sold to the children at cost through the school. I was not surprised by that report, because residential school Survivors often talk about poor nutrition and being hungry.

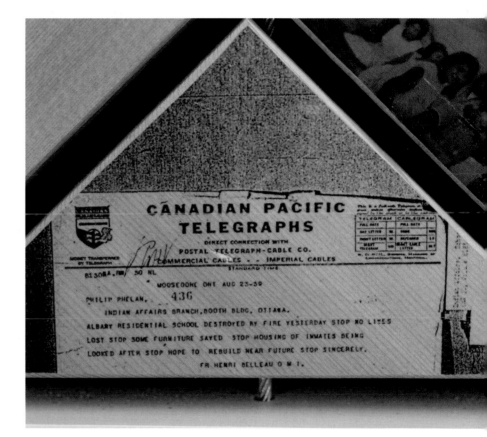

There is also an old telegram on the Blanket. Sent by Father Henri Belleau in northern Ontario at 11:44 PM on August 23, 1939, it was addressed to Philip Phelan at the Indian Affairs Branch in Ottawa. It reads: "Albany Residential School destroyed by fire yesterday STOP No lives lost STOP Some furniture saved STOP Housing of inmates being looked after STOP Hope to rebuild near future STOP."

What sticks with me from this telegram is the word *inmates.* It says so much about the way children were thought of at residential school: instead of being students or pupils, they were prisoners.

The other documents that stay with me are the letters from parents requesting that their children come home from residential school. There's a letter written to government officials in Ottawa that asked why the kids at Round Lake residential school in Stockholm, Saskatchewan, couldn't come home for Christmas. We never learn the answer.

In 1939 a telegram was the fastest way to send news.

Keots
Planters

Russell. T. Ferrier,
Supt. of Indian Education,
Ottawa.

R

Dear Sir,

We are in receipt of a letter from the Indian Agent
referring to the Christmas holidays being denied our children
attending school. We just wonder why has the Department taken
such a move. We, poor Indians, think it is a crime to deprive us
and our children of such joy and consolation. As we all know
Christmas Day and New Year's day are above all home festivals,
days of unity and charity in our christian families. It is cust-
omery for all institutions such as Universities, Colleges, Academies
and convents to grant holidays to their students at this season.
Why should the Indians be denied the same privilege and happiness?
Moreover, we understand that all such institutions as named above
are not denied with the goverment grant during the Christmas
holidays, why should our Residential School be deprived of the same
favour?

It is not our intention to challenge the Department upon
the enactment of such regulations, but we feel sorry not to be
treated at par with the white people in this connection.
We feel molested in our rights over our children and trust that
our appeal will not go unanswered. May it please the Indian Dep-
artment to adjust this matter for the good of all.

Signed:

Chief Tom Desjarlais

H.M. Sam Alann

S.M.

Station on the tin side

Kindly reply to head man

Sam Fred Abraham

A letter written in 1944 by Chief Councillor Cornelius Bignell from The Pas Indian Band on behalf of the parents in his community complained about conditions at Elkhorn residential school in Manitoba.

"We wish to have our children brought back from the above-mentioned school and to attend the day schools in our reserve," he wrote. "We would rather see...our children attend them than to have them so far away and being poorly treated."

I think that is what connects me to these letters. I am a father and I walk my daughter to school almost every day. Those walks are some of my favourite times together, and I can't imagine if she were taken far away and treated poorly.

The parents in The Pas Indian Band asked Chief Councillor Cornelius Bignell to help bring their children to the day school on their reserve.

Opposite: *Parents of children at the Round Lake residential school request that their children be allowed to come home for Christmas.*

CHAPTER TEN PLASTIC DOLLS

IT WAS IMPORTANT FOR the experience of the children and grandchildren of residential school Survivors to be part of the Witness Blanket. Like me, they didn't go to residential school, but they still live with its consequences. That is why we are called Intergenerational Survivors.

Two plastic dolls from the 1950s are mounted on the Blanket. The bigger doll has blond hair and a blue skirt and she's putting on lipstick. The smaller doll is dressed up as a nurse and she's holding a tiny baby in her arms. Both dolls have their heads tilted down in the same direction.

HONOURING MY COUSIN

My cousin, Phyllis Olney, contributed them to the Witness Blanket. She is an Intergenerational Survivor. When she sent me the dolls, she included a short note, explaining that she got the dolls when she was ten years old, on returning to Alert Bay, British Columbia, for the first time since she was born there in 1959.

"My mother told me that they had been mine," she wrote. "They would have been given to me before I was two years old."

The two dolls that Carey's cousin Phyllis donated to the Blanket.

Phyllis has been told that her mother left Bella Bella, on British Columbia's central coast, to go to St. Michael's residential school on Cormorant Island when she was a young girl.

"She claims the experience was okay," Phyllis wrote, "because her biological father lived in Alert Bay with his new family."

When Phyllis's mother left residential school, she married a much older man. Together they had four children, three boys and a girl. Phyllis's mother left them when they were all quite young.

"I have kept the dolls all these years," Phyllis wrote. "I have always felt that they were cold, hard and very impersonal. Not the kind of dolls that a little girl would want to have with her to cuddle and be comforted by. Which about sums up my relationship with my mother."

The dolls didn't bring back happy memories of my cousin's childhood, but they were one of the only things her mother ever gave her. I struggled with how to include them on the Witness Blanket. When I first held them in my hands, I couldn't see how they would fit with all the other objects we had collected. But I had made a promise that I would include something from every residential school that had existed in Canada and from every person who contributed an item to the Blanket. My cousin had given me these two dolls, and I knew it

was important to her that they be on the blanket. I had to find a way to honour that, so I had to use one or the other or both dolls.

As an artist, I also had to think about how all the pieces on the Witness Blanket fit together. I thought maybe there was a way to tie the dolls to another object. I started going through all the books we had been given. That's when I came across a children's book called *Stranger at Home*, by Christy Jordan-Fenton and Margaret Pokiak-Fenton. It's based on a true story from Aklavik (Immaculate Conception) residential school in Aklavik, Northwest Territories. It tells the story of a girl coming home from residential school and not fitting in anymore. She speaks a different language and dresses in strange clothes. Her mom doesn't recognize her and says, "Not my girl."

The sequel to the powerful memoir *Fatty Legs*

a stranger at home
A True Story

Christy JORDAN-FENTON &
Margaret POKIAK-FENTON

Artwork by Liz Amini-Holmes

The cover of the book that sits behind the dolls on the Blanket.

The book and Phyllis's story were connected for me. It was the same for so many kids who went away to residential school: all they thought about was when they could go home again. But what happened when, like the girl in the story, they got home only to learn that they didn't fit in anymore? And what happened when a parent could no longer recognize or connect with their own child?

Stories like Phyllis's and *Stranger at Home* say so much about how residential schools hurt Indigenous families. What does that loss of family and community turn into? In these cases, and many others, it turned into generations of parents who didn't know how to love their children because they themselves didn't feel loved. When I realized this, I knew I needed to match *Stranger at Home* with my cousin's dolls. Their stories fit together.

I think about Phyllis's mother, my father's sister, coming back home to Bella Bella after being at St. Michael's and feeling out of place in her own community, in her own family and with her own mother.

That experience turned her into the kind of mother that Phyllis described as "very impersonal." I loved my auntie so much—she was one of my favourite aunts.

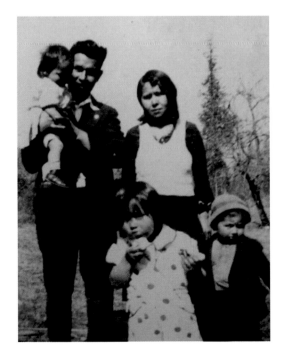

Carey's grandparents with (left to right) Carey's uncle Chuck, aunt Myrtle and aunt Georgina.

She always gave me money and had treats for me whenever I visited her. She knew how to love me, but I wasn't her child.

Because of those memories, I was conflicted about showing my favourite auntie as a cold, hard mother. But I knew that my cousin's experience was real. I had to put aside my own feelings and honour Phyllis.

When the Witness Blanket was on tour, I took it to the Canadian Museum for Human Rights in Winnipeg, Manitoba. While it was being installed, an Elder there shared a story with me. She said when she learned that she was going to have a baby of her own, she was afraid she wouldn't know how to love her child because she couldn't remember getting love from her own mother. She and her mother were both residential school Survivors.

When this woman was pregnant, she would look in the mirror and practise saying "I love you" over and over again. Imagine having to practise something like that. The love between a parent and a child is something we like to think comes naturally.

> **The dolls and the book speak to my own experience as an Intergenerational Survivor, maybe more than any other objects on the Blanket.**

The woman said all of her practising in front of the mirror worked. Now she has grandchildren, and when they see her they say, "I love you." Those words seem so simple, but they are hard to say if no one has ever said them to you before.

That's what the two plastic dolls and the book *Stranger at Home* represent. They show how the residential school experience flows from one generation to the next. They show the experience of Survivors who became parents and the intergenerational effect that had on their children—both sides of the same situation. You'll notice that one of the dolls on the Blanket is wearing traditional regalia. Knowing that the dolls hold difficult memories for my cousin, I asked my mom to make the doll a **button blanket** and a headband. As an artist, doing that helped me make sense of the story I wanted those objects to tell—a story of love, culture and family disrupted by the legacy of the residential school experience.

It was easy to put bricks or rusty pieces of metal together on the Blanket, but when I had pieces, like the dolls, that didn't seem to easily fit with everything else, it was a lot harder. That small panel ended up being one of the last parts of the Witness Blanket that I put together. I am particularly proud of that part of the Blanket and of having figured out how to make it work. The dolls and the book speak to my own experience as an Intergenerational Survivor, maybe more than any other objects on the Blanket.

Victor and Edith Newman with their children Marion, Carey and Ellen.

IN SPITE OF THE ODDS

Lance Scout is also an Intergenerational Survivor. He's from the Blood Reserve in southern Alberta. That community had two residential schools: St. Paul's and St. Mary's. One was Anglican and one was Catholic. Together, the two schools were open on the reserve for more than 100 years.

Lance contributed dozens and dozens of archival photographs to the Witness Blanket. When we travelled to his community to meet him, he showed us a monument that had just been erected on the reserve. It's a tribute to all the residential school Survivors from the Blood Tribe. It is made up of three panels facing east toward where the community's tipis and lodges once stood.

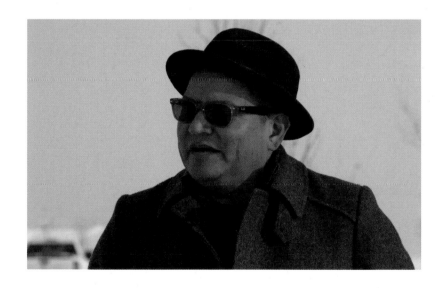

Lance Scout at the Blood Reserve monument.

On the front of the monument there's a message written in the Blackfoot language by Elder Charlie Crow Chief. The English translation reads, "In spite of the odds against it, we have survived. It is surprising that we have survived the hardships that we have encountered. We have survived to this point in our lives. We can declare our survival. And we will tell the story of our journey to this survival."

The monument on the Blood Reserve in Alberta.

A poem by Diane Bird called "Healing the Hurts" is inscribed on the back of the monument. It contains memories, both good and bad, of Diane's time at residential school.

The two side panels—the wings on the monument—are inscribed with the family names of people who went to St. Mary's and St. Paul's, names like Big Smoke, Wolf Child and Little Bear.

"For me, it's emotional," Lance said. "It says a lot of the experience."

It is a reminder that residential school Survivors are still living among us today. But maybe more importantly, building the monument on the Blood

> IN SPITE OF THE ODDS AGAINST IT,
> WE HAVE SURVIVED.
> IT IS SURPRISING THAT WE HAVE SURVIVED
> THE HARDSHIPS WE HAVE ENCOUNTERED.
> WE HAVE SURVIVED TO THIS POINT IN OUR LIVES
> WE CAN DECLARE OUR SURVIVAL
> AND WE WILL TELL THE STORY OF OUR
> JOURNEY TO THIS SURVIVAL.

A detail from the monument.

Reserve helped Lance understand what his own parents went through as children who were sent to residential school.

"[I understood] what had been taken from them," Lance said.

As an Intergenerational Survivor of residential schools, I think I understand what Lance is saying.

If you consider all the kids who went to residential schools across Canada in a period lasting for more than 100 years, it's easy to see why that experience continues to ripple outward and be felt generations later by their children, their grandchildren and thousands upon thousands of Indigenous people who didn't ever go to residential school.

HEALING THE HURTS
by Diane Bird

Where I learned:
 To be tough
 To stand up for myself
 To cry silently (where no one can see)
 To eat burnt, lump porridge
 To join track and field training
 Just to have bacon and eggs
 To be to work in the kitchen
 So I could steal food
 We couldn't have
 To want to be loved so desperately
 To be called names
 Such as horrible peacemaker

Never seeing my one love in life.
My dad!

And yet...
 I had a bed, food and clothing
 I had good friends
 I learned the 3 Rs
 I learned responsibility
 I learned not all teachers are bad
 I chose to stay at the school
 For one and a half years
 On summer and special holidays
 Because...
My home life was rotten

Today
 I reflect on past days
 My higher power intervened
 To save me for today
 To teach my ways to others
 That anything is possible

APPLICATION FOR ADMISSION

To the
Director of Indian Affairs,
Ottawa, Canada

Jan. 5 196

Sir,—

I hereby make application for admission of the undermentioned child in
the Blue Quills Residential School; to rema
therein under the guardianship of the Principal for such term as the Minister of Citizens
and Immigration may deem proper:

Indian name of child **Eric Large**

English name

Age **7 - (19- 11- 45)**

Name of Band **Saddle Lake**

No. of ticket under which child's annuity is paid **# 263**

Father's full name and No. **Joe Large**

Mother's full name and No. **Maggie Stanley (deceased)**

Parents living or dead **only the father**

State of child's health **Good**

Religion **R.C.**

Does applicant speak English? **No**

Previously attended **No**

Joe Large
(Signature of father)

NOTE—If mother or guardian signs, a
must forward full explanatory note.

I recommend the admission of the above
who is of good moral character and is eligible
admitted as a grant-earning pupil.

I hereby certify that the above application for
admission has been read over and interpreted to
the parent or guardian and that the contents were
...him or her and that I witnessed his

RECLAIMING THE SPACE

THE LAST RESIDENTIAL SCHOOL IN CANADA closed in 1998. Since then, some of those buildings have been knocked down, and some are empty and abandoned, while others have been reinvented as something completely new.

The Blue Quills residential school was located 200 kilometres (124 miles) northeast of Edmonton, Alberta. It opened in St. Paul in 1931. On the Witness Blanket, there is an application to that school for a boy named Eric Large. It's dated January 5, 1953. Eric is listed as being from the Saddle Lake Band. He was born on November 19, 1945, so he was seven at the time of his application. His father was Joe Large and his mother was Maggie Stanley. She's listed as deceased. It says the state of his health is good, he's a Roman Catholic and he doesn't speak English. That's all the information we have about Eric. He was a student at Blue Quills from 1953 to 1965.

St. Eugene Mission residential school in Cranbrook, BC, in 1926.

The residential school eventually shut down in 1970, but the Blue Quills buildings stayed open. Indigenous leaders in the area fought to take the education of their people into their own hands. And that's exactly what happened. Blue Quills became a college, and then in 2015 it became University Blue Quills. Today, 300 students from across western Canada go to school there to take programs focused on Indigenous culture.

On the Witness Blanket there are broken shards of stained glass from the St. Eugene Mission church in Cranbrook, British Columbia. There was a residential school there from 1912 to 1970. The minister and headmaster used the profits from a valuable mineral deposit on the land to have an expensive window made in Italy and transported to the Kootenays to be used in the school church. The pieces on the Blanket are from when the window was damaged in the early 1900s.

The St. Eugene Golf Resort and Casino has repurposed the old residential school building and site.

Now the residential school is the St. Eugene Golf Resort and Casino, a hotel with 125 rooms that employs around 250 people from the area. There are five First Nations with 1,500 members that share the land around the resort. They held a referendum and voted to restore the mission and turn it into a resort.

Band members were part of the crew that helped renovate the buildings. The St. Eugene Golf Resort and Casino officially opened in 2000, thirty years after the residential school closed.

The Mohawk Institute residential school in Brantford, Ontario, was open from 1834 to 1970, one of the longest-running residential schools in the country. On the Witness Blanket is a black-and-white photo of five boys at the school. They are all wearing overalls and posing on a wide lawn. The smaller boys are holding gardening tools: a rake, a push mower and a hoe. The biggest boy is standing in front of two flower pots.

In many residential schools boys worked outside, gardening and maintaining the grounds.

When that school closed, a non-profit organization took over the building. In 2013 a leak in the roof caused significant damage. That's when the Six Nations of the Grand River had to vote on what to do with the site. Almost everyone voted in favour of saving it. They started a "Save the Evidence" campaign, with the goal of restoring the building and raising awareness about the history of residential schools in Canada. Today it's called the Woodland Cultural Centre and it preserves and promotes the Indigenous culture and history of the area.

GROWING HOPE

Lucy Kuptana pointed out a couple of pansies as she walked through the Inuvik Community Greenhouse, a big space filled with rows and rows of raised beds, each box assigned to a different person. It was October and the pansies were the only flowers still in bloom; weeds were pushing through most of the other boxes in the greenhouse.

Lucy loves to show off the greenhouse. "This is one of the best places in this town," she said when we visited her.

"I think this is the best way to repurpose the space. It's so positive. Walking in here in August when everything is lush and in bloom and the smells hit you of all the flowers and vegetables, it's such a nice feeling."

SURVIVOR LUCY KUPTANA

Inuvik is in the Northwest Territories. It's located 200 kilometres (124 miles) north of the Arctic Circle. It's not the kind of place where you'd expect to find a community greenhouse. But that year alone, Lucy had grown and harvested bags of carrots, parsnips and onions. She also grew nice Roma tomatoes. And she even sent some cabbages to her family farther north, in Tuktoyaktuk. In the Arctic, fresh vegetables are rare and expensive. Because of this, some of the people who garden in the Inuvik greenhouse sell their produce at the weekly Arctic Market.

The greenhouse was originally an arena that was part of a residential school in Inuvik. That's right, a greenhouse that used to be a hockey arena. Inside the greenhouse, if you look up, you can still see the viewing area where people used to sit and watch games.

The schools had two residences, Stringer Hall and Grollier Hall. Stringer Hall closed in the 1970s, but Grollier Hall and the arena stayed open until 1996. When the school finally closed its doors in June of that year, people in the community had to decide what to do with the building. As in many other communities that had residential schools, there were people who wanted to tear it down. But there were others who wanted to keep the buildings so the residential school experience would never be forgotten. In the end, the residence was torn down, but the arena stayed. The Inuvik Community Garden Society was behind the idea of keeping the space and converting it into a greenhouse that everyone could use. In 2018, the greenhouse celebrated twenty years in operation.

"I think this is the best way to repurpose the space," Lucy said. "It's so positive. Walking in here in August when everything is lush and in bloom and the smells hit you of all the flowers and vegetables, it's such a nice feeling."

This is a very different feeling from the one Lucy had when she went to school there. She grew up in Aklavik, a town across the Mackenzie River from Inuvik. She went to Grollier Hall in 1974, when she was six years old, and lived in the junior girls dormitory for eight years.

Lucy's father, Tommy, was a trapper and hunter in the Mackenzie Delta. They lived off what he gathered from the land.

Grollier Hall in Inuvik, NWT. The arena was converted into a greenhouse in 1998.

"It was whatever furs he was able to sell, whatever fish he was able to catch, whatever meat he was able to hunt," Lucy said.

He wanted his family to be raised in the bush and to have a traditional lifestyle, but he also knew they needed an education. In the end, when the authorities came to their house and said all the kids had to go to residential school in Inuvik, Lucy's dad didn't have a choice.

"I couldn't imagine it, our poor parents, what they went through," Lucy said.

They told her dad he had one of two options. He could send all his children to Grollier Hall, where they would be together, or they would be split up and put into separate foster homes. Lucy remembers asking her sister why her dad didn't fight to keep them at home. Her sister said, "Lucy, this was the choice he was given. He kept us together and that was the most important thing."

> **The kids worked hard. The days were structured around school and chores. The students even had to maintain the arena, grooming the ice.**

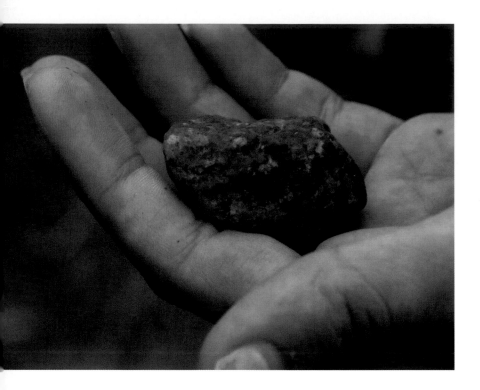

Even small things like this stone are honoured on the Blanket.

Life at Grollier Hall was very different from what Lucy had known in Aklavik. It was tough. She remembers a lot of emotional, psychological and sometimes physical abuse by the supervisors. The kids worked hard. The days were structured around school and chores. The students even had to maintain the arena, grooming the ice.

"We never had spare time," Lucy said. "[It] was probably a good thing because it made the years go past pretty quickly."

Lucy remembers going to church with her parents before she went to residential school. There was a lot of singing, and she was happy there. But all of that has changed.

"When I go to church, I still get flashbacks," she said. "It reminds me of Grollier Hall. I get that overwhelming feeling of sadness because I'm away from my parents."

Back at the greenhouse, Lucy picked up a rock from the floor of what used to be the Grollier Hall arena. She handed it over for the Witness Blanket.

"From one era to another," she said.

◆　◆　◆

The Witness Blanket has something in common with that old hockey arena that was turned into a community greenhouse. Both are evidence of residential schools, and the many terrible things that happened there, but instead of remaining as ugly reminders, they take negative memories and feelings and turn them into something positive.

I think that by transforming buildings in that way, you can reclaim the space. I don't think you can simply take the buildings down and expect the memories of residential school to go away, because after you remove the structure, the emptiness remains.

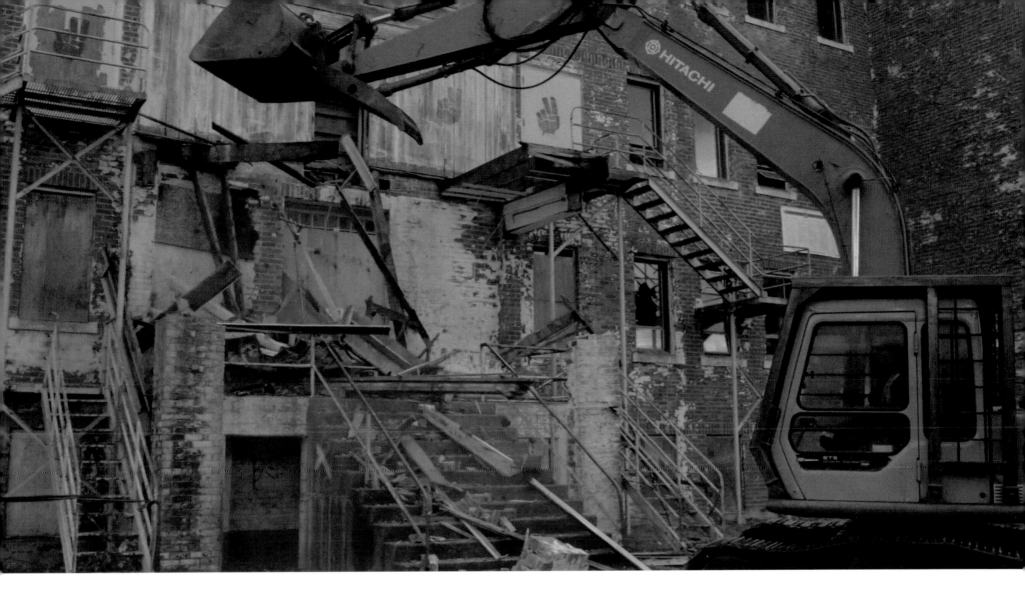

For example, St. Michael's residential school in Alert Bay, British Columbia, was knocked down in 2015. The decision about whether to take it down was controversial. Some people said, "Just get rid of it, we don't want to see it again," but others wanted to transform it into something else, as was done in Inuvik.

When I visit the spot where St. Michael's once stood, I can still feel the building in that empty space. I think the presence will remain there until the community is able to transform the site into something new, reclaiming it for future generations.

Choosing to demolish St. Michael's residential school in Alert Bay, BC, in 2015 was a controversial decision for the community.

When Josie Hanuse went to see the demolition of St. Michael's residential school, she brought the same suitcase that she had carried into the school in 1967, at the age of five.

The greenhouse in Inuvik is not only evidence of the residential schools, it is also a place of sustenance where community comes together. While for some it is a reminder of how Indigenous people in Canada had their families, culture and language taken away from them during the residential school era, as the years go by it creates new, positive memories.

◆ ◆ ◆

Lucy lives in Inuvik with her husband, two sons and two grandchildren. As a grandmother, she often thinks about what it would be like for her to watch her granddaughter go away to residential school.

"I couldn't imagine that," Lucy said. "To be sent away to live somewhere else, being raised by somebody else."

She realizes now that it must have broken her parents' hearts.

It has taken a long time, but the greenhouse in Inuvik is now a fixture in the community; there are always babies there and kids running around.

"You see a lot of people you know that have grown up in Inuvik gardening and using this space," Lucy said. They even have rubber boots for the people who don't have their own.

Lucy likes to stop by after work.

"If you're having a rough day, you go to the greenhouse and water and weed," she said. "[It will] calm you down and relax you and make you feel more positive."

Lucy Kuptana and Rosy Hartman collect objects for the Blanket in the Inuvik Community Greenhouse.

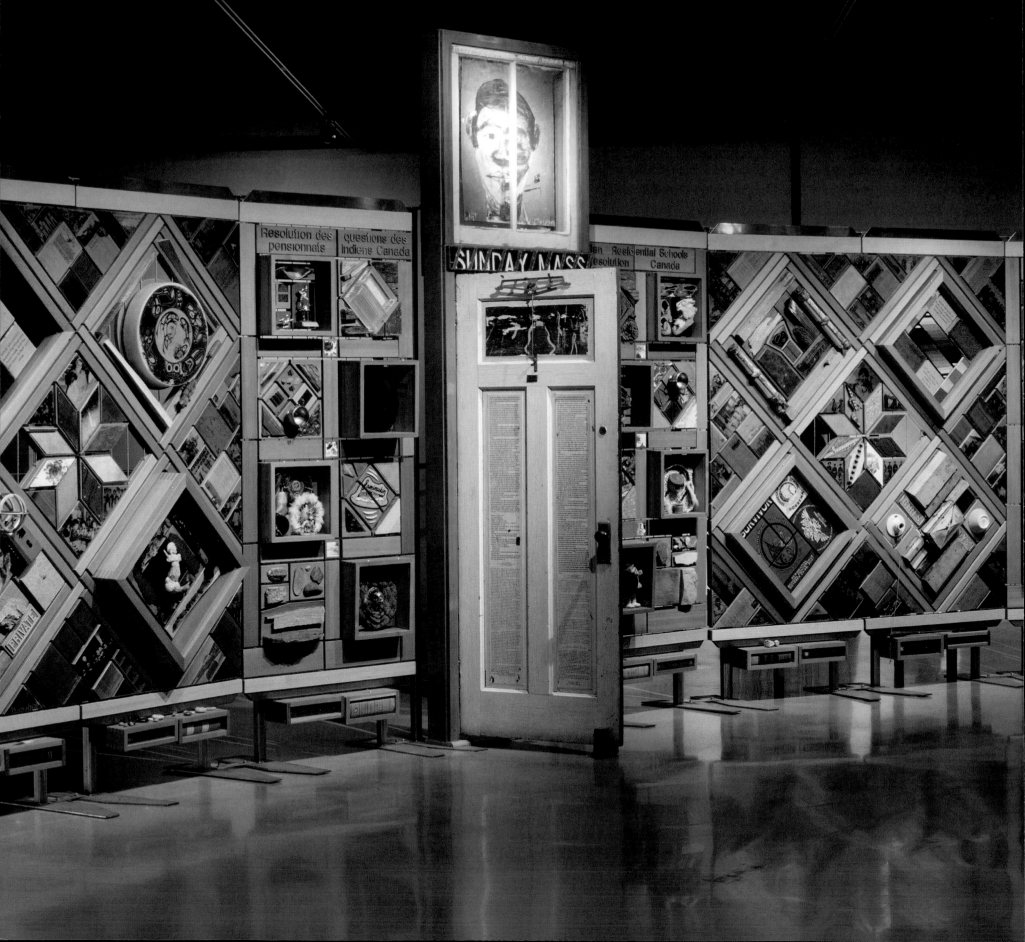

 # BEHIND CLOSED DOORS

THERE'S A WHITE WOODEN DOOR right in the middle of the Witness Blanket. Because of its size, brightness and placement, it's the first thing you see when you stand in front of the Blanket. The door came from the boy's infirmary at St. Michael's residential school in Alert Bay, British Columbia.

Like so many of the objects that came before it, I had the door in my studio for a long time before I finally figured out how I wanted to use it. I like the various textures and colours of the pieces on the Blanket. There are smooth metal objects that are cool to the touch, rough and rusty nails and hinges, soft pieces of fabric and hard stones and brick. Something about being able to touch them with my own hands made residential schools seem more real to me.

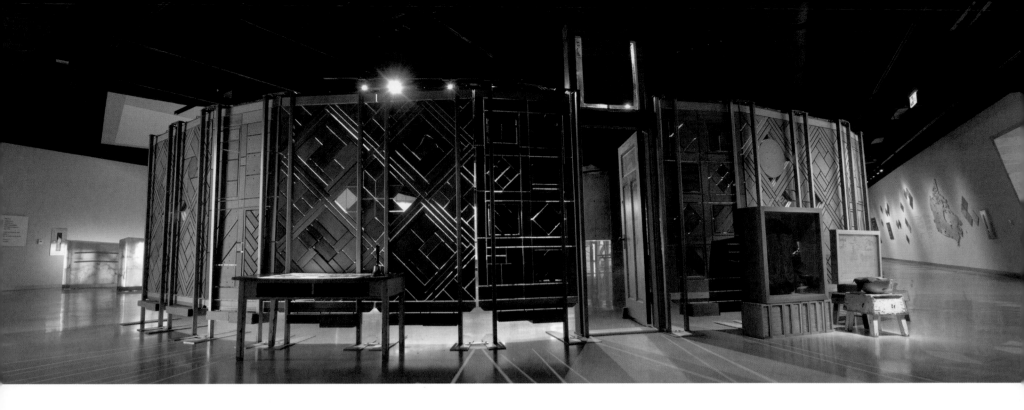

A view of the back of the Blanket at the Canadian Museum for Human Rights in Winnipeg, MB.

That was part of my idea for the Witness Blanket to begin with. I wanted to physically connect people with the experience of residential school, with the things we imagine when we look at the objects. If people couldn't touch all the objects (some are behind glass), then that big wooden door could become the way to create that experience.

I wanted people to be able to put their hands on the doorknob, push open the door and walk through. I wanted them to think about the little kids who turned that same doorknob, pushed open that same door and walked through to the other side. If I put the door right in the middle of the piece, I could get people to do that and see for themselves what was on the other side.

If you peer through the spaces of the Blanket, you can just make out the objects that are displayed behind it. These pieces are part of the Blanket exhibit but are not physically attached to it. There's a bench, a desk and a stool from Sechelt residential school in British Columbia. There's a bed frame with names etched on it from McIntosh residential school in Kenora, Ontario. Denise Mamakeesic contributed it to the Blanket. "I remember the names on here, these were my friends, this was my bed," Denise wrote.

There's also the sweater I mentioned in chapter 5 that was part of the girls' school uniform at Cariboo residential school in Williams Lake, British Columbia. This sweater was a part of the everyday uniform at the mission school, Helen Sandy explained in a note that came with the sweater.

I wanted the space on the other side of the door to be a place where people could stop and think about the objects they were seeing all around them. Hundreds of photos and documents that we couldn't fit on the Blanket are projected one by one on the surface of the desk. It's a little darker and quieter back there. You can move among the objects. To get there, you have to physically pass through the doorway. I think it connects people with the experience.

I also added other pieces to the door. There's a scale that came from the Yale School in North West River, Newfoundland and Labrador. It was donated by one of the school's principals, Barry Flynn. I had in my mind that putting it there, in the middle of the Blanket, represented a sort of balance or measure of the weight of the history and stories. In the top panel of the door, there's a plaque of a painted face. That came from Val-d'Or Native Friendship Centre in Quebec. The eyes are so proud and resilient. I put them there to represent the strength of all the Survivors who bravely shared their experiences.

There are also writings filling up the two long panels in the door, some of them from residential school Survivors. They tell all kinds of stories. The excerpt from *Up Ghost River*, by Edmund Metatawabin, describes his first day at St. Anne's residential school in Fort Albany, Ontario. Edmund talks about leaving his family and walking away from his home for the first time. "Papa took my hand and I looked back and saw our chimney spurting smoke," he wrote. "I realized I wouldn't be there for the final fire before they left for a winter in the bush. It struck me that I wouldn't go with them at all, and I squeezed his hand tighter as we walked to school."

> *I wanted the space on the other side of the door to be a place where people could stop and think about the objects they were seeing all around them.*

The scales before they were mounted on the door.

This painted plaque came from the Val-d'Or Native Friendship Centre in Quebec.

Opposite: *This door is in the middle of the Witness Blanket. Before Carey figured out how to include it on the Blanket, he stored it in his studio and made sure the door was always kept open.*

There's an excerpt from a book by Katherine Palmer Gordon called *We Are Born with the Songs Inside Us: Lives and Stories of First Nations People in British Columbia.* It talks about Indigenous people reclaiming their history and culture, finding the songs that still exist somewhere inside them.

There's also an excerpt from *Speaking Our Truth: Cowichan Stories of Residential Schools,* by Nancy James. She's an Intergenerational Survivor who didn't understand why her parents wouldn't teach her their language. Later in life, she learned that they had been punished for "speaking their tongue" while they were at residential school. They thought that by not teaching Nancy her own language, they were protecting her.

songs from their past histories,
history, community culture, as the residential schools did,
and—as the First Nations of Canada understand all too
well—they will suffer a inevitable and tragic decline in both their
cultural health and overall wellbeing as a whole.
But there is a much happier story here also: that of all of the
First Nations men and women across the country who are
fortunate enough to know their songs. Some learned them at
their parents' feet, or are reconnecting to their roots and
learning their songs as adults. Others, drawing upon what is
inside them and what they know about themselves, are simply
creating their own unique melodies. Imbued with the
essential components of a healthy life... confidence in cultural
identity, language, traditions and related contemporary
practices—children, adults and elders are thriving in every
aspect of their daily lives, whether in education, careers,
family and community life or as arts and the arts. They are
determining their path in life with self-assurance and pride.
That is not despite being stopped in their culture, as
stereotypes would suggest, but because of it. They are
empowered to give expression to the songs in them, the
cultural voices within them with which they were born and which
they have learned to use in many compelling and meaningful
ways, both as First Nations people and in their own individual
and unique manner.

Simple... another truth has profound implications for
Canadian society. First Nations are the fastest-growing
segment of the country's population. That's hugely exciting for
anyone who understands the great potential that statistic holds.
Increasing numbers of young people of Aboriginal heritage in
Canada—proud of their identity and culture, confident in their
abilities and strengths, full of joy and humour and promise—are
emerging at the forefront of business, government, the arts,
social and environmental stewardship, technology and sports.
They are tackling education, community wellbeing and
parenthood head-on and successfully. Many are—or will
be—widely acknowledged and respected and loved for their
achievements, large and small.
Some live on Indian reserves, some don't. Many of them are
learning or relearning their languages. They are moving forward
with pride, courage and strength to do remarkable things. They
are going to school, learning technical skills, studying art and
filmmaking and engineering and medicine and law. They are
playing professional hockey and leading their communities. They
are looking after old people, and working for city hall. They love
to golf, run triathlons, play in bands, do stand-up comedy, hang
out at the park, and watch their favourite television shows with
their kids.
What they all have in common is an unshakeable belief in the
importance of their cultural heritage to their wellbeing, their
success in what they do, and their everyday lives. Their are
are stories of hope and inspiration, not only for other First
Nations people, but for all Canadians.

From: "We Are Born with the Songs Inside Us:
Lives and Stories of First Nations People in British Columbia," by Kathryn v.
Palmer Gordon (Harbour Publishing, 2013)

taking away from...
did not trust no more.
Later that evening the priest and nuns were mumbling some
kind of different language. I did not really know English too well.
They were mumping all these strange kind of things. They
were kneeling down and getting up and kneeling down. This
was my very first day.
I remember all of a sudden I really wanted to go to the
washroom. I needed to have a bowel movement. I already
knew from the afternoon where the bathroom. It was really
strange to me because I was used to an outhouse. But I knew
where to go then.
I was going to get up, and this nun just pushed me right back
down. I started feeling discomfort in my stomach and kind of
squirmed. Every time I was trying to get up and go she pushed
me down, slapped me down. Finally when I could not hold it
anymore, I ended up pooping my pants, I was really
embarrassed. I did not know but I know then but I know now
that it was undignified and what embarrassment and it always
stayed with me.
When they were finally finished saying these strange prayers,
this nun came to me and saw what I did. Oh my goodness, I
ended up peeing myself too. She slapped me and punished me
for that. I was just crying, I remember. She told my brother to
put me in the little boys' room. He brought me to the
washroom, take off my clothes and put me under the shower.
The shower was cold water. I just felt dirty. It was the ultimate,
bad experience of my introduction into the residential school. I
will never forget it.

Excerpt by Harold Whiskeyjack from:
"Nīhtā Nēhiyaw Saddle Lake Residential School Legacy Book"

I want to talk about my own experience growing up as an "inter
generational" survivor. Both of my parents, my late mom and my
late dad had attended Residential School. My dad went to
Coqualeetza Residential School and my mom went to Kuper Island
Residential School. As a child growing up I witnessed a lot of
alcohol and physical abuse and I struggled as a young child. I had a
struggle in my mind as to why this was happening. I guess the
other thing that I struggled with was that I always wanted to know
the language, they both knew the language and they wouldn't teach
me and they wouldn't say why.
It wasn't until I started my own healing journey that I realized way,
because they were punished for speaking their language. Regarding
their culture they were told "they were savages" or "culture is of
the devil." They didn't want me to have anything to do with my
culture as well. But they had no control over that because as a
young person I was always going to the bighouse because I wanted
to learn about it.
So I understood it later on that they were trying to protect me
from their own bad experiences. For being put down for who they
were, being punished for their culture, being punished for speaking
their tongue.

Excerpt by Nancy James from:
"Speaking Our Truth"
Cowichan Stories of Residential School

St. Michael's on the day Carey collected items for the Blanket.

SPIRITS FROM THE PAST

It was dark inside St. Michael's residential school in Alert Bay. I had to use a flashlight to find my way around. The power had been turned off because the building had been condemned. There were sections of the building we couldn't even go into because it was too dangerous. After years of neglect and water damage, the floor could have collapsed underneath us. The walls inside were bubbling with moisture and age. Paint was peeling. Piles of wood and pieces of furniture were stacked in the classrooms. Chairs were overturned in the hallways, and wires from the electrical system were hanging from the ceilings.

On that grey, rainy January day, the school had an eerie feeling, with the wind blowing through the broken windows, rustling and swirling around and through us. It was almost as if there were spirits from the past guiding us through the old building.

There was a big group of us touring the school that day. There were residential school Survivors, other people from the community and our team from the Witness Blanket project. We were there to hear stories from the Survivors and collect objects before St. Michael's was torn down. We collected many things, including the big wooden door from the boys' infirmary, the object that would become the centrepiece of the Blanket.

It was important to travel to Alert Bay that day and gather objects myself. It was one of the few trips I was able to go on, because while the rest of the team had been travelling across the country collecting pieces for the Blanket, I was back at the studio figuring out how they would all fit together.

I went to the places I had a personal connection with: Alert Bay is my home territory. It's where my father was born. He didn't go to St. Michael's, but many of my family members did. My dad went to Sechelt residential school on the Sunshine Coast and St. Mary's residential school in Mission, British Columbia. After travelling to St. Michael's I went to those places as well.

On that day at St. Michael's, Survivors shared stories about their experiences there. One man talked about how, when the building was used for band administration, some people wouldn't come to visit him in his office. Eventually he learned that it was because his desk was set up in the former boys infirmary. He moved his office the next day. He said that over the years, many Survivors have talked about the abuse they suffered inside that room. It was a space inside the school that held a lot of bad memories for people.

Carey inside St. Michael's, taking the infirmary door off its hinges.

I was walking through the building, picking up things from different rooms that either were visually interesting to me or had some connection to a story I had heard. When I walked along the dark hallway past the door to the infirmary, I stopped. I knew this was a significant part of the history of the building. Because the building was coming down, I had been given permission to take anything I wanted, so I decided to take the whole door.

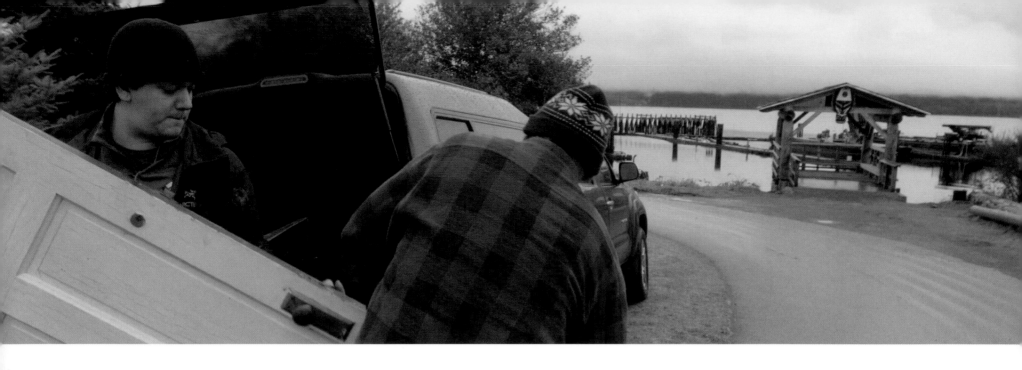

Loading the infirmary door into Carey's truck.

Taking a door off its hinges isn't easy. But standing in front of it in that dark hallway, I knew I wanted to take it back to my studio. I walked out to my truck to get my tools. I went back to the door and carefully pulled the pins from the hinges and wrestled it out of the door frame.

The door was heavy and I had to carry it down three flights of stairs to get it to my truck. Dennis, one of the Survivors who had shared a little bit of his story that day, saw me struggling and offered to help. He picked up one end of the door and helped me carry it outside. It felt significant that he was the one who helped me take it out of St. Michael's.

Together we put the door in the back of my truck and I brought it to my studio in Victoria, where it stood waiting for me to understand its purpose. Eventually I put it in a door frame and placed it at the centre of the Blanket.

Partly because of the abuse that took place in the St. Michael's boys infirmary, but also because of all of the different kinds of tragic and terrible things that happened in residential schools, often behind closed doors, I had this idea that I didn't ever want the door on the Blanket to be closed. Every once in a while, I would walk into the studio and find the door closed. I would always open it. Eventually, I made a doorstop. Now, whenever the Witness Blanket is on display, I make sure the door is always open, so there is nowhere for any secrets to hide.

I knew that seeing that big wooden door from the boys' infirmary at St. Michael's in the middle of the Witness Blanket might be difficult for some Survivors of that residential school. It was a physical reminder of a place that held so many bad memories for so many people, and I didn't want any of them to be emotionally triggered by seeing it. That's why I transformed the door by adding things like the scale and the plaque and the writings. I wanted to make sure that it wouldn't look the same as it had when Survivors had seen it at the school.

FITTING THINGS TOGETHER

George Littlechild is a Cree artist from Alberta. His late mother, her siblings and her parents all went to residential school. Two of George's uncles died at residential school. George is a **Sixties Scoop** Survivor. He donated a charcoal drawing to the Blanket. It's called *The Priest and His Prey*. It's a very powerful and disturbing image of a priest in his collar with a young Indigenous boy lying on a bed in front of him. The only colour in the drawing is the piercing blue of the priest's eyes.

I had to shrink a lot of the paintings and photographs to fit the Blanket, but I didn't want to do that with this drawing. I felt it would lose its power. I decided the best place for it was on the inside of the door, as a symbol of what happened in that infirmary.

George Littlechild lives on Vancouver Island now. Not long after he donated his drawing, I was able to meet him and hear the story behind it.

George sat down with me and said, "Carey, I don't know if I've ever told you the history of this drawing and how it came to be."

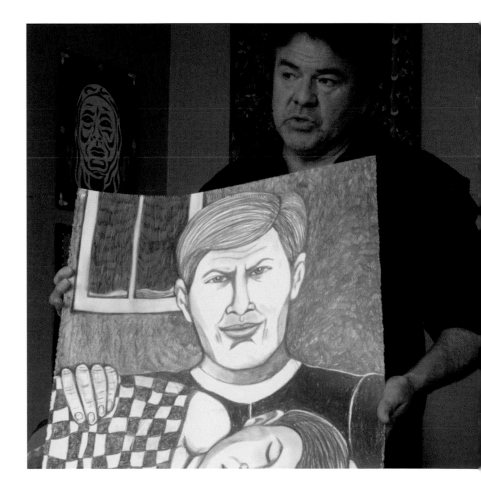

George Littlechild holds his drawing called The Priest and His Prey.

I was stunned by what he told me and where the inspiration for the piece came from.

He said, "Carey, that Survivor is your uncle."

Emotion overwhelmed me, and I sat listening with tears rolling down my cheeks.

My uncle Edwin went to St. Michael's, and at the Truth and Reconciliation Commission hearings he shared a story about the abuse he endured when he was a student there. George Littlechild happened to be there listening, and that story inspired the drawing. Now I was learning that I had placed *The Priest and His Prey*, the work connected to my uncle's story, on the very door behind which some of his abuse happened.

I didn't plan this connection; it came about by fitting things together in a way that made sense in my mind. It is a powerful coincidence and, in a way, it shows how closely so much of this history is connected. For me personally, it makes the door one of the most powerful pieces on the Witness Blanket.

◆ ◆ ◆

On my big art pieces, I always try to find somewhere for my daughter, Adelyn, to make her mark. After the Witness Blanket was finished and installed, I came up with the idea of putting handprints on the door, symbolically holding it open.

If you ever see the Witness Blanket in person and find yourself looking at all the items on the other side, look down at the lower part of the door. You will see two little handprints, in black paint, right at kid height, pushing the door from the inside. They are Adelyn's. When she made them she was about four years old, the same age as many kids who were forced to go to residential school.

Opposite: *George Littlechild's drawing* The Priest and His Prey, *is mounted on the inside of a door in the middle of the Witness Blanket. The work is based on a story about Carey's uncle Edwin, who went to St. Michael's residential school, the school the door came from.*

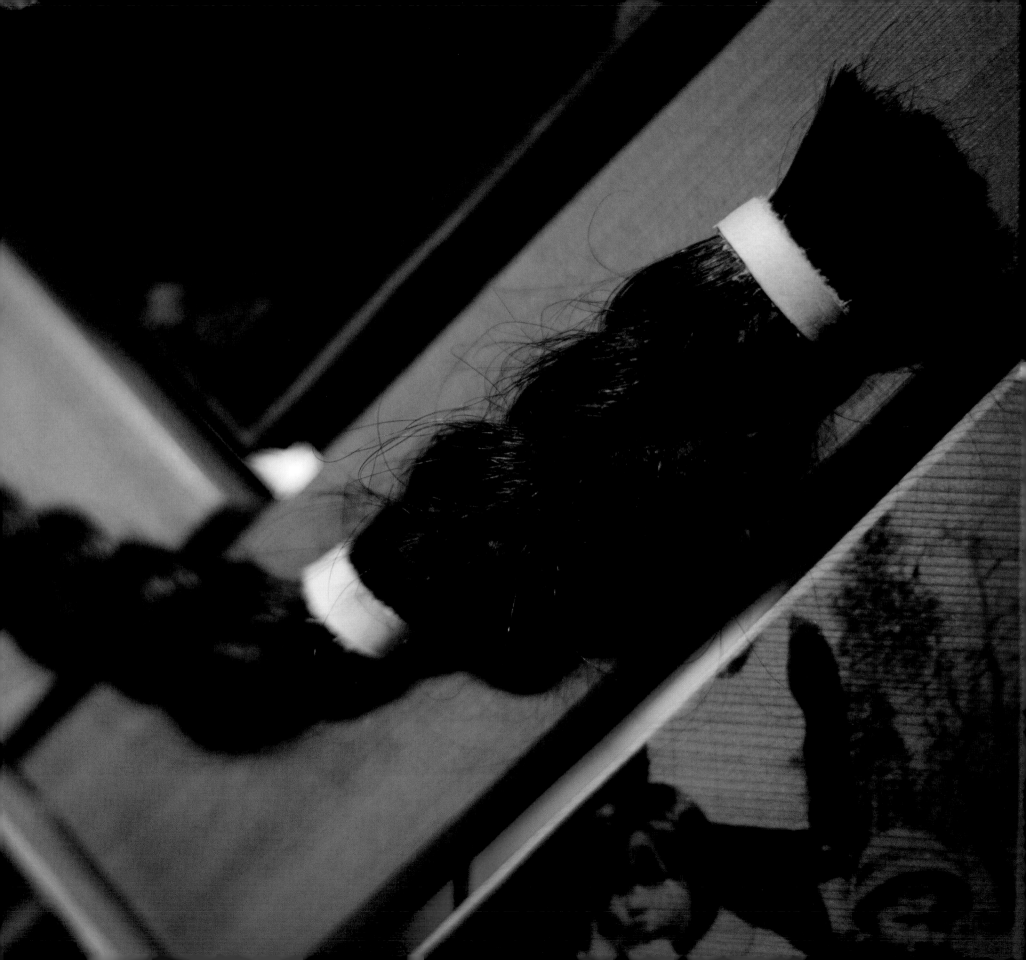

CHAPTER THIRTEEN ◆ IDENTITY

A SHADOW BOX ON THE WITNESS BLANKET contains items connected with my family. There is a feather that belonged to my grandmother, Aggie Victor. She had given it to my father when she was still alive, and he contributed it to the Witness Blanket in her honour. There are several old photographs of my dad and his family from when he was young. The one in the middle of the box is the photo of him and his three siblings from their last Christmas at home.

There is also a leather book cover that was made by a man named Jerome Parnell. He was an amazing artist; he was also the biological father of my younger sister, Ellen, and an Intergenerational Survivor. He was Haida, born in Massett, British Columbia, but when he was young, he taken away from his home and sent to live with a Mormon family in Alberta. That was part of something called the Sixties Scoop, when thousands of Indigenous children were taken from their families and sent away to mostly non-Indigenous foster homes.

Like my older sister, Marion, and me, Ellen is half Indigenous, half settler. Our family adopted her when she was an infant, and even though we come from different parents, we share something more than our childhood memories. We share a common history.

I wrote the following words for a film called *Picking Up the Pieces: The Making of the Witness Blanket,* made from scenes that we recorded during the process of collecting pieces and building the Blanket. Here I describe the motivation behind my sisters' powerful contribution to the Blanket: "A common method of extinguishing cultural identity was to cut the children's hair when they first arrived at residential school. Survivors from across the country, including my father, shared stories of this difficult and traumatic experience. In many Indigenous cultures, hair is identified with strength and is only cut during times of mourning. My sisters, Marion and Ellen, decided to honour our father and other Survivors by cutting their hair and contributing the shorn braids to the Witness Blanket."

> *A common method of extinguishing cultural identity was to cut the children's hair when they first arrived at residential school.*

Making the Witness Blanket was a personal journey for me. I wanted to do something to honour my father. I also wanted to leave something for my daughter and future generations. My sisters wanted to honour our father, so when they found out that the Truth and Reconciliation Commission had approved my project, they agreed to grow their hair as long as possible and, when the time came, cut it and contribute their shorn braids to the Witness Blanket.

Those two braids are in our family shadow box. Looking at them is a little unsettling. They are not the kind of thing that you see every day, at least not in that context. The braids are held in place by three pieces of hide. My sisters have dark brown hair, so the light tan colour of the hide creates a stark contrast. The hair is braided tightly, but because of the ceremony they went through, the braids are slightly frayed. If you look very closely, you can see a residue of red powder; it is a traditional medicine called ochre and it is also from the ceremony.

Ellen's preparation began a year before the actual cutting ceremony. From that moment on she was more aware of her hair than she had ever been before.

"I became more thoughtful of what my hair actually means to me," she said. "Before, my mentality was that 'it was just hair. It will grow back.'"

But by purposefully thinking about it, over time she became more attached to her hair and what it represented.

Marion describes the hair-cutting ceremony like this:

My sister and I bathed in the clear river waters from melting glaciers for four sunrises in a row, while offering our prayers. On the fifth sunrise, sitting next to the fire our father built, facing the ocean and the hills at our family home, we had our braids cut off as we cried our sorrows away.

We cried for our father's loss of his childhood. We cried for our grandparents, our aunts, our uncles and our cousins who were all torn apart by their experiences at residential schools. We cried for the culture and the sense of self and well-being that was removed from all of those beings at such a young age.

Below and p. 136: Shirley Alphonse, an Elder and spiritual woman, and Carey's mother, Edith Newman, begin the hair-cutting ceremony.

We cried in relief that we were brought up in a time and place where we could avoid such persecution. We cried in frustration at having to learn our culture in bits and pieces, rather than having been immersed in our customs since birth, as we should have been.

We cried until our tears ran to happy tears. Happy that we are able to walk free and live as we wish to, surrounded by a loving and healthy family and our beautiful culture that managed to survive a near obliteration.

On the sixth and seventh days we rose to pray at sunrise over our hair, which lay outside on cedar boughs, sprinkled with ochre. On day eight our brother took our hair and wrapped it in red cloth. My sister and I brought the cedar bough our hair had rested on to the river and let it wash away, taking our grief and worries with it.

It was a powerful and emotional moment. I can still picture the smoke swirling around, embracing and connecting us. I remember small details like the crackle and hiss of the fire. But clearest of all, I remember hearing the rasp of the scissors as Shirley Alphonse, the Elder and spiritual woman who performed the ceremony, began to cut the first braid.

"It felt like a part of me, my body, my spirit was being cut and removed," Ellen said, describing that moment. "And I immediately thought of all those children, scared and torn from their families, who had their identities stripped from them."

Cutting their hair was a poignant experience for my sisters, and the sacrifice they made that morning will reverberate through their lives for a long time to come. Although Marion said that she "enjoyed the bob cut for a couple of weeks," after a little while she began to realize that she was missing her long hair.

Victor Newman embraces his daughter Ellen after the ceremony.

Marion throws the ceremonial cedar boughs into the river after the ceremony.

"I missed freeing it from against my neck whenever I put on a jacket or a sweater. I missed having it to hide behind when I wanted to avoid eye contact on public transit or during a moment of embarrassment," she said. "I missed how womanly it felt to let my hair down, curling it around my finger while flirting with my sweetheart."

I think those observations speak to how closely we associate our hair with our identity and self-image. The cutting of hair can even affect femininity and masculinity, comfort and security, strength and creativity. Marion and Ellen made the choice to cut their hair. They did it in ceremony, surrounded and supported by family. What would it feel like to have your hair abruptly taken without your consent? Especially if it happened on your first day at a new school, surrounded by strangers?

As I have said before, our father doesn't often talk about his time at residential school, but when he decided to go and give his statement to the TRC, that was the first story he told. Seventy years had passed since his head was shaved on his first day at Sechelt residential school. All these decades later, his hands still trembled at the memory, and as he spoke those words out loud, he wiped tears from his eyes.

"There is nothing simple about a haircut in my culture," Marion said. "It is a time for letting go of the past and starting fresh again. Mourning what is lost and moving forward. It is a mark of survival and growth through a painful time. I know this now."

When Ellen reflects on the experience, she says she learned "how important ceremony is. How important allowing time and creating space to purposefully heal is. How important it is to tell people's truths, to hear them—really hear them."

She also sees that sometimes we need to "just sit silently with those truths. That until we sit in the spaces which are uncomfortable, until we honour those experiences, we cannot have true **reconciliation**. And that this is a lifelong journey."

That is a piece of wisdom we can all learn from.

What would it feel like to have your hair abruptly taken without your consent? Especially if it happened on your first day at a new school, surrounded by strangers?

Carey holding his sisters' braids.

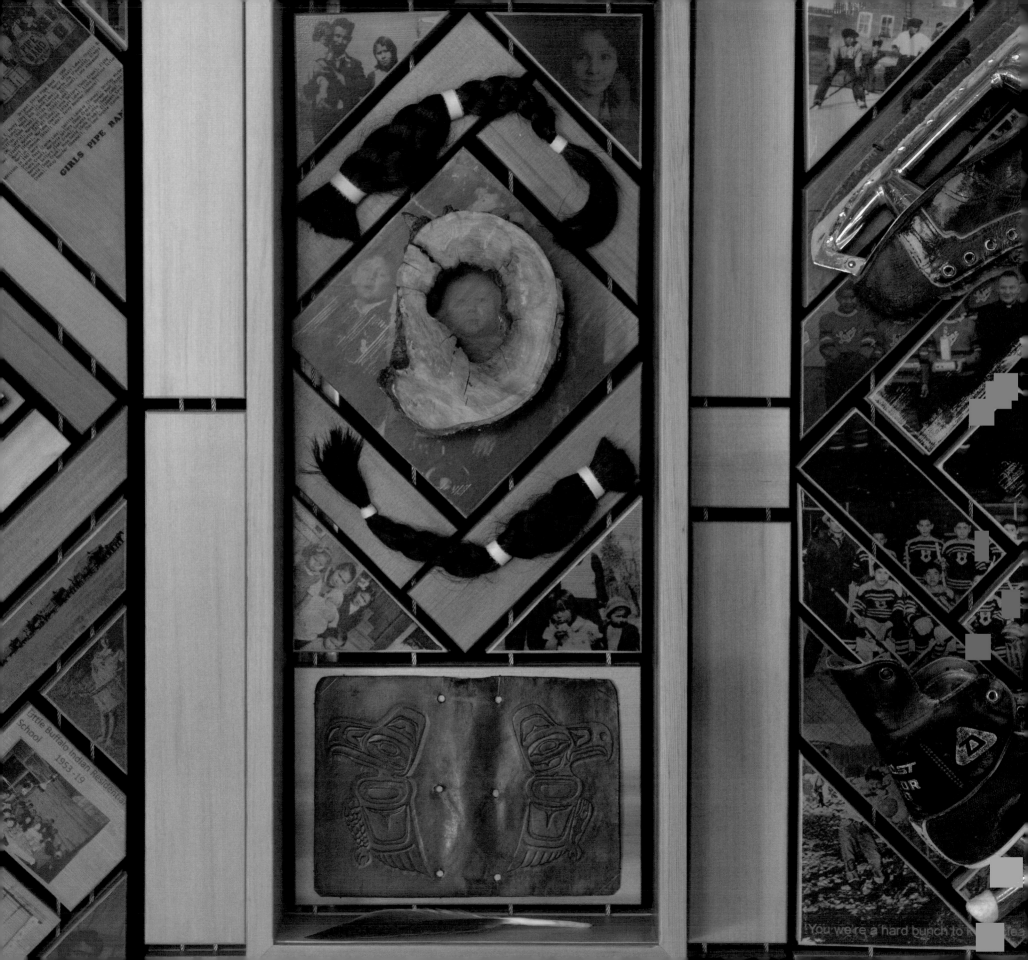

WALKING AMONG MEMORIES

THE IMAGE OF THE WITNESS BLANKET was slowly coming into focus in my mind. It had been a challenging and sometimes emotional journey, and even with all the pieces we had collected, there was one more thing that I felt I needed in order to finish the Blanket. So as the end of the collection process approached, our whole family travelled to Mission, British Columbia.

On the fourth morning of my sisters' preparation for cutting their hair, they bathed at sunrise in a peaceful and icy stream, along the side of the Fraser Valley. I decided to bathe as well, because I needed to prepare myself for the day ahead. After completing our rituals, we made our may to the site of the last residential school our father had attended.

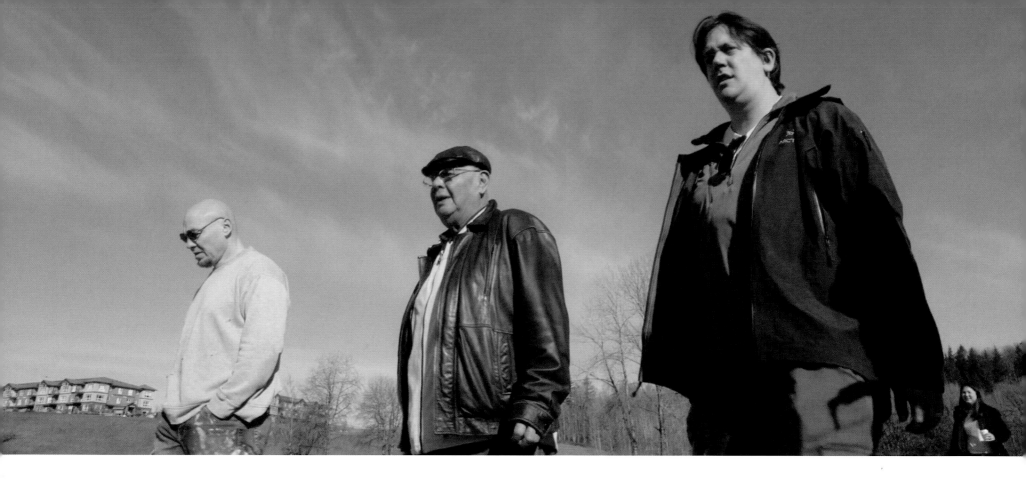

Geoff Waterfall takes Carey and his father, Victor, on a walk through the site of the old St. Mary's residential school in Mission, BC.

When we arrived at St. Mary's, my dad was incredibly grumpy. I think he was a little nervous or even afraid to go back there. In fact, when Geoff Waterfall met us in the parking lot, we were all feeling a little bit nervous. Geoff was the caretaker of the ruins of the school that my dad went to and our tour guide for the day. As we were walking toward the school site, he explained that at one time there was an effort to turn what was now a heritage park on the site of the old St. Mary's school buildings into a condominium development. Dad was upset that they hadn't let that happen. He thought it would be a good way to erase all the memories. I didn't say anything to him at the time, but I kept thinking, "If all of the buildings and spaces are gone, wouldn't part of the truth disappear with them?"

It was a beautiful sunny day. As we walked together, talking, apprehensive, I wondered how it would be for all of us—my sisters and my mother, my wife and me—but particularly for my dad. I approached that day the same way I had approached most of the project: I waited and watched and listened.

As we made our way through the site, I could see my dad mentally measuring the space. He commented on how much smaller the floor of the gym building was than he remembered. He talked about how he and his friends used to jump onto the pigs from the rail of the pen and try to ride them for as long as they could. I was glad to be there with him, watching as he confronted his childhood memories. He picked up little rocks now and then.

We walked through the ruins of his old dormitory, and he pointed out the actual places where some of his stories happened. I felt more connected with my father than ever before. Then we revisited a story that I have heard for as long as I can remember.

The events took place near the end of his time at St. Mary's. He and the other boys learned where the sacramental wine was kept. That was the wine used for religious ceremonies at the school. One day Dad and his friends came up with a plan to steal some.

"I was more of a renegade at the time," my dad said. "A bunch of us, one day, decided that we would go into the wine cellar. They had two great big forty-five-gallon drums in the basement of the priest's quarters. There was a little hole about yay big and a smaller person could crawl in. They have those little taps you put in, and we gathered up all the jugs we could and had him fill them all up and hand them out to us."

Next, the boys rolled the bottles down a nearby hill to hide them for later. At night, they snuck out, retrieved the wine and drank it under an apple tree in the orchard.

"I was there, singing away, underneath the tree, and that's where they found me," Dad said.

It felt different hearing the story there, in the place where it had actually happened, seeing the little hole that led to the cellar. Over the years, that story

> *I approached that day the same way I had approached most of the project: I waited and watched and listened.*

Boys crawled through this hole to take the priest's wine.

had meant different things to me. Standing there with my dad, I could picture the size of the boys and imagine them running by. I could almost hear their footsteps and the echoes of their voices. It seemed more real.

The school my dad went to closed in 1961 and a new school was built nearby. We walked to that site, where a building is still standing and in use. Geoff showed us around, and when we visited the daycare in that building, I could see my dad's mood beginning to shift.

"You know, these kids seem happy," he said. "You see them dancing through [the room]; you never saw that when we were here." I think his mood was changing because everything felt so different from how he remembered his time there.

We visited the dormitories and saw how the beds used to be lined up. We were in a long room and the sleeping areas were separated by a half-wall.

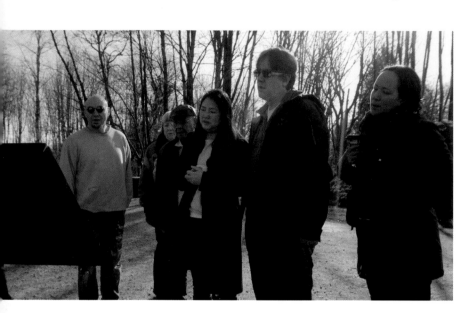

Carey and his family on the grounds at St. Mary's.

"So, what the kids would do, when the teachers weren't around, [was] they'd have races to the other end," explained Geoff. "They'd jump down, jump on the bed, jump to the next bed, up here, jump to the next bed..."

He showed us a stack of old metal bed frames. "That's why all the beds are bent," Geoff said. And then pointing to the linoleum flooring he added, "And that's why there are these indents."

I remember playing a similar game with my sisters when we were kids. We called it "Shark." We would race around the house leaping from one piece of furniture to the next, trying to avoid ever touching the floor. I picked up one of the linoleum tiles to put on the Witness Blanket.

For the final part of his tour, Geoff took us down to the basement to show us a room that the kids used to call "the dark room." It had no windows, and children were put in there as punishment. I went and stood in the room and closed the door. Even as a grown man, I could feel the fear tingling in the back of my neck. It was pitch black in there, completely dark, and I was briefly disoriented.

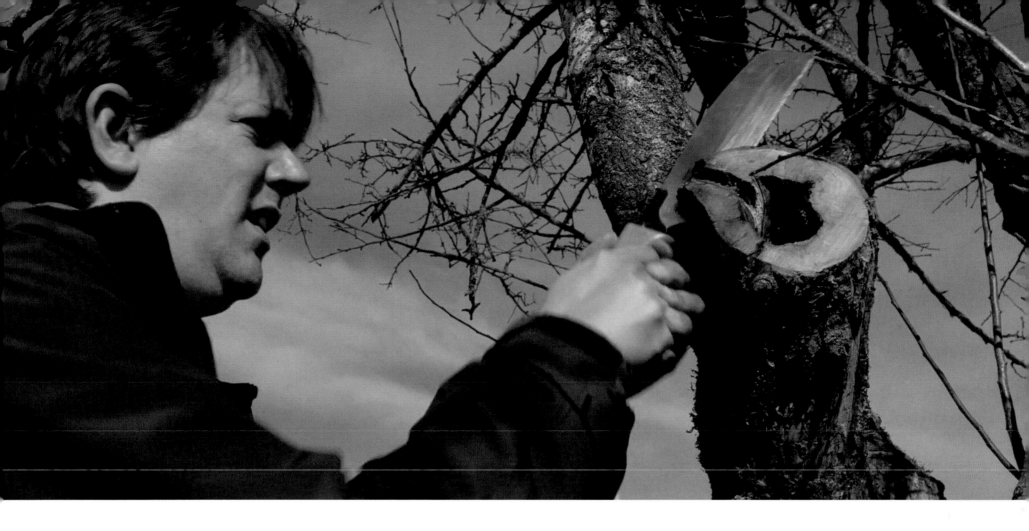

Carey cuts a piece off an apple tree in the orchard at St. Mary's. It became his contribution to the Witness Blanket.

I was relieved when the door was opened and the light led me back to my family.

Before we left that day, we went and found the apple orchard from my father's story. As the rest of my family sat in the sunshine, chatting and looking across the beautiful Fraser Valley, I slowly cut a piece from one of the apple trees with my dad by my side. That was the one thing I needed to do.

My sisters gave their braids. My dad gave a feather from his mother and later some of the stones he gathered that day. Along the way, many other people contributed their pieces and stories, but this was my contribution. You see, almost from the moment I had the idea to make the Witness Blanket, I knew that one day I would be right there, in that orchard, cutting a branch in honour of my father.

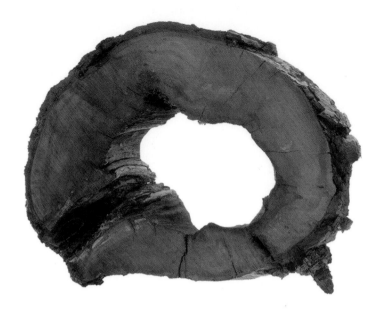

The piece of the apple tree before it was mounted on the Blanket.

Dad's story about drinking the holy wine came to mean something special to me. It is a story about resilience, about not letting the worst things in life define you. What he doesn't often say is that when the priests noticed that the wine was missing, all the boys were lined up and told that if the guilty boy didn't come forward, everyone would suffer. My dad stepped forward.

To this day, when I hear that story, it fills me with a certain kind of pride—the pride reserved for a child looking up to a parent. When I was a boy, I thought of it as a funny tale about a rebellious teenager who was, in a way, standing up to the residential school system itself. But as I grew older I began to appreciate it differently—as a test of character, as a measure of the humanity that my dad held on to in an inhumane place. Now that I am a father myself, I recognize the strength that he passed down to me. I understand why he was sometimes hard on me, especially when he thought I wasn't trying hard enough or when he thought I was being unkind or selfish. I think it was because he had to fight so hard to hang on to those things for himself. For me to become anything less than he hoped for might have meant that all his efforts to protect me—and all of his own suffering—was wasted.

As we got ready to leave, I thought back to that windowless room in the basement. I thought about how darkness keeps things hidden away, but how it can also be disorienting. Even though it might feel easier or safer to keep traumatic memories locked away, eventually they need to come out into the light.

> **Even though it might feel easier or safer to keep traumatic memories locked away, eventually they need to come out into the light.**

For most of his life, my father had locked his childhood away in darkness. But by visiting what remained of St. Mary's, he walked among memories, reclaiming the space. I remember watching him as he stood and looked around the site. The sun was bright, and the air was crisp and cool and honest.

Our family watched as the weight of all those memories he had been carrying for so long began to lift from his shoulders. It was as though the sunshine that day was somehow chasing away the shadows of his past.

By confronting the place where they all began, by standing there and seeing that everything was so much smaller than he remembered, he had made his memories lighter, smaller, easier to carry. By sharing a little bit of the burden with the rest of us, we could all take some of the responsibility for carrying his memories.

Carey's father, Victor, confronts the ghosts of his childhood on the site of St. Mary's residential school.

 # THE TRUTH ABOUT RECONCILIATION

BACK AT THE VERY BEGINNING, when I was sitting in my living room with my feet on that small folding stool, the Witness Blanket was just an idea or a dream. If I were to speak my truth, I'd say that deep inside me, I thought that by making this Blanket I would be stitching together pieces of reconciliation itself.

What I realize now is that back then I didn't yet understand the meaning of reconciliation. The more I learned about the truth of what happened at residential schools, the intergenerational trauma that followed and the historical and ongoing effects of colonialism (the theory that leads to colonization), the better I understood the size and complexity of the issues that reconciliation must address.

I now understand that truth has to come before reconciliation, and that reconciliation is not limited to social repairs, like providing clean water and equal access to health care and education. Those are basic human rights.

The Heart Garden was planted at Rideau Hall in Ottawa, ON, for the closing ceremonies of the Truth and Reconciliation Commission on June 3, 2015.

Lasting reconciliation needs to be about disrupting the colonial systems that created these problems in the first place. It is about respect for this land, and recognizing all humans who live in Canada as equal.

At first that realization left me feeling overwhelmed, as though the problems were too big and too many to overcome. But then I started to think about how much I had learned about myself. That was when I began to understand that reconciliation is a journey rather than an act or a destination. Although I don't necessarily feel less conflicted about the experience of growing up part Indigenous and part settler, knowing the factors that led to that turmoil in the first place is a step toward coming to terms with all the parts of who I am.

Making the Witness Blanket tested me in many ways. The personal, artistic and emotional challenges were far greater than I ever anticipated. I often think that if, at the very start, I had known about everything I would have to accomplish in order to complete the project, I would never have believed it was possible. But with perseverance and with the help of many people, I saw it through. While many things didn't turn out exactly as I had planned, the changes were mostly for the better, and what started out as an idea about making a blanket from bricks and stone and metal turned into much more.

I am no longer the same man as the one who began this project. I watched the weight lift from my father's shoulders as he returned to the site of the last residential school he attended. I saw my family draw closer as we shared his journey.

I am no longer the same man as the one who began this project.

Carey walks with Shelagh Rogers (right) at the closing ceremonies of the Truth and Reconciliation Commission on June 3, 2015.

The Duke and Duchess of Cambridge view the Blanket and meet Carey on their tour of British Columbia and Yukon in 2016.

I watched my daughter grow and I considered her place in all of this. I heard stories that broke me into pieces and stories that put me back together. I laughed, I cried and then I cried some more. I have been enriched by the beauty and generosity of people I met along the way, those who made this Blanket a reality, who created meaning through their stories and spirit, their work and patience. I have been humbled by their trust.

I'm not sure if it comes from the pain and power that are held with truth, the fragments of hope that slowly build, one upon another, or the whispers of my ancestors, but I have begun to realize that we each bear witness by our own experiences. We are responsible for learning from and remembering them.

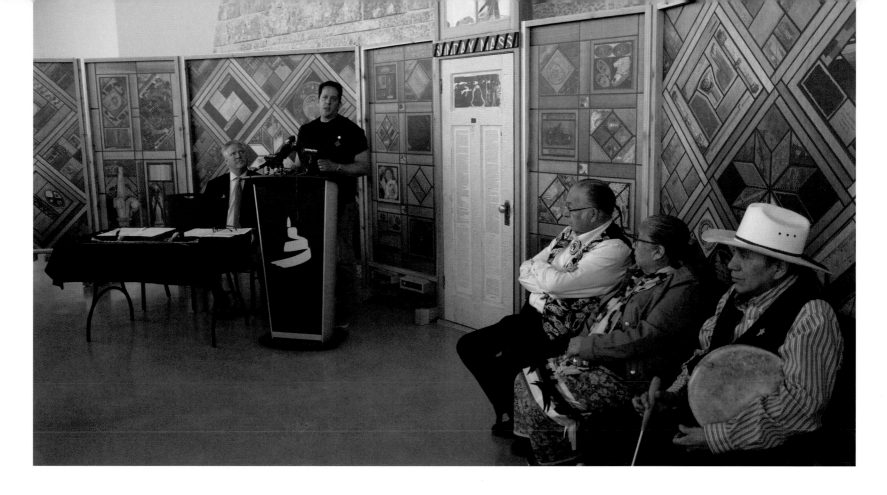

I will always remember, because through all of this I have been changed. And I think that is the truth about reconciliation. We don't change each other. The responsibility is individual. It happens inside each of us, by our own actions and decisions, one human at a time.

The pieces on the Witness Blanket each represent a different story, a different person and a different place. Through the stories of a few Survivors we begin to understand the stories of all Survivors. The idea was that these everyday objects would communicate in a different language, connecting each of us through our own memories and experience. That their presence would recall residential schools themselves, somehow making them more tangible. That the enduring spirit within these bits and parts would form something undeniable, a heartbeat that would gently and resolutely command our attention.

In the traditions of my Salish ancestors, a blanket is gifted to uplift the spirit, protect the vulnerable or honour the strong.

Carey speaks at the Canadian Museum for Human Rights after signing an agreement to place the Witness Blanket under its stewardship.

Thomas Moore went to the Regina Indian industrial school in 1897. These photos, taken before and after he went to the school, were intended to show the "benefits" of residential school.

Students with their teacher on the steps of the Round Lake residential school in Saskatchewan in the 1940s.

I made this Blanket for the Survivors, and for the children who never came home; for the dispossessed, the displaced and the forgotten.

It is for the parents who hold their stories inside, afraid of what confronting them might cause in their hearts, afraid of how the truth might affect their children.

It is for those who are angry, those in pain and those who are working to find their way through; for those who are bitter, and those who remember and those who have spent a lifetime trying to forget.

To forget the braids that were shorn, the heads that were shaved, the dignity that was stolen, and the beatings, abuse and violation.

I made this Blanket so that I will never forget—so that *we will never forget*.

It is for the families who have lost their aunts and uncles and sisters and brothers and mothers and fathers and children.

It is for the ones who left us too soon. We have all lost someone too soon.

I made this for the communities that were broken, their future scooped up and sent away, never to be the same, silence replacing the sound of children's laughter.

It is for the victims of violence and the perpetrators of that same violence, some of whom were never taught a better way. We cannot excuse violent acts, but if we can understand the root of the violence, we can begin to find solutions.

It is for those like me, who didn't realize how deeply we were affected until we tried to speak our traditional languages or sing our traditional songs, who didn't know what we didn't know.

It is for those who found, when they had children of their own, that they had to learn how to show them love. I love my daughter, my only child, but I was

afraid to have a son, for fear that I wouldn't know how to relate to him. That is the way it was for many years between me and my father.

It is for those of us who spent parts of our lives ashamed of our heritage. For those who have yet to learn to respect themselves for who they are and where they are from.

I made this for our cultures, our languages and our traditions, which were legislated away.

It is for the governments and churches who tried to take them.

It is for the resilience that held fast to those traditions, passing them on through generations so that they are now able to flourish again.

I made this for anyone who doesn't know what a residential school is or the truth of what happened there or the policies and laws that created them.

I made this for those who wonder, "When are they going to get over it?"—so that we can have that discussion, in earnest, and begin to change those perceptions.

I made this Blanket for the people who want to learn and for those who feel guilt. For those who walk beside us and those who are, only now, ready to walk beside us.

I made this for the conversations to come, for the lessons we have yet to learn, and the future we are building together.

I made this Blanket for hope. I made it for truth. I made it to catch our tears. I made it for me and I made it for each of you.

It is for our children, our children's children and every generation to come.

It is for my daughter.

But from the very beginning this Blanket was inspired by, and has always been, for my father.

Carey's daughter, Adelyn, in front of the finished Witness Blanket.

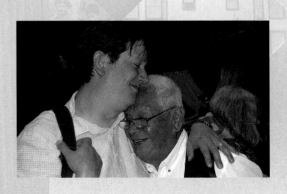

Carey and his father, Victor, after the Blanket was finished.

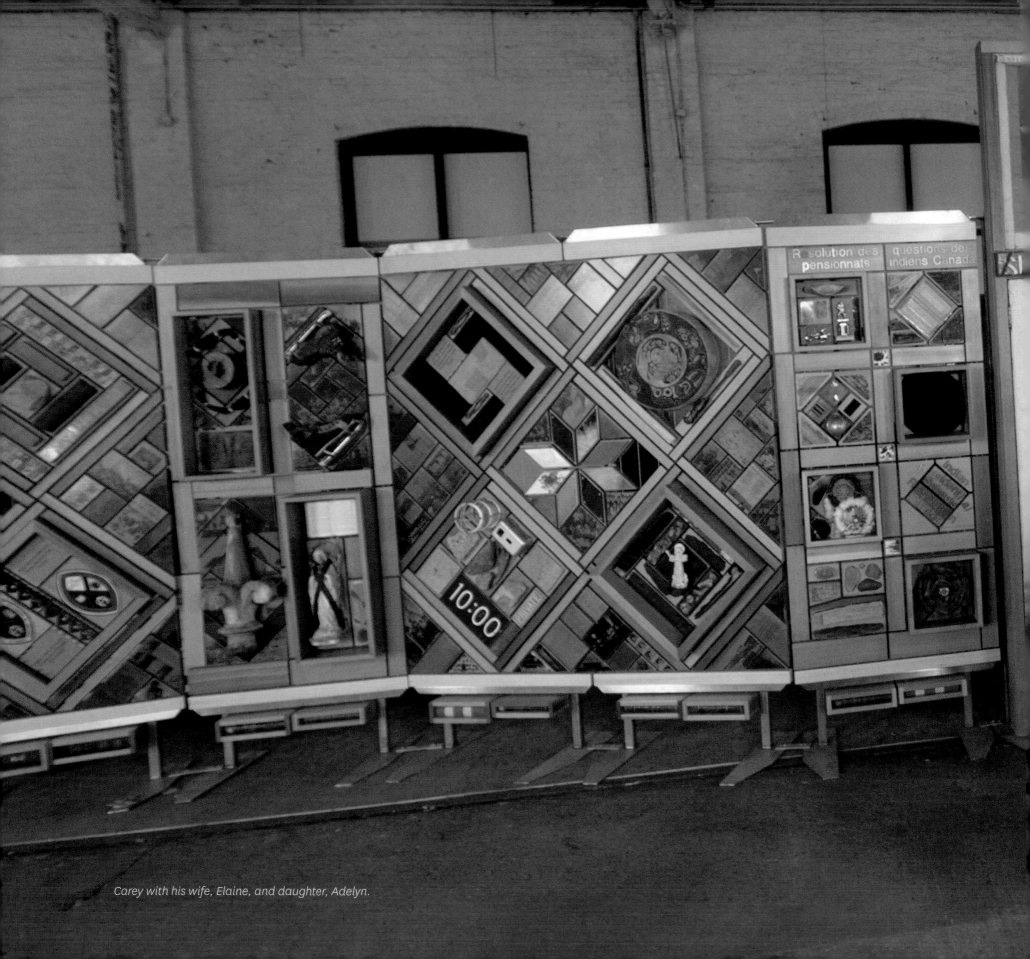

Carey with his wife, Elaine, and daughter, Adelyn.

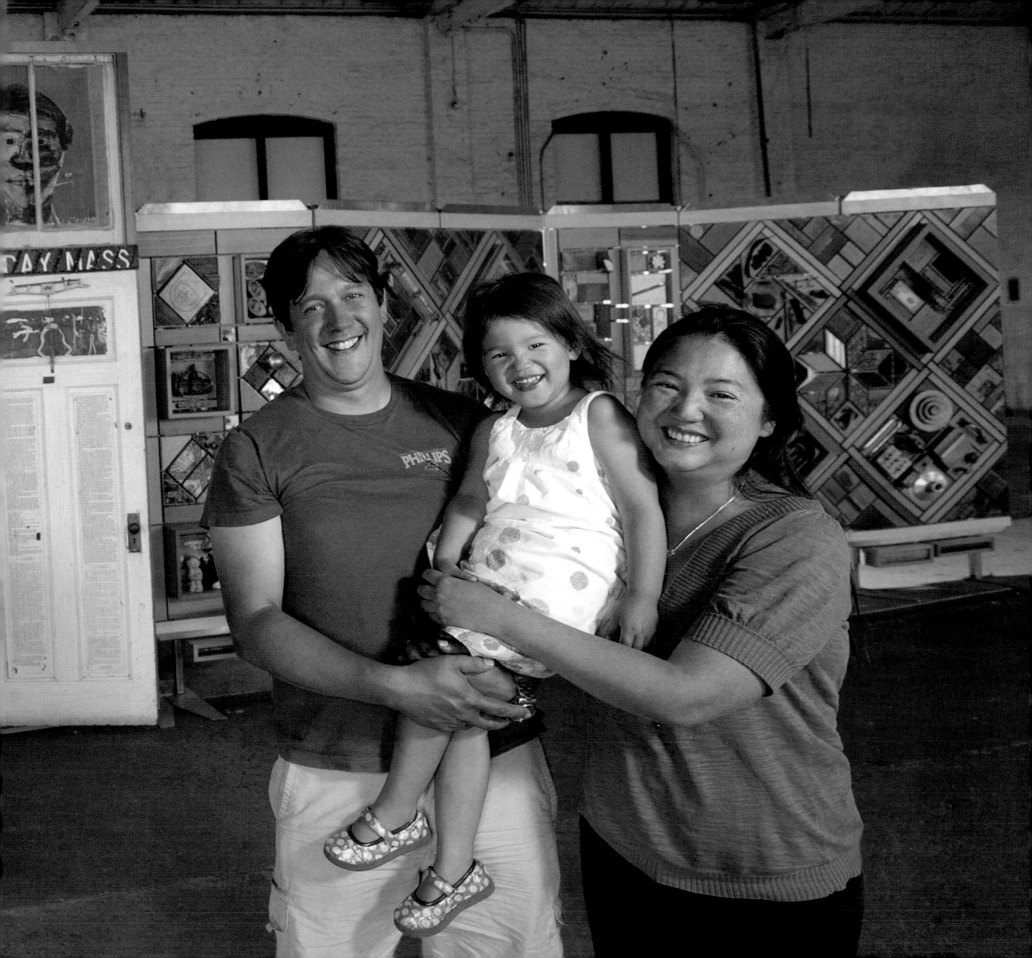

GLOSSARY

ancestor—a family member who lived before the time of your grandparents

assimilate—to remove cultural uniqueness by forcing everyone to accept one dominant way of life

Big House—a place for ceremony, celebration and community gathering

button blanket—traditional regalia of some Northwest Coast Indigenous people

CBC (Canadian Broadcasting Corporation)—Canada's publicly owned radio and television broadcaster

collective truth—the idea that when many individual stories are put together they add up to undeniable truth

colonization—the imposition by people from one culture of their own political, legal and social systems on people from another culture in an attempt to steal land from them and extinguish their rights

Common Experience Payment—court-ordered payments to Survivors based on the number of years they attended residential school

Cree syllabics—the system of letters and symbols used to write in the Cree language

dance screen—a curtain, painted with crests of the Potlatch hosts, that obscures the area in a big house where dancers prepare

day school—a school created with the same intention as residential schools; students were permitted to go home every day

Department of Indian Affairs—the branch of the federal government, currently called Indigenous and Northern Affairs Canada, that attempts to control all aspects of Indigenous life in Canada

Elder—a title used in some Indigenous cultures that reflects both age and wisdom of a person

Indian agent—a local administrator of the Canadian government who held power over the lives of all Indigenous people in their jurisdiction

Indian residential school system—a school system, imposed by the Canadian government and run by churches, that removed Indigenous children from their communities with the intention of extinguishing family and cultural connections

Indian Residential School Settlement Agreement (IRSSA)—the legal agreement between the Government of Canada and residential school Survivors that provided the framework for all aspects of the largest class-action settlement in Canadian history

Indigenous Peoples—in Canada this term is most commonly used to collectively describe First Nations, Métis and Inuit

industrial school—a residential school that used students as unpaid child labour

infirmary—a room in a residential school that was used to treat sick or injured students

Intergenerational Survivor—a descendant of a residential school Survivor who is in some way affected by the experience of that Survivor

intergenerational trauma—the consequences of trauma passed down from residential school Survivors to their descendants

National Centre for Truth and Reconciliation—an archive of testimony, objects and documentation that relates to the residential school era in Canada

pipe ceremony—a sacred ceremony that involves sitting in a circle and passing around a pipe filled with tobacco

portage—a place where a canoe must be carried over land because the waterway is impassable

Potlatch—a traditional gathering practised in some Indigenous communities, in which people come together to deal with social, political, spiritual and cultural issues through ceremony

reconciliation—in this book, reconciliation refers to the process of acknowledging and repairing the harms inflicted on Indigenous people by colonization

regalia—traditional attire that is worn in ceremonies; it varies from one Indigenous culture to another

reserve—land designated by the federal government, through the Indian Act, for the exclusive use of First Nations people

settler—a person who lives in Canada but whose ancestors originally came from another country

Sixties Scoop—a legacy of the residential school system in which a disproportionate number of Indigenous children were taken from their families and communities and adopted or placed in foster care

Survivor—Indigenous person who endured the residential school system and all the effects and trauma of that experience

sweat lodge—a structure in which spiritual cleansing takes place through sitting in heat and steam

totem pole—a Northwest Coast Indigenous art form, typically carved from cedar, that depicts stories, families or significant events

Truth and Reconciliation Commission of Canada (TRC)—established through the IRSSA as a means to record and document the experiences of residential school Survivors and begin the process of Canada's reconciliation with Indigenous people

REFERENCES

Anglican Church of Canada. Truth and Reconciliation. anglican.ca/tr/.

Barman, Jean, Yvonne Hebert, and Don McCaskill, eds. *Indian Education in Canada,* Vol. 1, *The Legacy.* Vancouver, BC: UBC Press, 2011.

Carr, Geoffrey Paul. "Educating Memory: Regarding the Remnants of Indian Residential School." *Journal for the Society for the Study of Architecture in Canada* 34, no. 2 (2009): 87–89.

Carr, Geoffrey Paul. "The House of No Spirit: An Architectural History of the Indian Residential School in British Columbia." PhD dissertation, University of British Columbia, 2011.

Indian Residential Schools Settlement: Official Court Website. residentialschoolsettlement.ca/.

Inuvik Community Greenhouse. *Inuvik Community Greenhouse: Fostering Community through Gardening.* inuvikgreenhouse.com/.

Miller, J.r. "Residential Schools in Canada." *The Canadian Encyclopedia.* thecanadianencyclopedia.ca/en/article/residential-schools/.

Mosby, Ian. "Administering Colonial Science: Nutrition Research and Human Biomedical Experimentation in Aboriginal Communities and Residential Schools, 1942–1952." ianmosby.ca/.

National Centre for Truth and Reconciliation. University of Manitoba. nctr.ca/map.php.

Newman, Carey, and Cody Graham, dirs. *Picking Up the Pieces: The Making of the Witness Blanket.* Media One, 2018.

Niessen, Shuana. *Shattering the Silence: The Hidden History of Indian Residential Schools in Canada.* Regina, SK: University of Regina, Faculty of Education, 2017. (Project of Heart eBook.)

United Church of Canada Archives. *The Children Remembered: Residential School Archive Project.* thechildrenremembered.ca.

Yukon Archives. *Yukon Residential Schools Bibliography: A List of Documents Held at the Yukon Archives.* Yukon Tourism and Culture, 2011. tc.gov.yk.ca/findingaids/residential_schools.pdf.

READING LIST

Campbell, Nicola, I. *Shin-chi's Canoe*. Toronto, ON: Groundwood Books/House of Anansi Press, 2008.

Dimaline. Cherie. *Marrow Thieves*. Toronto, ON: Cormorant Books, 2017.

Dupuis, Jenny Kay, and Kathy Kacer. *I Am Not a Number*. Toronto, ON: Second Story Press, 2016.

Gray Smith, Monique. *Speaking Our Truth: A Journey of Reconciliation*. Victoria, BC: Orca Book Publishers, 2017.

Jordan-Fenton, Christy, and Margaret Pokiak Fenton. *Fatty Legs: A True Story*. Toronto, ON: Annick Press, 2010.

Jordan-Fenton, Christy, and Margaret Pokiak Fenton. *Stranger at Home: A True Story*. Toronto, ON: Annick Press, 2011.

Loyie, Larry, and Constance Brissenden. *As Long As the River Flows*. Toronto, ON: Groundwood Books/House of Anansi, 2005.

Milloy, John S. *A National Crime: The Canadian Government and the Residential School System, 1879 to 1996*. Winnipeg, MB: University of Manitoba Press, 1999.

Robertson, David Alexander. *Sugar Falls: A Residential School Story*. Winnipeg, MB: Portage and Main Press, 2012.

Sellars, Bev. *They Called Me Number One: Secrets and Survival at an Indian Residential School*. Vancouver, BC: Talonbooks, 2012.

Vowel, Chelsea. *Indigenous Writes: A Guide to First Nations, Metis and Inuit Issues in Canada*. Winnipeg, MB: Portage and Main Press, 2017.

Reaching Across the Country

For more than a century, there were Indian residential schools across Canada. In 2013 and 2014, the Witness Blanket team traveled nationwide, collecting pieces of this history.

The project resulted in the collection of 887 donated and reclaimed items, all of which are included in the installation and mobile app. This inclusive approach symbolizes reconciliation, which requires national participation and commitment.

As Carey Newman, artist of the Witness Blanket, states, this cross-country involvement is "a testament to the human ability to find something worthwhile, even beautiful, amidst the tragedies, memories and ruins of the residential school era."

Collection Sites (approximate locations):

◆ Residential school

○ Private or organization

▫ Church or government

Dans tous les coins du pays

Pendant plus d'un siècle, il y avait des pensionnats indiens un peu partout au Canada. En 2013 et 2014, l'équipe de la Couverture des témoins a voyagé d'un bout à l'autre du pays pour recueillir des morceaux de cette histoire.

L'équipe a ainsi assemblé une collection de 887 objets donnés ou récupérés, qui sont tous inclus dans l'installation et dans l'appli mobile. Cette approche inclusive est symbolique de la réconciliation, qui nécessite la participation et l'engagement à l'échelle nationale.

Comme le dit Carey Newman, artiste de la Couverture des témoins, cette participation pancanadienne « illustre la capacité humaine de trouver ce qui est valable, ou même beau, dans les tragédies, les souvenirs et les ruines de la période des pensionnats ».

Sites de collection (lieux approximatifs) :

◆ Pensionnat

○ Collection privée ou organisation

▫ Église ou gouvernementx

List of Residential Schools of Canada. Courtesy of the TRC.

Alberta

Residential Schools/Pensionnats	Location/Emplacement	Church/Église
Assumption (Hay Lakes)	Assumption	C
Blue Quills (Saddle Lake, Sacred Heart, Lac la Biche)	Lac la Biche, 1891-98 Saddle Lake, 1898-1931 St. Paul, 1931	C
Crowfoot (Blackfoot, St. Joseph's, St. Trinité)	Cluny	C
Desmarais (St. Martins, Wabiscaw Lake, Wabasca)	Desmarais-Wabasca	C
Edmonton (Red Deer Industrial, St. Albert)	St. Albert	U
Ermineskin	Hobbema	C
Fort Vermilion (St. Henry's)	Fort Vermillion	C
Grouard (St. Bernard's, Lesser Slave Lake Roman Catholic)	Grouard	C
Holy Angels (Fort Chipewyan, École des Saints-Anges)	Fort Chipewyan	C
Joussard (St. Bruno's)	Joussard	C
Lac la Biche (Notre Dame des Victoires, Blue Quills)	Lac La Biche	C
Lesser Slave Lake (St. Peter's)	Lesser Slave Lake	4A
Morley (Stony/Stoney)	Morley	U
Old Sun (Blackfoot)	Gleichen	A
Sacred Heart (Peigan, Brocket)	Brocket	C
St. Albert (Youville)	Youville	C
St. Augustine (Smoky River)	Peace River	C
St. Cyprian's (Victoria Home, Peigan)	Brocket	A
St. Joseph's (High River, Dunbow)	High River	C
St. Mary's (Blood, Immaculate Conception)	Cardston	C
St. Paul's (Blood)	Cardston	A
Sarcee (St. Barnabas)	Sarcee Junction, T'suu Tina	A
Sturgeon Lake (Calais, St. Francis Xavier)	Calais	C
Wabasca (St. John's)	Wabasca Lake	A
Whitefish Lake (St. Andrew's)	Whitefish Lake, Atikameg, (St. Andrew's Mission)	A

British Columbia / Colombie-Britannique

Residential Schools/Pensionnats	Location/Emplacement	Church/Église
Ahousat	Ahousat	U
Alberni	Port Alberni	U
Anahim (Anahim Lake)	Anahim Lake	N
Cariboo (St. Joseph's, William's Lake)	Williams Lake	C
Christie (Clayquot, Kakawis)	Tofino	C
Coqualeetza	Chilliwack	U
Cranbrook (St. Eugene's, Kootenay)	Cranbrook	C
Kamloops	Kamloops	C
Kitimaat	Kitimaat	U
Kuper Island	Kuper Island	C
Lejac (Fraser Lake)	Fraser Lake	C
Lower Post	Lower Post	C
Port Simpson (Crosby Home for Girls)	Port Simpson	A
St. George's (Lytton)	Lytton	A
St. Mary's (Mission)	Mission	C
St. Michael's (Alert Bay Girls' Home, Alert Bay Boys' Home)	Alert Bay	A
St. Paul's (Squamish, North Vancouver)	North Vancouver	C
Sechelt	Sechelt	C

Manitoba

Residential Schools/Pensionnats	Location/Emplacement	Church/Église
Assiniboia (Winnipeg)	Winnipeg	C
Birtle	Birtle	P
Brandon	Brandon	U/C
Churchill Vocational Centre	Churchill	N
Cross Lake (St. Joseph's, Norway House, Jack River Annex, Notre Dame Hostel)	Cross Lake	C
Elkhorn (Washakada)	Elkhorn	A
Fort Alexander (Pine Falls)	Pine Falls	C
Guy Hill (Clearwater, The Pas, Sturgeon Landing (SK))	Clearwater Lake	C
Mackay – Dauphin	Dauphin	A
Mackay – The Pas	The Pas	A
Norway House	Norway House	U
Pine Creek (Camperville)	Camperville	C
Portage la Prairie	Portage la Prairie	U
Sandy Bay	Sandy Bay Reserve	C

Northwest Territories/Territoires du Nord-Ouest

Residential Schools/Pensionnats	Location/Emplacement	Church/Église
Akaitcho Hall (Yellowknife)	Yellowknife	N
Aklavik - Immaculate Conception	Aklavik	C
Aklavik (All Saints)	Aklavik	A
Federal Hostel - Fort Franklin	Déline	N
Fort McPherson (Fleming Hall)	Fort McPherson	A
Fort Providence (Sacred Heart)	Fort Providence	C
Fort Resolution (St. Joseph's)	Fort Resolution	C
Fort Simpson - Bompas Hall (Koe Go Cho)	Fort Simpson	A
Fort Simpson - Lapointe Hall (Deh Cho Hall, Koe Go Cho)	Fort Simpson	C
Fort Smith - Breynat Hall	Fort Smith	C
Fort Smith - Grandin College	Fort Smith	C
Hay River (St. Peter's)	Hay River	A
Inuvik - Grollier Hall	Inuvik	C
Inuvik - Stringer Hall	Inuvik	A

Nova Scotia / Nouvelle-Écosse

Residential Schools/Pensionnats	Location/Emplacement	Church/Église
Shubenacadie	Shubenacadie	C

Nunavut

Residential Schools/Pensionnats	Location/Emplacement	Church/Église
Chesterfield Inlet (Joseph Bernier, Turquetil Hall)	Chesterfield Inlet	C
Coppermine (Tent Hostel)	Coppermine	A
Federal Hostel - Baker Lake/Qamani'tuaq	Qamanittuaq	N
Federal Hostel - Belcher Islands	South Camp, Flaherty Island	N
Federal Hostel - Broughton Island/Qikiqtarjuaq	Qikiqtarjuaq	N
Federal Hostel - Cambridge Bay	Cambridge Bay	N
Federal Hostel - Cape Dorset/Kinngait	Kinngait	N
Federal Hostel - Eskimo Point/Arviat	Arviat	N
Federal Hostel - Frobisher Bay (Ukkivik)	Iqaluit	N
Federal Hostel - Igloolik/Iglulik	Igloolik/Iglulik	N
Federal Hostel - Lake Harbour	Kimmirut	N
Federal Hostel - Pangnirtung (Pangnirtang)	Pangnirtung/Panniqtuuq	N
Federal Hostel - Pond Inlet/Mittimatalik	Mittimatalik	N

Ontario

Residential Schools/Pensionnats	Location/Emplacement	Church/Église
Bishop Horden Hall (Moose Fort, Moose Factory)	Moose Factory Island	A
Cecilia Jeffrey (Kenora, Shoal Lake)	Kenora	P
Chapleau (St. Joseph's, St. John's)	Chapleau	A
Cristal Lake		M
Fort Frances (St. Margaret's)	Fort Frances	C
Fort William (St. Joseph's)	Fort William	C
McIntosh (Kenora)	McIntosh	C
Mohawk Institute	Brantford	A
Mount Elgin (Muncey, St. Thomas)	Muncey	U
Pelican Lake (Pelican Falls)	Sioux Lookout	A
Poplar Hill	Poplar Hill	M
St. Anne's (Fort Albany)	Fort Albany	C
St. Mary's (Kenora, St. Anthony's)	Kenora	C
Shingwauk	Sault Ste. Marie	A
Spanish Boys' School (Charles Garnier, St. Joseph's, Wikwemikong Industrial)	Spanish	C
Spanish Girls' School (St. Joseph's, St. Peter's, St. Anne's, Wikwemikong Industrial)	Spanish	C
Stirland	Stirland	M

Québec

Residential Schools/Pensionnats	Location/Emplacement	Church/Église
Amos (St. Marc-de-Figuery)	Amos	C
Fort George (St. Phillip's)	Fort George	A
Fort George (St. Joseph's Mission, Residence Couture, Sainte-Thérèse-de-l'Enfant- Jésus)	Fort George	C
Federal Hostel - George River	Kangirsualujjuaq	N
Federal Hostel - Great Whale River (Poste-de-la-Baleine, Kuujjaraapik)	Kuujjuaraapik/ Whapmaguustui	N
Federal Hostel - Payne Bay (Bellin)	Kangirsuk	N
Federal Hostel - Port Harrison (Inoucdjouac, Innoucdouac)	Inukjuak	N
La Tuque	La Tuque	A
Point Bleue	Pointe-Bleue	C
Sept-Îles (Seven Islands, Notre Dame, Maliotenam)	Sept-Îles	C

Saskatchewan

Residential Schools/Pensionnats	Location/Emplacement	Church/Église
Battleford	Battleford	A
Beauval (Lac la Plonge)	Beauval	C
Cote Improved Federal Day School	Kamsack	U
Crowstand	Kamsack	P
File Hills	Balcarres	U
Fort Pelly	Fort Pelly	C
Gordon's Gordon's Reserve	Punnichy	A
Lac La Ronge	Lac La Ronge	A
Lebret (Qu'Appelle, Whitecalf, St. Paul's High School)	Lebret	C
Marieval (Cowesess, Crooked Lake)	Cowesess Reserve	C
Muscowequan (Lestock, Touchwood)	Lestock	C
Onion Lake	Onion Lake	A
Prince Albert (Onion Lake, St. Alban's, All Saints, St. Barnabas, Lac La Ronge)	Prince Albert	A
Regina	Regina	P
Round Lake	Broadview	U
St. Anthony's (Onion Lake, Sacred Heart)	Onion Lake	C
St. Michael's (Duck Lake)	Duck Lake	C
St. Phillip's	Kamsack	C
Sturgeon Landing (Guy Hill, Manitoba)	Sturgeon Landing	C
Thunderchild (Delmas, St. Henri)	Delmas	C

Yukon

Residential Schools/Pensionnats	Location/Emplacement	Church/Église
Carcross (Chooulta)	Carcross	A
Coudert Hall (Whitehorse Hostel/Student Residence, Yukon Hall)	Whitehorse	C
St. Paul's Hostel (Dawson City)	Dawson	A
Shingle Point (St. John's)	Shingle Point	A
Whitehorse Baptist (Lee Mission)	Whitehorse	B
Yukon Hall (Whitehorse/Protestant Hostel)	Whitehorse	N

Church / Église

A = Anglican / Anglicane
B = Baptist / Baptiste
C = Catholic / Catholique
M = Mennonite / Mennonite
N = Non-denominational / Non-confessionelle
P = Presbyterian / Presbytérienne
U = United / Unie

Truth and Reconciliation Commission of Canada

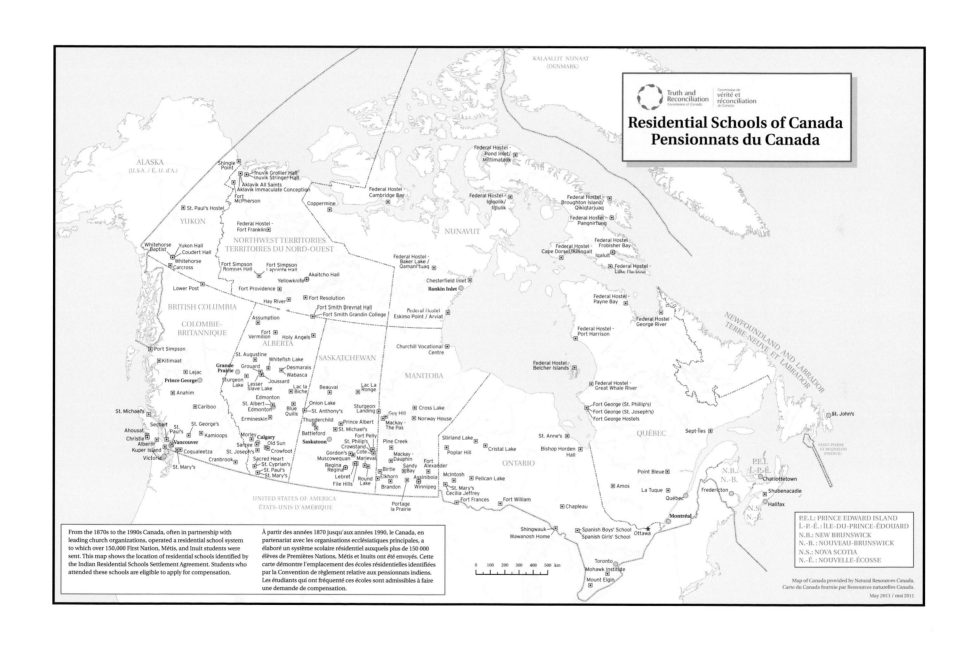

Residential Schools of Canada
Pensionnats du Canada

Truth and Reconciliation Commission of Canada
Commission de vérité et réconciliation du Canada

KALAALLIT NUNAAT (DENMARK)

ALASKA (U.S.A. / É.-U. d'A.)

Shingle Point
Inuvik Grollier Hall
Inuvik Stringer Hall
Aklavik All Saints
Aklavik Immaculate Conception
Fort McPherson
St. Paul's Hostel
Coppermine

YUKON
Federal Hostel - Fort Franklin

Federal Hostel - Cambridge Bay

Federal Hostel - Pond Inlet/ Mittimatalik

Federal Hostel - Igloolik/ Iglulik

Federal Hostel - Broughton Island/ Qikiqtarjuaq

Federal Hostel - Pangnirtung

NUNAVUT

NORTHWEST TERRITORIES
TERRITOIRES DU NORD-OUEST

Whitehorse Baptist
Yukon Hall Coudert Hall
Whitehorse Carcross
Lower Post
Fort Simpson Bompas Hall
Fort Simpson Lapointe Hall
Akaitcho Hall
Yellowknife
Fort Providence
Hay River
Fort Resolution

Federal Hostel - Frobisher Bay
Iqaluit
Federal Hostel - Cape Dorset/Kinngait
Federal Hostel - Lake Harbour

Federal Hostel - Baker Lake / Qamani'tuaq
Chesterfield Inlet
Rankin Inlet

Federal Hostel - Payne Bay
Federal Hostel - George River

BRITISH COLUMBIA
COLOMBIE-BRITANNIQUE

Fort Smith Breynat Hall
Fort Smith Grandin College
Federal Hostel Eskimo Point / Arviat

Assumption
Fort Vermilion
Holy Angels

Churchill Vocational Centre

Federal Hostel - Port Harrison

Port Simpson
Kitimaat
Lejac
Prince George
Anahim
Cariboo

ALBERTA

St. Augustine
Whitefish Lake
Grande Prairie
Grouard
Desmarais
Wabasca
Sturgeon Lake
Lesser Slave Lake
Joussard
Lac la Biche
Beauval
Lac la Ronge

SASKATCHEWAN

MANITOBA

Federal Hostel - Belcher Islands

Federal Hostel - Great Whale River

NEWFOUNDLAND AND LABRADOR
TERRE-NEUVE ET LABRADOR

St. John's

St. Michael's
Ahousat
Christie
Alberni
Kuper Island
Victoria
St. Mary's

Sechelt
St. Paul's
St. George's
Kamloops
Morley
Sarcee
Coqualeetza
Cranbrook

Vancouver

Edmonton
St. Albert
Edmonton
Ermineskin
Blue Quills

Onion Lake
St. Anthony's
Thunderchild
Battleford
Calgary
Old Sun
Crowfoot
Sacred Heart
St. Cyprian's
St. Paul's
St. Mary's

Sturgeon Landing
Prince Albert
St. Michael's
St. Philip's
Crowstand
Cote
Marieval
Muscowequan
Regina
Lebret
File Hills

Guy Hill
Mackay - The Pas
Cross Lake
Norway House

Pine Creek
Mackay - Dauphin
Sandy Bay
Round Lake
Elkhorn
Brandon

Stirland Lake
Poplar Hill
Cristal Lake

St. Anne's
Bishop Horden Hall

QUÉBEC

Sept-Îles

SAINT-PIERRE ET MIQUELON (FRANCE)

Fort George (St. Phillip's)
Fort George (St. Joseph's)
Fort George Hostels

Fort Pelly
Gordon's

Fort Alexander
Assiniboia
Winnipeg
St. Mary's
Cecilia Jeffrey
Fort Frances

McIntosh
Pelican Lake

ONTARIO

Fort William
Chapleau

Point Bleue
Amos
La Tuque
Québec

Shingwauk
Wawanosh Home
Spanish Boys' School
Spanish Girls' School
Ottawa

Montréal

Fredericton
Shubenacadie

N.B.
N.-B.

P.E.I.
Î.-P.-É.
Charlottetown

N.S.
N.-É.
Halifax

Portage la Prairie

UNITED STATES OF AMERICA
ÉTATS-UNIS D'AMÉRIQUE

Toronto
Mohawk Institute
Mount Elgin

From the 1870s to the 1990s Canada, often in partnership with leading church organizations, operated a residential school system to which over 150,000 First Nation, Métis, and Inuit students were sent. This map shows the location of residential schools identified by the Indian Residential Schools Settlement Agreement. Students who attended these schools are eligible to apply for compensation.

À partir des années 1870 jusqu'aux années 1990, le Canada, en partenariat avec les organisations ecclésiatiques principales, a élaboré un système scolaire résidentiel auxquels plus de 150 000 élèves de Premières Nations, Métis et Inuits ont été envoyés. Cette carte démontre l'emplacement des écoles résidentielles identifiées par la Convention de règlement relative aux pensionnats indiens. Les étudiants qui ont fréquenté ces écoles sont admissibles à faire une demande de compensation.

0 100 200 300 400 500 km

P.E.I.: PRINCE EDWARD ISLAND
Î.-P.-É.: ÎLE-DU-PRINCE-ÉDOUARD
N.B.: NEW BRUNSWICK
N.-B.: NOUVEAU-BRUNSWICK
N.S.: NOVA SCOTIA
N.-É.: NOUVELLE-ÉCOSSE

Map of Canada provided by Natural Resources Canada.
Carte du Canada fournie par Ressources naturelles Canada.

May 2011 / mai 2011

INDEX

ACKNOWLEDGMENTS

We would like to begin by acknowledging that most of this book was written on the traditional unceded territories of the Lekwungen people.

Although it is impossible to acknowledge the confluence of efforts and circumstances that have made this book possible, we would like to single out some individuals for their contributions.

We raise our hands:

◆ To Victor Newman and all the other residential school Survivors who not only shared the personal stories that fill these pages but also contributed the physical pieces that became the Witness Blanket. *Gilakas'la* for your generosity and courage.

◆ To each of the Intergenerational Survivors who shared their reflections and experience. The words of people like Marilyn (Murray) Allison and Lance Scout increase understanding of the ongoing effects of colonialism.

◆ To Rosy Hartman, Marek Tyler and the Witness Blanket collection team who travelled across the country, visited dozens of communities, spoke to thousands of people and gathered the objects and stories that made the Blanket a reality.

◆ To the construction team who spent countless hours in the studio helping to build the Blanket: Colin Graham, Tejas Collison, Robert Byers, Edith Newman, Donna Patterson and Lindsay Delaronde.

◆ To Iris Ting, René St. Pierre, Moy Sutherland, Jane Hutchins and many other friends and family who gave up their evenings, weekends and often their sleep to bring the project to the finish line.

◆ To Cody, Graem, Adam and the team at Media One in Victoria, British Columbia, who travelled with the collection team, recording and documenting not only the stories of Survivors but also the project itself.

◆ To the staff of our managing partner, the Victoria Native Friendship Centre, particularly the former and current executive directors, Bruce Parisian and Ron Rice.

◆ To the Canadian Museum for Human Rights in Winnipeg, Manitoba, for giving the Witness Blanket its final home.

- To everyone at Orca Book Publishers who helped turn this book into a reality and, most important, to our editor, Sarah Harvey, who first recognized the potential of this story.

- To Teresa Bubela, for her thoughtful and beautiful design of this book.

- And to our families, for giving us the time and space to get this story just right.

KIRSTIE

To my mother, Nancy, for telling me my first stories, and to Kirk, for being my first editor, regardless of the hour. To Elliot and Hazel, who love the power of words as much as I do. And to Carey, for allowing me to bear witness to this piece of history and, most important, for trusting me to help tell your story. Thank you.

CAREY

I would like to start by acknowledging that I am a reflection of my family. To my parents, Edith and Victor, thank you for making me, teaching me and raising me to have a social conscience. Dad, thank you for your resilience. You started me on my artistic journey, your history is my history, and I am so proud to be your son. To my sisters, Marion and Ellen, thank you for your support, your wisdom and, of course, your braids.

To my wife and best friend, Elaine, you not only empower the best parts of me but you are my ballast, my foundation and my shelter. To my daughter, Adelyn, you once said, "My dad makes Witness Blankets" and for your first few years of life this project was all that you knew. Thank you for your painting and your handprints, your joy and your curiosity. You might never understand how much it means to me to have you in my life.

Finally, to Kirstie, thank you for sharing this journey with me. Your thoughtfulness, dedication and organization have not only enabled this book to take shape but have added to its heart.

PHOTO CREDITS

Alyssa O'Connor: p. 148

Andrew Querner: p. 6

Anna Elphinstone (courtesy of): p. 101

Annick Press/*Stranger at Home*: p. 105

Bruce Martin: p. 155

Canadian Museum for Human Rights (courtesy of): pp. 153, 163

Canadian Ski Hall of Fame and Museum (by permission of): p. 77

Carey Newman: p. 130

Coqualeetza Cultural Education Centre (courtesy of): p. 60

General Synod Archives, Anglican Church of Canada: pp. 62, 64, 113

Glenbow Archives: pp. 33 (ND-27-48), 45 (NC-7-750), 63 (NA-1128-13), 74 (NA-5190-8), 88 (NA-1811-54)

Ian MacCausland, Canadian Museum for Human Rights: pp. 52, 94, 122

Jesse Hlady: pp. 24, 56, 70, 72, 78, 84, 90, 92, 98, 99, 100, 102, 110, 125, 140, 155, 156

Jessica Sigurdson, Canadian Museum for Human Rights: cover, pp. viii, 10, 18, 26, 35, 36, 43, 46, 49, 58, 61, 82, 120, 124, 132

John Lehmann/*The Globe and Mail*: iv–v, pp. 28, 118

Ken Wilkinson: p. 171

Library and Archives Canada/Indian and Northern Affairs: pp. 30 (RG22M 778803/111 item 1067)

Marilyn (Murray) Allison (courtesy of): pp. 53, 54

Media One Inc. (courtesy of): pp. 2, 7, 8, 13, 14, 17, 20, 21, 22, 25, 29, 31, 32, 33, 34, 36, 39, 40, 41, 42, 44, 48, 50, 51, 55, 57, 60, 65, 66, 67, 73, 75, 76, 80, 85, 86, 87, 93, 94, 114, 116, 117, 119, 123, 126, 127, 128, 129, 135, 136, 137, 138, 139, 142–147, 150, 151, 152

Michelle Washington (courtesy of): p. 97

National Centre for Truth and Reconciliation Archives: p. 165 (Residential School Map T00005, Truth and Reconciliation Commission of Canada)

Newman family (courtesy of): pp. 3, 4, 5, 68

NWT Archives/Sacred Heart Parish (Fort Simpson) fonds: p. 65 (N-1992-255: 0082)

Provincial Archives of Alberta: pp. 60 (A14802), 62 (A11121), 73 (A13454)

Rita Michell (courtesy of): pp. 72, 81

Robert A. Alexie (courtesy of): p. 115

Robertson family (courtesy of): p. 171

Roth and Ramberg: p. 171

Royal BC Museum and Archives (courtesy of): p. 112 (image I-30599)

Saskatchewan Archives Board: p. 154 (R-A8223 (1) - (2))

Shingwauk Residential Schools Centre, Algoma University: pp. 44, 89, 95, 96

St. Eugene Golf Resort and Casino (courtesy of): p. 112

UCCA: pp. 85 (93.049P1262N/Norway House Indian Boarding School on fire, 1912), 154 (93.049P1162/Round Lake IRS circa 1940)

United Church Archives, Toronto: p. 56 (93.049P / 1661)

University of Victoria Legacy Art Galleries (courtesy of): p. 79

Witness Blanket team (courtesy of): pp. 12, 15, 16

Every effort has been made to locate and credit the copyright owners of the images used in this book. The publisher apologizes for any errors or omissions and would be grateful if notified of corrections that should be made in future reprints or editions.

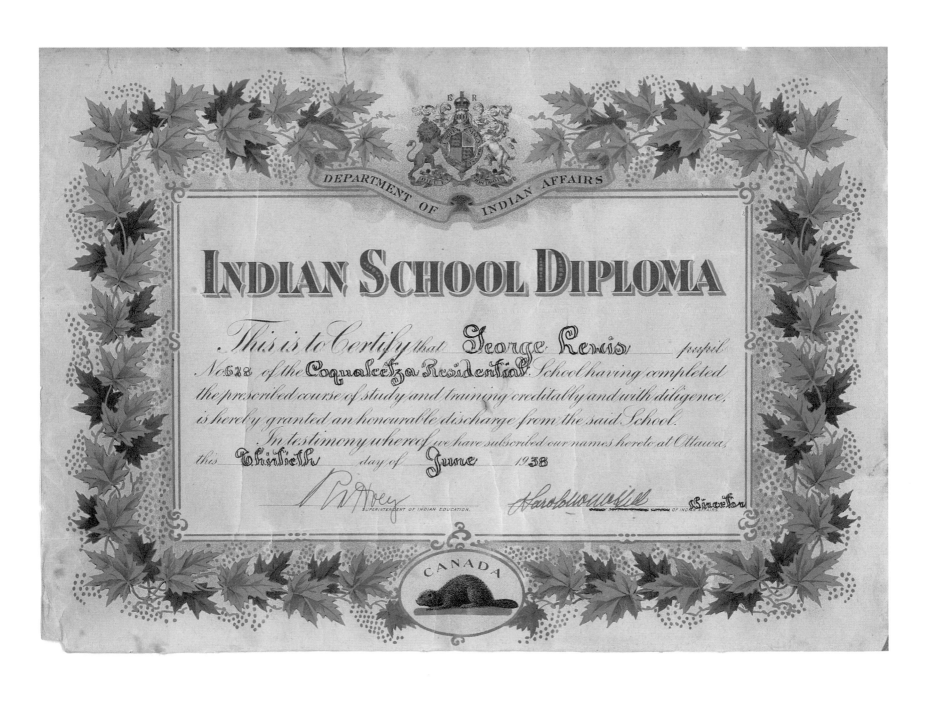

DEPARTMENT OF INDIAN AFFAIRS

INDIAN SCHOOL DIPLOMA

This is to Certify that *George Lewis* pupil No 628 of the *Coqualeetza Residential* School having completed the prescribed course of study and training creditably and with diligence, is hereby granted an honourable discharge from the said School.

In testimony whereof we have subscribed our names hereto at Ottawa, this *Thirtieth* day of *June* 1938

SUPERINTENDENT OF INDIAN EDUCATION.

DEPUTY SUPERINTENDENT GENERAL OF INDIAN AFFAIRS.

Director

CANADA

ABOUT THE AUTHORS

Carey Newman, or Hayalthkin'geme, is a multidisciplinary artist and master carver. Through his father he is Kwakwaka'wakw from the Kukwekum, Giiksam and WaWalaby'ie clans of Fort Rupert, and Coast Salish from Cheam of the Stó:lō Nation along the upper Fraser Valley. Through his mother he is English, Irish and Scottish. In his artistic practice he strives to highlight Indigenous, social or environmental issues. He is also interested in engaging with community and incorporating socially innovative practice into his artistic process. Carey's most recent major work, the Witness Blanket, made of items collected from residential schools, government buildings and churches across the Canada, deals with the subject of reconciliation.

In 2008 Carey was selected as the master carver of the Cowichan 2008 Spirit Pole. He travelled the province of British Columbia sharing the experience of carving a six-metre (twenty-foot) totem with over 11,000 people. In 2009 Carey was selected from artists across Canada to create a large installation for the 2010 Olympic Winter Games. The piece, entitled *Dancing Wind*, consisted of four large panels made from stainless steel, cedar and glass. He has produced works for corporations, government agencies and museums around the world and is continually grateful for the opportunity to explore new ideas.

Carey was awarded the Meritorious Service Medal in 2017, and in 2018 was named to the Order of British Columbia and appointed Audain Professor of Contemporary Art Practice of the Pacific Northwest at the University of Victoria.

Kirstie Hudson is an editor and writer in Victoria, British Columbia. She worked for the CBC for eighteen years at stations in Toronto, Vancouver, Prince Rupert and Victoria. In her career as an award-winning journalist, Kirstie's work has been recognized with a Jack Webster Award, Radio Television Digital News Association awards and a Gabriel Award. Over the years she has covered hundreds of stories, including the making of the Witness Blanket. As an instructor at the University of Victoria and Royal Roads University, Kirstie shared her love of storytelling with students in writing, communications and journalism.